30/20 DD

Rembrandt: the A

DØ243316

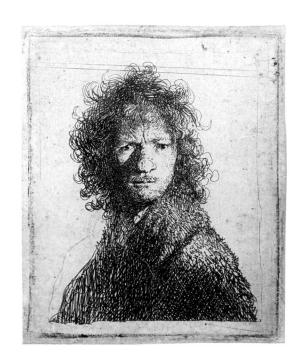

Sponsored by AMERICAN EXPRESS FOUNDATION

Holm Bevers & Barbara Welzel

Rembrandt: The Master & his Workshop

Etchings

Exhibition dates:

Kupferstichkabinett smpk at the Altes Museum, Berlin: 12 September 1991–27 October 1991 Rijksmuseum, Amsterdam: 4 December 1991–19 January 1992 The National Gallery, London: 26 March 1992–24 May 1992

Exhibition Organiser: Uwe Wieczorek

Copyright © Staatliche Museen Preußischer Kulturbesitz, Berlin, Rijksmuseum, Amsterdam, The National Gallery, London, 1991

All rights reserved. No part of this publication may be transmitted in any form or by any means, electronic or mechanical, including photocopy, recording, or any information storage or retrieval system, without prior permission in writing from the publisher.

Edited by Sally Salvesen

Designed by Derek Birdsall RDI

Translators: Elizabeth Clegg, Fiona Healy

Typeset in Monophoto Van Dijck by Servis Filmsetting Ltd, Manchester Printed in Italy by Amilcare Pizzi, s.p.a., Milan on Gardamatt 135 gsm

ISBN: 0-300-05154-9 (paperback)

Contents

Patrons Director's Foreword Introduction

- 8 Rembrandt as an Etcher *Holm Bevers*
- 18 Catalogue
- 132 Bibliography

Patrons

Her Majesty Queen Elizabeth II

Her Majesty The Queen of the Netherlands

His Excellency Dr Richard von Weizsäcker President of the Federal Republic of Germany

Foreword

The richest concentrations of Rembrandt's work are to be found in Amsterdam, Berlin and London; and so it seemed entirely natural that this great *Rembrandt* exhibition should be held in all three cities. But in this, as in so much else, England is not quite like the rest of Europe.

In Amsterdam and Berlin one institution houses Rembrandt's paintings, drawings and etchings. In London, by an accident of history, the paintings hang in the National Gallery, while the drawings and etchings are held at the British Museum. Nonetheless, by a happy and generous act of collaboration, the British Museum is playing a full part in the Rembrandt exhibition. The paintings section of the Amsterdam and Berlin Exhibitions will move to the National Gallery. The British Museum meanwhile is putting on show its entire collection of Rembrandt drawings, while a selection of its finest etchings—the subject of this catalogue—is exhibited at the National Gallery. It will thus be possible for the London public, like the exhibition visitors in Amsterdam and Berlin, to enjoy the full range of the artist's work.

Warm thanks are due to our colleagues in Berlin and Amsterdam, to American Express Foundation for their support, and to the outstanding—and, over many decades, habitual—generosity of the British Museum.

Neil MacGregor Director The National Gallery London

Introduction

The exhibition of Rembrandt's Etchings was originally planned and selected by Hans Mielke and Peter Schatborn in 1988/89. The authors have been responsible for its development since 1990.

In Berlin and Amsterdam the exhibited etchings are from the respective collections (the Kupferstichkabinett smpk and the Rijksprentenkabinet). In London the exhibited etchings are from the collection of the British Museum. In the catalogue inventory numbers are given in brackets and * indicates the example which is illustrated.

The authors are particularly grateful to Jan Kelch, Hans Mielke, Martin Royalton-Kisch and Peter Schatborn for their stimulating suggestions.

Holm Bevers and Barbara Welzel

Rembrandt as an Etcher Holm Bevers

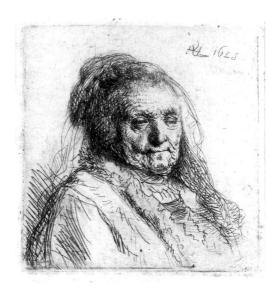

1: Rembrandt, *Portrait of bis mother*. Amsterdam, Rijksprentenkabinet.

'I have seen a number of his printed works which have appeared in these parts; they are very beautiful, engraved in good taste and in a good manner . . . I frankly consider him to be a great virtuoso.'1 So wrote in 1660 the Italian baroque painter Guercino to the Sicilian aristocrat and connoisseur Don Antonio Ruffo, whose collection contained a number of works by Rembrandt. The fame of the Dutch artist was not just confined to his native land, but was already well established in large parts of Europe, principally because of his prints.2 In his book on the history of prints published in 1662, the English author John Evelyn praised the 'incomparable Reinbrand, whose Etchings and gravings are of a particular spirit.'3 Rembrandt's etchings had already become collectable during his own lifetime. Michel de Marolles, whose large and important graphic collection formed the nucleus of the Bibliothèque Nationale in Paris, lists 224 entries under Rembrandt's name in his catalogue of 1666.4 Even today, the fascination of collecting etchings by Rembrandt, especially rare impressions and states, has lost none of its mystique. Equally, his style awoke the interest of contemporary artists, and was copied by Giovanni Benedetto Castiglione (1609–1665) among others. Entire generations of artists in the eighteenth and nineteenth centuries worked in Rembrandt's manner. Even prints by Pablo Picasso contain numerous references to his etchings.

Rembrandt produced prints from about 1628 to 1661, that is from his juvenile beginnings in Leiden to his late years in Amsterdam. For unknown reasons he appears to have abandoned etching after 1661, as the only known work after this date is a portrait (B. 264) from 1665.

The earliest catalogue raisonné was compiled by Edmé Gersaint in 1751, and followed by Adam Bartsch's in 1797. These two authors constructed an œuvre of 341 and 375 works respectively, using his signed and dated prints as the comparative basis against which unmarked works could be stylistically evaluated. The classification system devised by Bartsch, which groups and numbers prints thematically, has successfully withstood the test of time. The number of etchings presently accepted as being by Rembrandt has shrunk to around 290, with many of those attributed to him by Gersaint and Bartsch now given to pupils or followers.

A cursory study of the prints shows that they cover a wide variety of subjects. In his paintings, Rembrandt confined himself principally to the two areas most highly regarded at that time: portraiture and illustrative themes taken from

the Bible, mythology and history. For his etchings, however, he expanded his repertoire to include subjects which in seventeenth-century Dutch art were usually executed by specialists. In addition to the above-mentioned, Rembrandt turned his attention to genre, landscape, nudes, miscellaneous sketches and studies as well as allegories and still-life. The combination of his thematic diversity and his mastery of the various techniques enabled him to achieve an unrivalled intensity of artistic expression.

Known since about 1430, the medium of engraving was chiefly used in the seventeenth century for reproductive prints, that is the reproduction of paintings by professional engravers. Etching is a younger invention; some of the earliest examples were made by Dürer during the second decade of the sixteenth century. In the course of the next century, the status of etching rose to a par with that of engraving, with etchings being highly prized by collectors and artists alike. It was first and foremost the medium of the painter-etcher, that is of those artists who actually etched their own inventions. In his 1645 treatise on printmaking, the French engraver and author Abraham de Bosse recommended that etched lines be made to look like engraved ones, as these have a precise, sharp-edged appearance and produce a clearly definable structure. Rembrandt took the opposite approach: he used the needle as if it were a paintbrush, and in doing so became the first artist to maximise the aesthetic possibilities of the

The soft layer of wax covering the copper plate allows the artist to draw flowing lines of diverse strength to mould his forms. Rembrandt obtained the nuances of tone used to create light by multiple biting of the plate or using acids of varying intensity. He only occasionally used the burin—the engraver's principal tool—to optimise the effectivness of hatching. Of far greater importance was drypoint, a technique which involved scratching the line directly in the metal surface with a special needle—almost like using pen on paper. The action pushes the displaced metal to the side and creates the socalled 'burr', which is coated when the plate is inked, and produces an impression with black velvety lines. The first artist to employ this technique was the Master of the Housebook, who was active in the region of the middle Rhine during the late fifteenth century. But it was Rembrandt who became the greatest exponent of drypoint by fully integrating its specific characteristics into his pictorial concept, either on its own, or in conjunction with etching. With the exception of the landscape etchings of Hercules Seghers, no other artist experimented with printing techniques to the extent Rembrandt did. He created a very fine, powdery tone, probably by using sulphur to bite the metal, which produced an effect similar to that obtained by aquatint—a technique first tried by Jan van de Velde IV in Amsterdam during the 1650s.⁵ Impressions from a plate with a porous ground are characterised by fine gradations of tone and appear as if washed. Two of the finest examples of Rembrandt's application of this technique, which he in fact rarely used, are his portrait of Jan Cornelius Sylvius (Cat. No. 22) and The landscape with the three trees (Cat. No. 19).⁶

Rembrandt was not a trained engraver but a painter, and so it is hardly surprising to find that he favoured techniques which matched his artistic inclination. For him, etching and drypoint were not subordinate mediums suitable only for reproductive exercises, rather they represented a means of achieving new heights of personal expression. While his prints were, for the most part, stylistically, iconographically and compositionally independent of his painting, they were, nevertheless, accorded equal status.

Little is known about Rembrandt's beginnings as an etcher. The two earliest dated prints are from 1628 and show Rembrandt's elderly mother (B. 352, 354). But the twenty-two year-old artist was already an accomplished and talented etcher. All the specific characteristics of his manner are evident. The lines of The Artist's Mother (Fig. 1) are airy and sketch-like, light and shadow are indicated not only by hatching of varying thickness, but also by lines which have been bitten to different depths. Rembrandt's attention to physiognomic detail may have been inspired by the miniature portraits engraved and drawn by Dutch Mannerists such as Jacques de Gheyn or Hendrick Goltzius. However, no prints are known which could have been of immediate importance for the development of Rembrandt's etching technique. Neither of his teachers, Jacob Isaacz. van Swanenburgh in Leiden nor Pieter Lastman in Amsterdam, can have taught Rembrandt the art of etching; indeed, Lastman did not etch at all. The question of Rembrandt's beginnings is related to the evaluation of two etchings which are usually categorised in the literature as representing the first works of the young artist, from the years 1625/26. The Circumcision of Christ (S. 398; Fig. 2) and The Rest on the Flight into Egypt (B. 59; Fig. 3) are both executed in a somewhat schematic and uncertain manner, and although the former bears the signature Rembrant fecit, its

authenticity is by no means certain.7 The Rest on the Flight into Egypt is related, but not stylistically identical. Its quick, sketchy lines and the frequent use of zig-zag are features of a group of early etchings by Jan Lievens, who was also active in Leiden between 1625 and 1631.8 His etching of St John the Evangelist (Fig. 4) bears the name of Jan Pietersz. Berendrecht, a publisher in Haarlem, whose address also appears on The Circumcision attributed to Rembrandt. While the conceptual approach of both artists shows the influence of their teacher Lastman, their graphic style does not.9 Moreover, their manner of etching cannot be connected directly to the generation of important Dutch etchers, such as Esaias and Jan van der Velde and Willem Buytewech, who were active during the first three decades of the seventeenth century. A possible source of inspiration may have been the etchings of Moses van Uyttenbroeck and Jan Pynas;10 equally Gerrit Pietersz. Sweelinck, the first important Dutch painter-etcher and Lastman's teacher, may have played a role.11 Related to The Rest on the Flight into Egypt is a small group of etchings (B. 9 & 54) which are considered to be by Rembrandt from c. 1626/27. However, Rembrandt as an etcher is only really tangible with the appearance in 1628 of his first dated prints.

Towards the end of his stay in Leiden and for a period after he moved to Amsterdam in 1631, Rembrandt produced a number of small selfportraits (Cat. Nos. 1 & 2), portraits of old men, possibly including his own father, as well as some of his aged mother (Cat. No. 4). All of these served as studies of the 'affetti' and physiognomy of the elderly. Around 1629/30 he captured beggars and other street dwellers in small genre illustrations (Cat. No. 3), for which he was thematically and technically motivated by the etchings of beggars by the French artist Jacques Callot. A group of etchings showing heads and beggars executed around 1631 in a coarse and schematic style was previously accepted, by Bartsch among others, as original; they can, however, now be attributed to pupils, including Jan Joris van Vliet. 12 In addition to portraits and genre scenes, Rembrandt now turned his attention to an object which was to fascinate him for the rest of his life: the bible. Instead of following the tradition of producing a complete cycle to illustrate his choosen subject, he usually confined himself to a single print. The majority of those produced around 1630 are small many-figured scenes, conceived in a painterly fashion (B. 48, 51, 66); indeed, images such as The Circumcision of Christ (B. 48; Fig. 5) are more or less translations of his earlier history paintings into miniature-scale

etchings.¹³ Rembrandt constructed his figures and the other elements of his composition by means of a complex system of lines of varying density and bitten depth.

As well as his role as a painter-etcher in the early 1630s Rembrandt turned to reproductive prints. His model was undoubtedly Rubens, who sought to publicise his compositions by having them reproduced in Antwerp by engravers who remained under his constant supervision. In 1631 Jan Joris van Vliet, then active in Leiden, etched four designs which name Rembrandt as the inventor; one of the paintings which served as a model is still in existence.14 After Rembrandt moved to Amsterdam in 1631 Van Vliet continued to work for him; he reproduced some studies of heads in addition to his more famous etchings of Rembrandt's two large baroque compositions, The Descent from the Cross (B. 81; Fig. 6) of 1633 after the panel from the cycle of the Passion painted for Frederik Hendrik (Munich, Alte Pinakothek), and the Ecce Homo (B. 77; cf. Cat. No. 38) of 1635-1636 after a grisaille specially painted for this purpose (London, The National Gallery). 15 Both etchings were at one time believed to be by Rembrandt, but he probably made only the final corrections to the plates before the prints—with his name and privilege—were placed on the market. Other grisaille paintings from the 1630s may have been intended to serve as models for prints which were never made.16 As it was, Rembrandt made little use of the possibilities of reproductive prints, and by 1636 had abandoned them altogether—in contrast to Rubens for whom they constituted a successful and profitable section of his business. Apparently Rembrandt's standing as a painter-etcher was such that he felt he could devote himself exclusively to this activity, especially as he knew public opinion judged etching to be artistically equal to reproductive prints.¹⁷ Furthermore, there may also have been the problem of finding suitable engravers and publishers—essential for anyone wishing to compete with the outstanding quality of the prints leaving Rubens's studio.18

The majority of Rembrandt's own etchings from the early 1630s illustrate genre and biblical themes. In his principal religious etching of this period, *The Annunciation to the Shepherds* of 1634 (Cat. No. 9), Rembrandt's dramatic rendering of light and dark paves the way for his future achievements. Despite the acclaim he received as a portraitist during his first years in Amsterdam, Rembrandt etched only a few portraits (B. 266, 269). A distinctive group of prints from the middle of the 1630s are his etched sheets of sketches (Cat. No. 5 & 12), and Rembrandt

2: Rembrandt, *The Circumcision*. Amsterdam, Rijksprentenkabinet. 3: Rembrandt, *The Rest on the Flight into Egypt.* Amsterdam, Rijksprentenkabinet.

4: Jan Lievens, *St John the Evangelist*. Amsterdam, Rijksprentenkabinet.

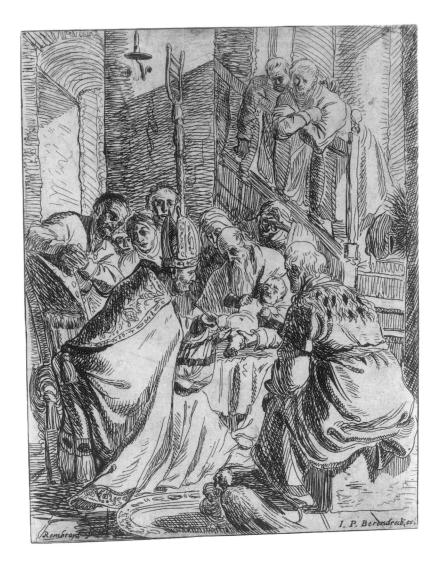

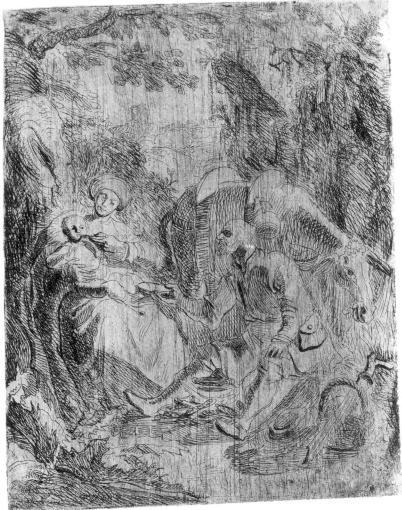

appears to have been the first to render as a print an artistic process which belongs to the medium of drawing.

Towards the end of the 1630s, possibly from 1637, Rembrandt developed a more spontaneous and freer approach, and on occasions simply delineates his figures. From 1639 he used the medium of drypoint with increasing frequency, particularly to accentuate contours, and indeed entire sections, by means of dark velvety lines. Rembrandt must have realised that he could not achieve a sufficiently dramatic and painterly effect when rendering light and dark by relying solely on bitten lines of varying depth. The first two etchings to be reworked using drypoint were his wonderful rendering of *The Death of the Virgin* (Cat. No. 14) of 1639 and *The Presentation in the Temple* (B. 49), probably from the same year.

The Death of the Virgin reflects Rembrandt's preoccupation with Dürer's woodcut cycle devoted to the Life of Mary. Rembrandt's study of the works of other artists must be seen as a continuous and varied dialogue. His own enormous collection of paintings, sculpture, medallions and numerous albums containing drawings and prints by predecessors and contemporaries provided a constant source of inspiration.¹⁹ Imitatio was not considered a sign of an artist's inability to invent, rather it demonstrated the breadth of his erudition and education. Artists should attempt not only to compete with famous models but also to surpass them.²⁰ Rembrandt had detailed knowledge of his artistic heritage, especially the history of graphic art. The fact that he filed his own prints among the works of those artists he most admired testifies to his awareness of his own role within the historical development. His collection was undoubtedly a status symbol intended to document his affiliation to the social class of 'gentlemen virtuosi'.21

The contents of the kunst boecken show Rembrandt to be a collector with encyclopaedic taste and the eye of a connoisseur; he was as interested in quality as in variety and completeness. Thanks to the inventory of 1656 we are well-informed about the contents and arrangement of his collection.²² He possessed folders of prints of the great Italian renaissance and baroque artists: engravings and etchings by Andrea Mantegna, the Carracci, Guido Reni and Jusepe de Ribera; woodcuts after designs by Titian and three kostelijcke boecken devoted entirely to prints after Raphael. In addition, Rembrandt owned albums containing works by the most important earlier and contemporary Netherlandish and German artists: engravings and woodcuts by Martin Schongauer, Lucas Cranach, Albrecht Dürer and Lucas van Leyden; prints after Pieter Bruegel and Marten van Heemskerck; engravings by his famous Dutch predecessor, Hendrick Goltzius; reproductive prints after Rubens, Jacob Jordaens and Anthony van Dyck; not to mention works by his own contemporaries and pupils, such as Jan Lievens and Ferdinand Bol.

The works he used as models served very different purposes. Beyond providing inspiration for compositions (Cat. No. 8, 10, 24, 40), they offered Rembrandt the opportunity of engaging in artistic paragone: his Ecce Homo, for example, is related to the famous engraving by Lucas van Leyden, which Rembrandt had acquired for a large sum of money (Cat. No. 38). It was not unusual for him to integrate into his compositions individual elements or figures 'borrowed' or adapted from other artists, as in the case of a putto from Raphael's Triumph of Galatea whom Rembrandt changed into an ordinary boy (Cat. No. 10). Rembrandt studied the printing technique of Andrea Mantegna, especially his manner of hatching (Cat. No. 36 & 37). The initial idea for his famous Self-portrait leaning on a stone sill, in which he portrayed himself as a true gentiluomo (Cat. No. 13), came from Raphael's portrait of Baldassare Castiglione, which Rembrandt copied in 1639, and Titian's so-called Ariosto.

It is difficult to characterise the stylistic tendencies of the 1640s. Simple, quiet forms abound. More emphasis is placed on the contours of the figures, while at the same time a reduction in their vitality and movement can be observed. Moreover, frequent changes in style occur. For example, Abraham and Isaac (B. 34) and The Rest on the Flight into Egypt (B. 57) are both from 1645 (Figs. 7–8), yet the former could be described as 'painterly' in style, while the latter is more 'linear'. To a certain degree, the subject matter influenced Rembrandt's choice of etching technique. His portraits (Cat. No. 16) are more in line with the systematic parallel- and cross-hatching of engravings, while the sketchy manner of his landscapes is not unlike that of his landscape drawings (Cat. No. 20). In other words, the artist approached these two particular themes in a very different manner.

Around 1646–47 Rembrandt made a number of portraits, most of which were probably commissioned, of friends and public figures in Amsterdam. In the most important of these, the portrait of 'Jan Six' from 1647 (Cat. No. 23), Rembrandt favoured a dense, dark structure, broken only by a few bright areas to highlight and define the sitter's features. In no other etched

5: Rembrandt, *The Circumcision*. Amsterdam, Rijksprentenkabinet.

6: Rembrandt, *The Descent from the Cross*, Amsterdam, Rijksprentenkabinet.

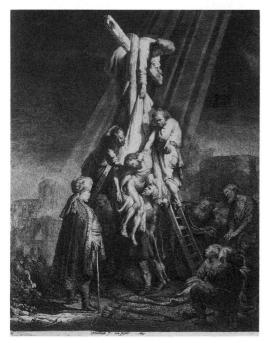

7: Rembrandt, *Abraham and Isaac*. Amsterdam, Rijksprentenkabinet.

8: Rembrandt, *The Rest on the Flight into Egypt.* Berlin, Kupferstichkabinett SMPK.

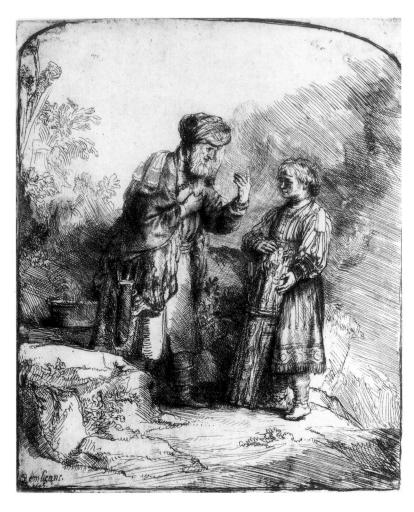

portrait did he come as close to giving his print the appearance of a mezzotint. This can hardly have been a coincidence, but rather the result of Rembrandt constantly exploiting all the means at his disposal to achieve optimum tonality. The technique of mezzotint was discovered during the 1640s; it involves first roughening the entire plate and then scraping down the 'burr' created by this process in proportion to the lightness of tone required.²³ The 'painted' appearance of the superb *Hundred Guilder Print* (Cat. No. 27) of 1647 is the result of the combined use of different techniques and lines; here Rembrandt employed his entire stylistic repertoire in one work.

Although Rembrandt painted comparatively few landscapes, they play an important role in his etched œuvre. In his paintings of the late 1630s and early 1640s he made ample use of heroic compositions with mountains and dramatic lighting, but for his prints—and drawings—he turned to the low, flat countryside of his native soil. It was also during these years that he produced a number of prints of male nudes, which, among other things, may have served as models for his pupils to improve their drawing skills (Cat. No. 21).

Around 1650 a radical change occurred in Rembrandt's graphic work. The individual, block-like elements of his compositions are organised into a clearly definable arrangement of receding parallel layers. His attitude to the actual line also changed considerably: in place of finely moulded forms, he now favours regular oblique lines of parallel hatching which cut across the different elements. Rembrandt may have adapted this hatching system from the engravings of such artists as Andrea Mantegna. These lines are especially prevalent in his biblical themes which, around the middle of the 1650s, were frequently conceived as cycles (Cat. No. 36 & 37). In Rembrandt's landscape etchings of 1650-1652 drypoint plays an increasingly important role (Cat. No. 28), as is evident from the velvet tonality of early impressions of the first state of the Landscape with three cottages (Cat. No. 32). The same applies to his portraits from the middle of the 1650s (B. 274, 275), with the exception of the 'sketchy' Portrait of Clement de Jonghe (Cat. No. 30). Rembrandt's triumphant masterpieces of the 1650s are the two large religious illustrations, The Three Crosses of 1653 (Cat. No. 35) and the Ecce Homo of 1655 (Cat. No. 38). Both are done in drypoint—although other techniques are evident in the former-and apparently without using bitten lines to provide a rough guide. The soft, velvety tonality of the drypoint burr is

9: Rembrandt, *Ecce Homo* (detail). Berlin, Kupferstichkabinett SMPK.

particularly effective in the *Ecce Homo*, especially in the early impressions of the first state printed on Japanese paper (Fig. 9).

The 1650s can be termed Rembrandt's 'experimental phase', with the actual process of printing assuming an even greater importance. Either by leaving the ink on the plate, or by wiping it so that only a film of ink remains, Rembrandt achieved a surface tone somewhat like a wash. This not only affected the actual appearance of the impression, but had the further advantage of making each impression unique. The effect created by surface tone is comparable with that produced by monotype, or single print. This technique, invented by Giovanni Benedetto Castiglione in the 1640s, requires the artist to draw his design directly in the inked plate before running it through the press. Understandably, scratched or bitten lines play no part in this process. The most extreme example of Rembrandt employing surface tone can be seen in The Three Crosses (Cat. No. 35): in the first, second and fourth states the crucified figure of Christ is bathed in light, otherwise he is submerged with his fellow suffers in a unformly dark surface tone.24 Moreover, Rembrandt consciously used the condition of the plate to create surface texture by retaining the scratches and stains which occur when the plate is wiped or incorrectly bitten. The sky of many of his landscapes, including The Goldweigher's Field, St Jerome and the Landscape with the three cottages (Cats. Nos 28, 31 & 32 respectively), is marked by such irregularities.

The type of paper used played an ever increasing role for the overall appearance of the impression. In addition to the common white hand-made paper of Europe, Rembrandt used paper from the Far East which was imported through the port of Amsterdam. Paper from Japan and China was luxurious and expensive, thin and absorbent, and its ivory-yellow or light grey tone produced a warm, soft effect. Such paper was particularly well-suited as it softened the otherwise hard contrast between bitten and scratched lines, as the impressions of The Landscape with the Goldweigher's Field (Cat. No. 28) exemplify. The majority of the first and second state impressions of the Hundred Guilder Print (Cat. No. 27) owe at least part of their atmospheric effect to having been printed on Japanese or Chinese paper. Far Eastern paper was also used for quite a large number of impressions of the Ecce Homo (Cat. No. 38). Not quite so common are prints on thick, grey oatmeal (cartridge) paper, which also produces an interesting surface texture. Rembrandt sometimes used vellum (Cat. No. 35), but this was expensive and not very suitable as it

10: Rembrandt, *Portrait of a bald man*. Amsterdam, Rijksprentenkabinet.

11: Rembrandt, *Portrait of a bald man*. Amsterdam, Rijksprentenkabinet.

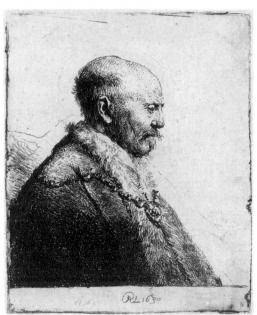

soaked up a lot of colour, made lines appear fuzzy and, because it tended to run, produced almost completely black areas.

An important aspect of Rembrandt's graphic art is his reworking of his plates. In the beginning, such changes were frequently just corrections to unimportant details, as in The Artist's Mother (Cat. No. 4) and The Fall of Man (Cat. No. 11). It is unfortunately not always possible to establish—and the existing catalogues are not very precise—the role of the different states of a plate in the evolution of a design. To take the example of first-state impressions: is one dealing with a finished design even when alterations follow, or with a trial proof; that is, an impression taken by the artist from the unfinished plate so that he can establish whether further work is required? Obvious mistakes and the number of extant impressions could in a number of cases help clarify the problem.²⁵ Only two impressions of the first state of The Annunciation to the Shepherds (Cat. No. 9) exist, and both of these are trial proofs. The first state of the Self-portrait drawing at a window (Cat. No. 25) could be a trial proof, even though a relatively large number of impressions exist. The case of The Pancake Woman (Cat. No. 10) is more complex: the two known impressions of the first state show the principal figure unfinished, yet both are signed and dated—a fact which could understandably be interpreted as confirmation that Rembrandt had completed his work on the plate. This may indeed have been the situation, and only after a number of impressions had been made did he reconsider the result and return to the plate—an approach which is also evident in other prints.

From 1647/50, or the start of Rembrandt's 'experimental phase', a more radical reworking of his plates involving changes to the original design can be observed (Cat. No. 35, 38). The most drastic alteration in the history of prints was made by Rembrandt to his two large illustrations of the Passion from the middle of the 1650s. The fourth state of *The Three Crosses* (Cat. No. 35) differs from the preceeding ones to such an extent that one can speak of a new pictorial variation which condenses and dramatises the original composition. Less far reaching are the alterations to the plate of the *Ecce Homo* (Cat. No. 38).²⁶

No other artist in the history of print-making reworked his plates as frequently as Rembrandt. Rare states were highly prized by collectors from the start. Rembrandt himself possessed a number of 'proefdrukken' or trial proofs of engravings after Rubens and Jacob Jordaens.²⁷ The famous collection amassed from about 1670 by Jan

Pietersz. Zomer (1641-1724) contained, according to the catalogue published in 1720, all of Rembrandt's etchings in different states.²⁸ At that time, connoisseurs collected prints according to the quality of the impressions and the paper, as well as for their rarity. Arnold Houbraken, discussing Rembrandt in his Groote Schouburgh (1718), wrote: This manner [of producing different states] brought him great fame and not a small profit; especially his art of making slight changes and unimportant additions to his prints so that they be sold anew. Indeed, the tendency at this time was such that no one could call himself a connoisseur who did not possess Juno with and without a crown, Joseph with a light and dark face, and others of the same kind'.29 Basically, he sees in the frequent reworking of the plates a good business sense. It is, however, wrong to imagine that pure market-strategy lay behind Rembrandt's working methods and artistic intentions.30 Houbraken's story is not unlike those recorded by other writers on art, such as Gersaint's tale of Rembrandt fabricating the auction of his estate for financial gain: they all belong to the myth that Rembrandt was avaricious.31 But Houbraken's text does contain a grain of truth, for at the same time as connoisseurs awoke to the desirability of such prints as visual documentation of the intellectual creative process it became interesting for artists to produce so many different states; Rembrandt, it could be said, both created and satisified the demand.

The fact that alterations to the plates could play an important role in the evolution of a design indicates that Rembrandt may have frequently drawn his composition directly in the thin layer of ground covering the plate without first making preparatory studies; in exceptional cases he may have even scratched the design directly into the plate itself.32 This may also account for the presence in some etchings of parts of older and abandoned designs which Rembrandt did not bother to burnish out—possibly because bizarre 'capricci' appealed to him. Such prints include the Landscape with three trees (Cat. No. 19) and The Virgin and Child in the clouds (B. 61). The latter shows an upside-down head at Mary's feet which may possibly have been the Virgin's face in an earlier version.33 Rembrandt also employed a method commonly used by engravers, including Hendrick Goltzius, which involved using a 'sketch' on the plate as the basis for the composition. The few extant trial proofs, such as those for The Annunciation to the Shepherds (Cat. No. 9) and the Portrait of a bald-headed man from 1630 (B. 292), give valuable insights into this process. The first state (Fig. 10) of the latter shows the finished head of the old man, but with the bust only lightly sketched; the second (Fig. 11) shows the bust completely etched-in.

When changes were to be made to an existing plate, Rembrandt frequently tested his ideas on an earlier impression rather than make an extra preparatory sketch. However, he did not always use these corrections. He added his body in black chalk on the second and fourth states of his early Self-Portrait of 1631 (B. 7; in London and Paris respectively; Fig. 12), but only in the fifth state did he actually etch it. Rembrandt made corrections on six different impressions of the first state of his Self-portrait leaning on a stone sill before finally deciding which was the most suitable for the second state (Cat. No. 13). Comparable alterations can also be seen in the complex evolution of the Raising of Lazarus (Cat. No. 7), while corrections on the counterproofs of the portraits of Jan Cornelisz. Sylvius (B. 266; London) and Jan Lutma (B. 276; Amsterdam) indicate that they may also have served the same purpose.

Although preparatory drawings by Rembrandt for etchings are rare, the extant examples are sufficient in number to permit us to establish their function within the creative process: they served as preparatory sketches for individual features as well as for entire compositions, as studies for single figures and groups, as complete designs and, finally, as an actual model—the latter two naturally in reverse to the etching itself.34 In many cases Rembrandt probably first sketched a rough outline of the composition, although few such drawings have survived. A sketch in red chalk for the small etching of 1638 showing Joseph telling his Dreams (B. 37; Drawings Cat. No. 2) is known.35 Individual studies of figures were made before or during work on the copperplate. On a sheet of drawings in Leiden, Rembrandt experimented with the pose of Adam and Eve for the etching of The Fall of Man (Cat. No. 11), and studies of figures and groups for the Hundred Guilder Print have also survived. One can assume that such studies also existed for equally complicated, many-figured compositions such as the Ecce Homo (Cat. No. 38) and The Three Crosses

More frequent are pen and wash studies. The principal features of the compositions for *Jan Cornelisz. Sylvius* (Cat. No. 22) and *St Jerome* (Cat. No. 31) were established in such studies, although the finished etchings show minor changes. Only four drawings have survived which were used to transfer the design directly onto the copper-plate. They are drawn in black or red

chalk, and include one for each of the portraits of *The Preacher Cornelis Claesz. Anslo* (Cat. No. 16) and *Jan Six* (Cat. No. 23). The numerous studies for the latter show the care taken by Rembrandt in the preparation of this portrait, but this is an exception.

We know almost nothing about the distribution of Rembrandt's etchings. For a short period during the 1620s he may have been employed, together with Jan Lievens, by the Haarlem publisher Johannes Pietersz. Berendrecht (cf. p. 8). During the early 1630s Rembrandt appears to have attempted to establish a commercial publishing company for reproductive prints modelled on the system devised by Rubens in Antwerp (p. 11). Hendrick Uylenburch, an influential art dealer in Amsterdam and a relative of Rembrandt's wife, Saskia, was involved in the enterprise as he is named as publisher on the third state of The Descent from the Cross (B. 81).36 However, they soon disbanded their association. As all other etchings omit any mention of a publisher,³⁷ it seems possible that Rembrandt printed them in his own studio; he may even have been responsible for their distribution. Such an assumption is supported by the high standard of the impressions and the frequent reworking of the plates. It seems probable that the majority of Rembrandt's plates were still in his studio during his last years, even though they are not listed in the inventory of 1656.38 Nevertheless, one cannot exclude the possibility that outside publishers were recruited. Documents relating to a legal battle show that in 1637 Rembrandt sold the plate of Abraham casting out Hagar and Ishmael (B. 30) to the Portuguese painter Samuel d'Orta, then a resident of Amsterdam. This transaction probably gave d'Orta the right to make further impressions.39 If d'Orta was also active as a publisher—as the sale of the plate to him indicates40—then the inference is that Rembrandt may have frequently sold plates after he had made a number of impressions for his own use. This is supported by the legal dispute which reveals that Rembrandt was accused of making too many impressions for himself, contrary to his agreement with d'Orta. In individual cases the plates may have passed to the person who commissioned the etching, particularly if it involved a portrait (Cat. No. 23).

Only much later does a publisher again enter the scene. It is unclear whether Rembrandt actually worked for Clement de Jonghe (Cat. No. 30). It was probably only after Rembrandt was declared insolvent in 1656 that De Jonghe acquired seventy-four of his plates. Although he did not add his own name, de Jonghe, who died in 1677, continued to have impressions made from them, even after Rembrandt's death in 1669. These plates, which included The Fall of Man (Cat. No. 11), The Pancake Woman (Cat. No. 12), The Hurdy-Gurdy Player and his Family receiving Alms (Cat. No. 26) and Faust (Cat. No. 33), are listed in the 1679 inventory of de Jonghe's estate.41 They span the different phases of Rembrandt's career, and show that impressions from older works could always be produced if there was a demand. In the eighteenth century, and indeed up to 1906, impressions were made from a number of the extant plates, many of which had been reworked since Rembrandt's day to enliven worn-out areas.42

The original number of impressions published in an edition is a matter for conjecture. An estimate can be gauged from the extant impressions, even after taking into account that a number have been lost over the centuries and that not all surviving examples from a plate are known. An etched plate can only produce a certain number of high-quality impressions because the process of printing wears down the etched lines, making them more indistinct with every impression. Approximately one hundred excellent impressions could have been obtained from one of Rembrandt's plates. However, this number sank drastically if drypoint was used because the burr is much more fragile. From such plates Rembrandt may have acquired fifteen to twenty really excellent impressions; a number which is consistant with existing examples. The velvet tonality so characteristic of the technique diminishes with every impression made over and above this number. Unfortunately, it is difficult to tell, especially when the plates have not been reworked by a later hand, whether it was Rembrandt or later owners who produced impressions of poor quality. Light could be shed on this problem by examining the watermarks, as well as by placing greater importance on the actual quality of extant impressions. Moreover, research in the archives in Amsterdam into publishers who might have worked together with Rembrandt could also prove to be rewarding.

When Rembrandt died in 1669 his etchings were to be found in all the famous print collections. The importance of his graphic work was never questioned, even by those late seventeenth- and eighteenth-century classicists who criticised his apparent disregard for the 'rules' of art. In his book on graphic art published in Florence in 1686 Baldinucci praised Rembrandt's 'highly bizarre technique, which he invented for etching and

12: Rembrandt, Self portrait. London, British Museum.

which was his alone, being neither used by others nor seen elsewhere. This he achieved by using lines of varying lengths and irregular strokes, and without outlines, to create a strong *chiaroscuro* of painterly appearance'. As Baldinucci emphasised the free and easy manner of Rembrandt's etchings, and it is this which separates them from the systematised appearance of reproductive prints and ensured they maintained an exemplary position until well into the nineteenth century. Of course Rembrandt was not the only artist in the seventeenth century to work in this manner, but he was the only one to apply it so significantly and in such extremes.

The important exhibitions on Rembrandt in Rotterdam and in Amsterdam in 1956 and again in Amsterdam in 1969 completely ignored his etchings. Unfortunately this has not been rectified in recent years, although Rembrandt's paintings and drawings continue to be the subject of much discussion. Such neglect may be the result of an increased interest in the more easily definable reproductive prints which distract attention from Rembrandt's very different 'bizarre' style. Our view of Rembrandt as a painter and draughtsman has been changed both by the work of the Rembrandt Research Project and the publication of numerous catalogues devoted to his drawings.44 Moreover, because considerable attention has been paid to paintings and drawings by Rembrandt's pupils and followers, 45 it has been possible to make a clearer distinction between these and autograph works by the master. This in turn has furthered our knowledge of studio practice and the method of working favoured by Rembrandt. Unfortunately, his prints have not yet been subjected to a comparable study. The aim of such a study should be twofold: on the one hand, technical aspects relating to questions on states and trial-proofs, the number of impressions which made up an edition as well as the watermarks must be examined, and on the other, a more detailed analysis of the themes and function of Rembrandt's etchings must be undertaken.

- 1. '. . . perche io ho veduto diverse sue Opere in stampa comparse in queste nostre parti, le quali sono riuscite molto belle, intagliato di buon gusto e fatte di buona maniera . . . et io ingenuamente lo stimo per un gran virtuoso.' Cf. W. Strauss and M. van der Meulen, with the assistance of S. Dudok van Heel and P.J.M de Baar. *The Rembrandt Documents*, (hereafter cited as *Documents*), 1979, p. 457, No. 1660/7.
- 2. Slive 1953, pp. 27 ff.
- 3. Cf. Documents 1979, p. 519, No. 1662/16.
- 4. Documents 1979, p. 565, No. 1666/7.
- 5. Cf. e.g. Holl. 1 (Portrait of Christina of Sweden) and Holl. 2 (Portrait of Oliver Cromwell).
- 6. Boston 1980–81, p. XXIII and pp. 150 ff., Cat. No. 97.
- 7. The Circumcision, which Gersaint (1751, G. 48) first recognised as entirely autograph, is generally considered to be Rembrandt's earliest etching. However, Hind (1912, No. + 388) rejected the sheet. Under no circumstance should the inscription *Rembrant fecit* be taken as absolute proof as this was only added in the second state.
- 8. B. and Holl. 4, 10; cf. Amsterdam 1988–89, pp. 22 ff. 9. Only a small pen drawing by Lastman from 1613 (Paris, Fondation Custodia) shows comparable lines; cf. Amsterdam 1988–89, pp. 5 ff.; Schatborn 1990, pp. 120 ff., Fig. 5.
- 10. Bauch 1960, pp. 103 ff.
- 11. Slatkes 1974, p. 252. On Gerrit Pietersz., see Boston 1980–81, pp. 18 ff.; Holl. 1–6.
- 12. Among others: B. 6, 175, 298, 314, 337; cf. Hind 1912, pp. 24 ff.
- 13. This can be seen, for example, from a comparison between the paintings of Judas returning the Thirty Pieces of Silver (Corpus A15) and The Presentation in the Temple (Corpus A34).
- 14. It is the *Old Woman reading* (B. 18) after the painting in the Rijksmuseum, Amsterdam (*Corpus* A₃₇); cf. Cat. No. 4, Fig. 4a. The etching is reversed. The other etchings are B. 1, 12 and 13; cf. Bruyn 1982, pp. 25 ff.
- 15. Corpus A65 & A89; Hind 1912, pp. 28 ff; Royalton-Kisch 1984.
- 16. Joseph telling his Dreams, Rijksmuseum, Amsterdam (Corpus A66); John the Baptist preaching, Gemäldegalerie SMPK, Berlin (Corpus Λ106); cf. Paintings Cat. No. 20. 17. Robinson 1980–81, p. XLIV.
- 18. The extent to which other etchings, which are generally accepted as by Rembrandt, could in fact be reproductive works by pupils has not as yet been explained satisfactorily, and cannot be dealt with here; some scholars consider the following to fall into that category: *The Good Samaritan* from 1633 (B. 90) and *Jan Uytenbogaert weighing Gold* from 1639 (B. 281). The hatching in the upper part of the etching of *The Artist drawing from a model* (Cat. No. 15) could be by a pupil. See for example, Haden 1877, pp. 34 ff.; Hind 1912, pp. 28 ff.; Royalton-Kisch 1984.
- 20. Cf. Amsterdam 1985–86, pp. 4 ff.
- 21. Scheller 1969, pp. 128 ff.
- 22. Urkunden, pp. 200 ff., No. 169; Documents 1979, pp. 367 ff. No. 1656/12.
- 23. Cf. Boston 1980-81, pp. XXXIII ff.
- 24. See the detailed description in London 1969, pp. 18 ff., No. x; Boston/New York 1969–70, pp. 86 ff., No. XIII; Amsterdam 1981, pp. 41 ff.
- 25. Pure trial-proofs are B. 8 I, 44 I, 77 I (van Vliet),
- 222 I,281 I, 292 I, 340 I and II, 354 I.
- 26. On this cf. Boston/New York 1969-70, pp. 101 ff., No. XIV.

- 27. Urkunden, p. 203, no. 169; Documents, p. 375, No. 1656/12; Robinson 1980–81, p. XLIII.
- 28. Robinson 1980-81, p. XL.
- 29. 'Dit doen bragt hem grooten roem en niet min voordeel by: inzonderheid ook het kunsje van lichte verandering, of kleine en geringe byvoegzelen, die hy aan zyne printjes maakte, waar door dezelve andermaal op nieuw verkogt werden. Ja de drift was in dien tyd zoo groot dat zulke luiden, die het Junootje met en zonder 't kroontje, 't Josephje met het wit en bruine troonitje en diergelyke meer, niet hadden.' Houbraken 1718, p. 271. Significantly, Houbraken follows this with a discussion of Rembrandt's pupils and the income they generated.
- 30. Alpers 1989, pp. 242 ff.
- 31. Gersaint 1751, pp. XXVIII–XXIX; Kris/Kurz 1980, p. 145.
- 32. See B. 107, 192 and 222 for sketches in drypoint.
- On B. 192, cf. Cat. No. 15.
- 33. Cf. Campbell 1980, pp. 10 ff.
- 34. Cf. Schatborn 1986, pp. 1 ff.
- 35. See Giltaij 1990.
- 36. In the fourth state the address was changed to that of Justus Danckers, who worked in Amsterdam during the 1680s.
- 37. An exception is the fifth state of *The Three Crosses* (Cat. No. 35); it bears the address of Frans Carelse.
- 38. Strauss 1983, pp. 261 ff.
- 39. *Documents*, p. 145, 1637/7; Amsterdam 1987–88, pp. 78 ff., nos. 55–56.
- 40. Plates sometimes found their way into the hands of other artists. A case in point is that of a plate by Hercules Seghers which was in Rembrandt's possession and which he transformed from a rendering of *Tobias and the Angel* into *The Flight into Egypt* (B. 56); cf. White 1969, pp. 218 ff.
- 41. De Hoop Scheffer/Boon 1971, pp. 2 ff.
- 42. A number of De Jonghe's plates were acquired by the Amsterdam collector Pieter de Haan (1723–1766), and later by the French amateur-engraver Claude-Henri Watelet. He owned 81 plates obtained from different sources. These plates were then bought by the French dealer Pierre François Basan, who had new impressions made for his Recueil, which was published between 1789 and 1797. The plates, which were in use until 1906, are now in the Museum of Raleigh, North Carolina. Cf. Hind 1912, pp. 16 ff., note 2; White 1969, Vol. 1, pp. 11, 19; De Hoop Scheffer/Boon 1971, pp. 2 ff. 43. '... fu una bizzarrissima maniera, ch'egli s'inventò, d'intagliare in rame all'aqua forte, ancor questa tutta Sua propria; ne più usato da altri, ne più Veduta, cioè, con certi freghi, e freghetti, e tratti irregolari, e senza dintorno, facendo però risultare dal tutto un chiaro scuro profonda, e di gran forza, ed un gusto pittoresco ...'; Urkunden, pp. 419 ff, No. 360, § 13.
- 44. Of particular importance are the catalogues of Rembrandt's drawings in Amsterdam and Rotterdam; cf. Schatborn 1985 and Giltaij 1988 respectively. The catalogue of the collection in London by Martin Royalton-Kisch will be published to coincide with the opening of the exhibition in the British Museum. Hans Mielke is preparing the catalogue of the drawings in Berlin.
- 45. Cf. Sumowski, Drawings.

Self-portrait in a cap, open mouthed

Etching and burin, 51×46 mm; one state Signed: *RHL 1630*. B./Holl. 320; H. 32; White pp. 108–9

Berlin: I (36–16)* Amsterdam: I (O.B. 697) London: I (1973 U. 769)

Rembrandt, lips parted and eyes open wide, fixes the viewer with his stare. A harsh light from the upper left plays across his face, casting the underside of his cap, forehead and left cheek into deep shadow. The left shoulder across which Rembrandt looks towards the viewer is only cursorily indicated, and the turn of his head increased the impression of spontaneity. The image suggests a 'snapshot' of a face captured in a moment of alarm. In the very small scale of the etching the figure is pushed close to the picture plane thus enhancing its presence.

This print belongs to a group of physiognomic studies. Their varying sizes suggest, however, that the group was not conceived as a series. Rembrandt used his own face as the model from which to observe and record various emotions (Fig. 1a; Cat. No. 2). Even though no preparatory drawing for this etching has survived, other prints in this group were based on drawings.1 The intention nonetheless, is to give an impression of uninhibited spontaneity, as if the etching had been produced while the artist was looking at his own reflection in a mirror. It is primarily through the nature of the strokes used that this effect is achieved: passages of shadow are not established by even hatching but rather with seemingly arbitrary, unsystematic lines.

Karel van Mander, in his didactic verse treatise of 1604, expressly recommended that painters should study the representation of the passions:

'Gheen Mensch soo standvastich / die mach verwinnen Soo gantschlijck zijn ghemoedt en swack gheneghen / Of d'Affecten en passien van binnen En beroeren hem wel zijn hert' en sinnen / Dat d'uytwendighe leden mede pleghen / En laten door een merckelijk beweghen / Soo in ghestalten / ghedaenten / oft wercken / Bewijselijcke litteyckenen mercken.

[...]

Dees affecten / zijn niet soor gaer en lichte T'exprimeren / als sy wel zijn te loven / Eerst met de leden van den aenghesichte / Thien oft wat meer van diverschen ghesichte / Als / een voorhooft twee ooghen en daer boven Twee wijnbrouwen / en daer onder verschoven Twee wanghen / oock tusschen neus ende kinne

Een twee-lipte mondt / met datter is inne'.2

(No man is so steadfast as to be able to master his emotions and weaknesses completely, or to reach a point where the stirrings of passion do not touch his heart and his mind. The visible parts of the body work in concert so that either through a clear movement of the whole figure, or in the face or through the gestures, one can make out clear signs of that which is felt within [...] These passions are not at all so easy to represent as they are claimed to be, and this is above all the case with the various parts of the face; for here we find ten or more different aspects, such as the forehead, two eyes and above them two eyebrows, and squeezed in beneath them two cheeks, and between the nose and the chin a mouth with two lips and all that is inside them.)

Rembrandt studied such emotions in his own face. His intention was evidently to achieve an authentic representation of his own facial expressions. Samuel van Hoogstraten, a pupil of Rembrandt, wrote in 1678: 'Dezelve baet zalmen ook in't uitbeelden van diens hartstochten, die gy voorhebt, bevinden, voornaemlijk vor een spiegel om tegelijk vertooner en aenschouwer te zijn'. 3 (The same benefit can also be derived from the depiction of your own passions, at best in front of a mirror, where you are simultaneously both, the representer and the represented.)

The purpose of this exercise seems to have been not only to record the artist's own face and its expressions, but also to assemble a repertoire of emotions for use in the composition of history paintings. Even the earliest among Rembrandt's painted self-portraits seem intended as models for various facial expressions and effects of chiaroscuro.4 Rembrandt's face occurs, for example, among the figures in The stoning of Saint Stephen in Lyon⁵ and in the unidentified historical scene in Leiden.6 Even the protagonist in Samson threathing his Father-in-law (Berlin),7 a painting from the Amsterdam period, has a physiognomy similar to that of the artist, where it conveys rage through its frowning brow,

1a: Rembrandt, *Self-portrait*. Berlin, Kupferstichkabinett SMPK.

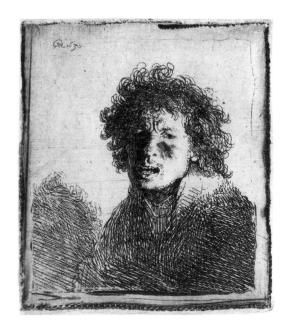

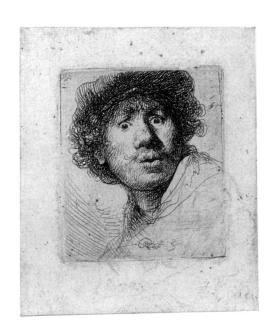

squinting eyes and open, cursing mouth. As this work is clearly not intended to allude to events in Rembrandt's own life, it is a persuasive example of the artist's attempt for an authentic and not merely formulaic rendering of emotion. Rembrandt's early etchings, clearly intended for sale, are the first record of his study of passions from the live model.

The etching exists in one state only. The earliest impressions, for example in London, reveal uneven plate edges, which were later smoothed down.⁸ Although the plate was almost entirely bitten, in some areas further work was added in burin.⁹ Rembrandt seems, for example, to have strengthened and made more precise the shadows on the left cheek and on the neck through the subsequent addition of several lines.¹⁰

B.W.

- 1. Amsterdam, Benesch 54; Schatborn 1985, No. 1 is possibly a preparatory drawing for B. 338; see also the drawing Benesch 53 in London.
- 2. Karel van Mander (1916), pp. 134-37.
- 3. Hoogstraten 1678, p. 110.
- 4. Amsterdam (*Corpus* A14); The Hague (*Corpus* A21); Munich (*Corpus* A19). See Bruyn 1983, pp. 57–58 and Raupp 1984, pp. 250–55.
- 5. Corpus A1.
- 6. Corpus A6.
- 7. Corpus A109.
- 8. Münz (11) refers to two states.
- 9. Not described in Hollstein.
- 10. The Berlin proof shows slight additions in black chalk, probably by a later hand, that extend the torso beyond the plate mark and add background shadow at the right.

2

Self-portrait, fromning

Etching, I: 75×75 mm; from II: 72×60 mm; 4 states (3 according to Hollstein) Signed and dated: (in I only): *RHL.* 1630 B./Holl. 10; H. 30; White p. 108

Berlin: IIa (6–16)* Amsterdam: I (O.B. 20)

London: I (1925–6–15–23); II (1843–6–7–5);

III (1973 U. 765)

'Op 't voorhooft (welck de Heidensche geslachten

Genius toewijdden) segg' ick / behoeven Wy te letten / nadien 't eenighe achten De Siel-wroeger / en 't aenschijn der gedachten /

Iae 't Boeck des herten / om lesen en proeven Des menschen gemoet: want kreucken en groeven

Daer bewijsen / dat in ons is verborgen Eenen bedroefden geest / benout / vol sorgen. Ia 't voorhooft gelijckt wel de lucht en 't weder /

Daer somtijts veel droeve wolcken in waeyen / Als 't hert is belast met swaerheyt t'onvreder'.¹

(It is my view that we should pay attention to the forehead which, according to the Ancients, was the seat of genuis and which some held to be able to reveal the secrets of the soul, and to be the visage of thought and even the book of the heart, in which human passions could be detected and tested: for its folds and dimples show that within us is hidden a distressed and troubled spirit. Indeed, at times when the heart is burdened with melancholy and discord, the forehead resembles the turbulent air crowded with dark clouds.)¹

This etched self-portrait with an angry expression also dates from 1630 (see Cat. No. 1). Presenting himself half-length, Rembrandt again uses the turned head looking across the left shoulder to establish both spatial depth and spontaneity. The tousled hair and heavily shaded torso add force to the figure's scowling expression, while the frontally-viewed head provides a certain monumentality. Characteristic here is the harsh and steeply slanted light that contrasts brightest illumination with deepest shadow. The shading makes the face appear asymmetric and so reiterates, with the nervous and wilful use of line, an impression of grim defensiveness. The zig-zag outlines of the fur coat are typical of work from Rembrandt's Leiden period.

No preparatory drawings have survived, as is the case with Cat. No. 1. The etching, however, is known in several states which document the work-process. In addition to those cited in the literature, there is a state (IIa) in Berlin not previously described. After Rembrandt had reduced the size of the plate to print state II, he added a second shoulder outline and a broader collar, as an experiment, in state IIa. In state III, both of these correction have been removed. While in state I, apparently by mistake, several white patches remain,² in state II these are filled in and state IIa was produced after this correction.

- 1. Karel van Mander (1916), p. 147.
- 2. Not described in Hollstein.

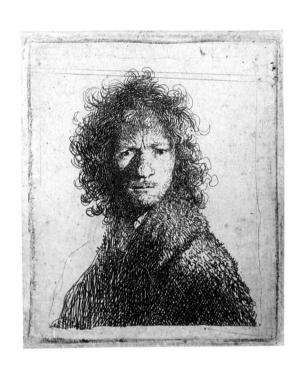

3 Beggar with a wooden leg (The Peg-leg)

Etching, I: 114 × 66 mm; II: 112 × 66 mm; 2 states. c. 1630 B./Holl. 179; H. 12

Berlin: I (266-16)

Amsterdam: I (O. B. 419)* London: II (1973 U. 743)

3a: Rembrandt, *Seated Beggar*. Berlin, Kupferstichkabinett sмрк.

3b: Jacques Callot, *The Beggar with the wooden leg.* Berlin, Kupferstichkabinett SMPK.

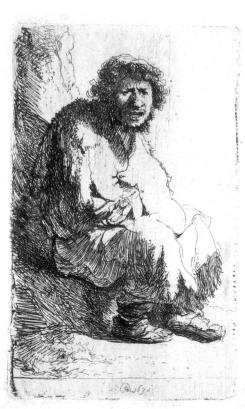

During his Leiden period, between about 1628 and 1631, Rembrandt was especially preoccupied with the subject of the beggar. His numerous beggar etchings are usually small in scale and show the subjects as isolated figures with no precise indication of setting. These etchings seem to be intended as individual sheets, not as part of a series of the kind that was usual in the traditional depiction of beggars.

The Peg-leg shows an old man, dressed in rags, with a wooden leg and a pair of crutches; his left arm is in a sling. His bristly face lies in shadow and its details are difficult to distinguish: his eyes appear to lie in deep hollows, his mouth is open as if shouting. To judge by its style and etching technique, the print dates from about 1630, from the same time as the Seated Beggar dated 1630 (Fig. 3a), which it also matches in size and use of line and which was perhaps conceived as a pendant to The Peg-leg.2 In both the style and the subject of this work, the young Rembrandt was inspired by Jacques Callot's famous beggar series Les Gueux (1621-22; Fig. 3b).3 The influence of Callot, recognised by Gersaint in 1751,4 is clear in the treatment of light and the contrast between bright and heavily-shaded areas, and also in the use of line—in particular the use of long, vertical strokes to model the figure. The same stylistic characteristics are to be found in Rembrandt's chalk studies of standing male figures from about 1629-30 (see Drawings Cat.

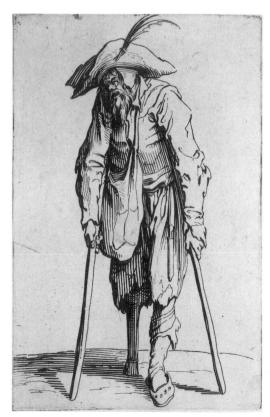

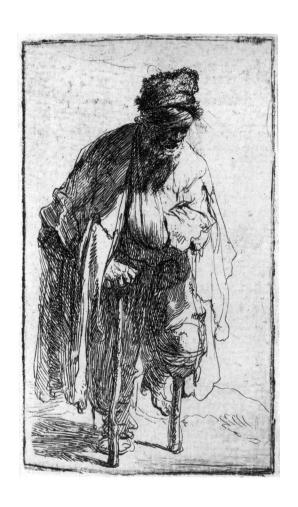

3c: Jan Joris van Vliet, *The Beggar with the wooden leg.* Berlin, Kupferstichkabinett smpk.

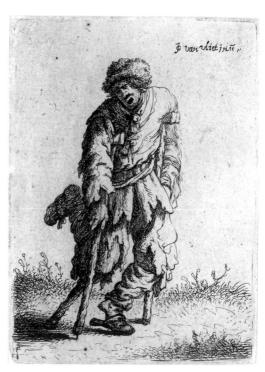

Images of beggars may be traced back to medieval examples; in late fifteenth- and sixteenth-century German and Netherlandish prints the subject is frequently treated in a complete series of images. The prevailing attitude of scorn and condemnation of the poverty that beggars brought upon themselves persisted into the seventeenth century. Thus, the ragged figures in the etched beggar series of Jan Joris van Vliet (1632)— who was a member of Rembrandt's Leiden circle—were presented as caricatures, open to ridicule and disparagement.⁵ Like Rembrandt, Van Vliet included in his series a beggar with crutches and a wooden leg (Fig. 3c). Scholars have responded in various ways to the question of how far Rembrandt's early etchings are to be understood in this sense, i.e. with a moralising and derisive attitude towards beggars.6

Rembrandt's Peg-leg shows a bogus cripple. He has tied on a wooden leg to arouse pity: his own leg has not been amputated but only bent back. This motif is to be found in Sebastian Brant's Narrenschiff (Ship of Fools) (1494).7 A satirical inscription on a print after Pieter Breughel (about 1560), showing a whole group of beggars, censures bogus cripples that only go begging out of laziness.8 In his Zede-printen (descriptions of Customs) (1623–24) Rembrandt's friend Constantijn Huygens casts scorn on beggars who, among other lazy tricks, try to arouse pity by displaying their peg-legs and crutches: 'Then he points to his peg-leg, then he beats on the ground with his crutches and, out of pity, you reach for your purse."9

It is probable that Rembrandt's contemporaries would have received his own beggar images such as The Peg-leg in essentially the same spirit. It appears, however, that Rembrandt's interest in beggars and vagabonds was determined by the fascination that these figures had exerted on him at the start of his career. They offered him a chance to study emotions in a way comparable to his etched self-portraits of the same period (Cat. No. 1 & 2). Etchings such as the Peg-leg and the Seated Beggar employ the same method of using gestures and facial expression to record the sort of states of mood that Constantin Huygens had so greatly admired in the figure of Judas in Rembrandt's painting Judas returning the Pieces of Silver (1629).10 Both Rembrandt's beggar images seem to embody the feeling of despair and anger, conveyed in the open-mouthed shriek. The moralistically devaluing tendency of contemporary beggar series is subordinate in Rembrandt's images to a sober depiction of revealed emotion. His attitude towards beggars seems to be imbued with the Lutheran idea that 'We are beggars on earth (as Christ

Himself was)^{2,11} It is surely significant that Rembrandt twice etched the scene of *Peter and John healing the Cripple at the Doors of the Temple*, in about 1629 and in 1659.¹² Here the concern with beggars is united with another subject often treated by the artist: the Prodigal Son. Both of these stress the inherently sinful nature of man, insisting that man is destined to sin and then to be forgiven.¹³

The two states of *The Peg-leg* differ only in their size; in state II the plate has been slightly reduced.

H.B.

- 1. B. 138, 150, 160, 162–167, 171, 173–175, 179, 183; on this, see also Bauch 1960, pp. 152 ff. In the case of the etchings and the drawings it is not always clear whether real beggars or, rather, merely simple people from the poorest class are shown; see Schatborn 1985, p. 10, Cat. Nos 2–4.
- 2. B. 174. The *Seated Beggar* has mostly been interpreted as a self-portrait, but it is by no means certain that this is correct; see, most recently, Held 1984, pp. 32–33.
- 3. Lieure 1924, Nos. 479–503.
- 4. Gersaint 1751, p. 143, No. 172.
- 5. B. 73-82, especially B.74.
- 6. Stratton, for example, stresses the satirical, moralising intention of the early beggar images (Stratton 1986). Held and Baldwin, on the other hand, conclude that Rembrandt had a positive view of beggars: Held believes that the sympathetic presentation of beggars is above all to be understood as a motif adopted for personal and psychological reasons (Held 1984), while Baldwin interprets the sympathetic treatment of the subject in Rembrandt's work in a religious light as a parable of man who, following Christ, is a beggar on earth (Baldwin 1985).
- 7. See Braunschweig 1978, p. 134.
- 8. Holl. 34.
- 9. Huygens 1623–24, p. 212. 'Dan maent hij met een stomp, dan slaet hij met twee krucken, En doet medoogentheit den neck ter borse bucken'.
- 10. Tümpel 1977, p. 33; Baldwin 1985, p. 122.
- 11. Baldwin 1985.
- 12. B. 95, 94.
- 13. On this point, see Held 1984.

4
The Artist's Mother

Etching, 149 × 131 mm; 3 states Signed: *RHL. f*; c. 1631 B./Holl. 343; H. 52; White, p. 112

Berlin: II (426–16) Amsterdam: II (62–116)* London: II (1973 U. 786)

There is no documentary evidence that this print really shows Rembrandt's mother. In Clement de Jonghe's inventory the print is cited with this title,1 and the fact that the same old woman appears in several etchings (e.g. Introduction, Fig. 1) and paintings seems to prove this identification.2 Just as Rembrandt's early etched self-portraits were a means of capturing the expression of mood (see Cat. 1 & 2), Rembrandt's mother was a model from which the young artist might study the physiognomy and form of old women. This seems to be the only explanation for the reproduction of a 'role portrait' in the form of a print. Gerard Dou, who from 1628 to 1631 worked in Rembrandt's studio, also used his teacher's mother as a model, and in 1631 Jan Joris van Vliet published a print after Rembrandt's Reading Prophetess which has his mother's facial features (Fig. 4a).3

Neeltgen Willemsdochter van Zuytbroeck, a baker's daughter, had nine children, the eighth

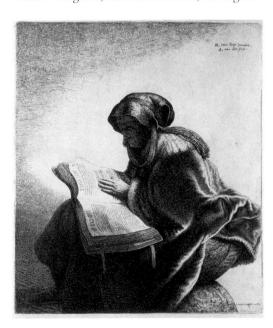

4a: Jan Joris van Vliet, *Reading Prophetess*. Berlin, Kupferstichkabinett smpk.

4b: Hendrik Goltzius, *Portrait of an old woman*. Berlin, Kupferstichkabinett SMPK.

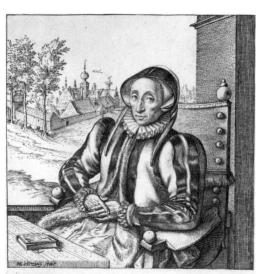

Damnofa quid non imminuit dies!

Actas parentum peier auis, tulit

Nos nequieres: mox datures

Progenem vitifiorem

of these being Rembrandt; she died in 1640. Rembrandt shows the old woman in half-figure turned to the right, with folded hands, sitting in a chair that is drawn up to a table. Her head-dress, her fur-trimmed cape, her wrinkled face, and folded hands are painstakingly recorded. Rembrandt's mother appears again in a comparable manner, though without the table, in the 1631 etching B. 348, and the similarity between the two works suggests that they were made at the same date. Two small head studies, however, show a much closer view of Rembrandt's mother.4 Her portrait in the chair seems more distanced, as Rembrandt here employed the half-length presentation frequently used for official portraits in the seventeenth century. In spite of a certain distance, the calm, introspective image of the artist's mother conveys the young man's respect for the old, and for their noble air of resignation, in a way which may be compared to Dürer's chalk portrait of his aged mother.⁵

A copper engraving by Hendrick Goltzius showing an older woman—perhaps his stepmother, Agathe Scholiers—in a comparable pose at a table might have been the model for Rembrandt (Fig. 4b).⁶

Rembrandt's plate seems to have been etched in two workings, the first showing the mother and, after that, the table; for the outlines of her skirt are still visible beneath the hatched lines of the table. The three states differ from each other only slightly: in the thickness of the hatching on the left below the artist's monogram. In the example of state II in Amsterdam, grey pen additions in Rembrandt's hand are to be seen on the foremost corner of the arm of the chair below the sitter's arm.

- 1. Urkunden, No. 346, item 10; 'Rembrandt's moeder'; De Hoop Scheffer/Boon 1971, pp. 6, 14.
- 2. Etchings B. 343–44, 348, 351–52 and 354 (Introduction, Fig. 1); paintings Bredius/Gerson 63–71. *Corpus* A27, A32, A37.
- 3. On Dou, see Sumowski 1983, Vol. I, pp. 525 ff., No. 245 (Amsterdam, Rijksmuseum), No. 253 (Berlin, Gemäldegalerie SMPK). The model for Van Vliet's etching is in the Rijksmuseum, Amsterdam; *Corpus* A37; B. 18.
- 4. B. 351-52.
- 5. Anzelewsky/Mielke 1984, pp. 82-83, No. 79.
- 6. B. 210; Holl. 225.

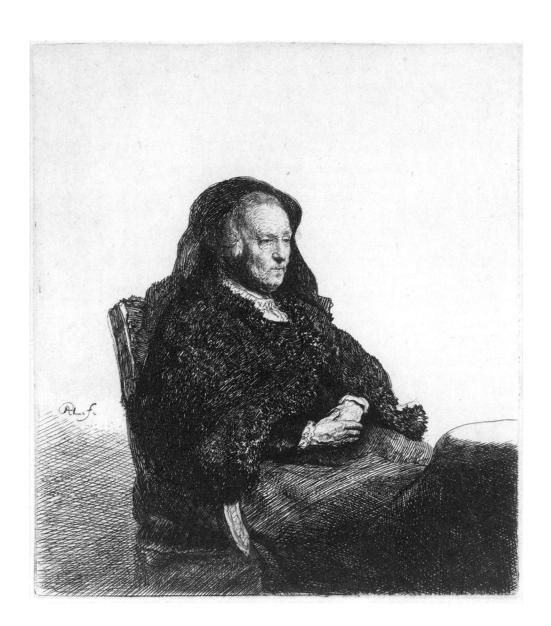

Sheet of sketches with a self-portrait

Etching, I: 101 × 114 mm; II: 100 × 105 mm; 2 states; c. 1631 B./Holl. 363; H. 90

Berlin: II (485–16) Amsterdam: I (O.B. 764)*

London: I (1848-9-4-187)

Etched sheets of sketches with individual figures and heads are a special case among Rembrandt's prints.1 One of the earliest examples of this type shows studies of the figures and heads of old men and beggars as well as a portrait of the artist. The figures are distributed across the sheet as if there were no connection between them, facing various directions; Rembrandt's portrait, viewed in a mirror and thus shown frontally, is towards the top right corner. The passages left blank which cut into the dark hair and the shaded eye area show that the head was originally intended to be covered by a broad-brimmed hat.2 The similarity between this print and another etched self-portrait of 1631 suggests that the sheet of studies was made in the same year (Introduction, Fig. 12).3

The impression of a freely executed sheet with sketches from life comes not only from the fragmentary and dissimilar figures, but also from the extensive scratching and experimental strokes and—in state I—the large acid spots, which seem to be traces of unskillful, speedy work on the plate. Studies after whole figures and parts of the body were a traditional method of practice for the draughtsman. They served not only for the preparation of a particular scene, but could also be used as occasion demanded, in the tradition of pattern books for a variety of compositions. A fine, albeit rare, example of this type from among Rembrandt's drawings is the Sheet with nine studies of heads and figures in Birmingham (see Drawings Cat. No. 8).4

Engraved or etched scenes with detailed studies of this type were to be found in drawing instruction manuals from the baroque period; budding artists carried out their first exercises in drawing by following these examples. However, in contrast to Rembrandt's etching, which brings together disparate motifs

as if by chance, engraved model sheets in instruction manuals usually show similar figures or motifs in various arrangements—the same head, for example, seen from various angles. It is possible that Rembrandt had intended a number of etchings made in the 1630s and 1640s—The Walking Frame (see Cat. No. 21), The Artist drawing from the Model (see Cat. No. 15), as well as study sheets with heads (see Cat. No. 12)—for a drawing instruction manual.⁶ It seems improbable, however, that the young artist had already conceived this plan at the beginning of the 1630s.

Rembrandt's etched sheets of studies should, rather, be seen in terms of the tradition of drawn study sheets, in which an apparently chance collection of disparate figures and motifs was intentional. Jacques de Gheyn, with whose work Rembrandt was familiar, produced drawings of this kind which have survived: these seek to emulate the appeal of sheets of studies or sketches made from life, and this itself becomes the real 'subject' of such works.7 Rembrandt's etched study sheets were not intended as pattern book models for pupils or workshop assistants; they reproduce, rather, a type of drawing that was highly valued by both art critics and collectors in the seventeenth century as crabbelinge or griffonnement.8 That this was the aim here is indicated not only by the carefully contrived grouping of the subjects, but also by the introduction of the irregular, black-printed plate edges as a type of frame for the whole. Nor do the impurities in the plate, such as the experimental strokes, appear to have come about by chance. In a similar way, in a sheet of studies in Rotterdam (Museum Boymans-van Beunigen), Jacques de Gheyn introduced experimental pen lines into his composition, that are apparently not roughly scribbled but deliberately placed (Fig. 5a).9 Rembrandt's collection of bizarre ideaswhich, like the beggars, preoccupied him at the start of the 1630s—must have been carried out as independent works of art for collectors of such capricci.

In state II the plate was somewhat reduced in size, and the spots of acid, for example above the artist's head, were erased.

H.B.

1. B. 363, 365-370.

- 2. This is also revealed in a small drawing dated 1630, in the Louvre, Paris, showing the artist's portrait in a mirror image of the self-portrait in B. 363; see Lugt 1933, p. 18, No. 1149, Plate xxxiii; Bauch 1960, Plate 261, note 132. Bauch classified the drawing as a reversed model for the head on the sheet of studies. Today the attribution to Rembrandt is no longer accepted; and the sheet was not included in the Paris 1988–89 catalogue.
- 2. B. 7
- 4. Benesch 340.
- 5. Bolten 1985; Dickel 1987.
- 6. Emmens 1968, pp. 157 ff.; Bruyn 1983, pp. 57 ff. 7. Van Regteren Altena 1935, pp. 46 ff.; Bruyn 1983,
- p. 55.
- 8. Held 1963, p. 89. Both terms signify a rough sketch, scrawl or scribble.
- 9. Van Regteren Altena 1983, Vol. II, No. 772, Vol. III, Plate 359.

5a: Jacques de Gheyn, *Sheet of studies*. Drawing. Rotterdam, Museum Boymans-van Beuningen.

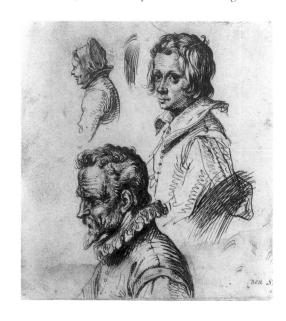

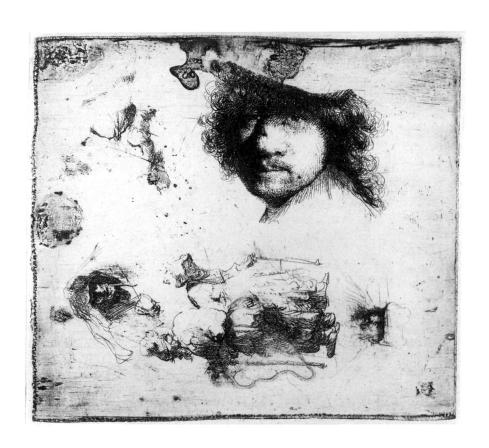

Seated female Nude

Etching, 177 × 160 mm; 2 states Signed: *RHL*. c. 1631 B./Holl. 198; H. 43; White pp. 172–73

Berlin: II (288–16)* Amsterdam: I (61: 1108) London: II (1843–6–7–126)

6a: Wenzel Hollar, Seated female nude. Berlin, Kupferstichkabinett SMPK.

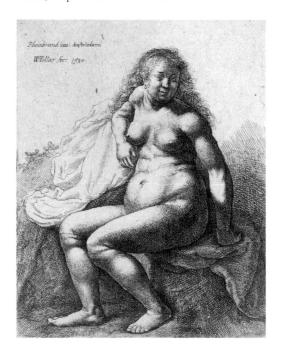

'He chose no Greek Venus as his model, but rather a washerwoman or a treader of peat from the barn, and called this whim "imitation of nature". Everything else to him was idle ornament. Flabby breast, ill-shaped hands, nay, the traces of lacings of the corsets on the stomach, of the garters on the legs must be visible if nature was to get her due. This is his nature which would stand no rules. No principle of proportion in the human body.'1 This unambiguous condemnation, drawing on the classicist aesthetic norms of the late seventeenth and early eighteenth centuries, is in marked contrast to the appreciation for this etching registered at the time of its creation, as shown by the copy of it made as early as 1635 by Wenzel Hollar (Fig. 6a).2

The Seated female Nude, together with two other prints which also may date from 1631,3 record Rembrandt's earliest preoccupation with the nude in his etched œuvre. Rembrandt shows the woman sitting sideways on a mound but with her torso turned towards the viewer. The shapes formed by the female body are recorded with great realism, as in the case of the folds of skin caused by the twist of the torso. The figure is lit from the right, and the gradations of light and shaded flesh give the etching its sensual allure. The woman looks intently at the viewer, but her eyes remain in shadow. The subtle tension established between the lighting and this direct stare, also a quality of Rembrandt's early self-portraits, gives the image its distinctive stamp.

While the early etching Jupiter and Antiope (Fig. 40a) depicts a mythological subject and thus belongs to the realm of bistoria, the other two show single figures. The subject of one of these has been identified: Diana at the bath (Fig. 6b). Our print, however, has until now only been given titles such as Naked Woman seated on a mound or, even more simply, Seated female Nude. In this way, albeit not explicitly, it has come to be understood as having no subject. It is possible that this impression may have been encouraged by the loosely-structured composition of the print, in which Rembrandt makes a draughtsman's use of the blank sheet. The brightly lit area of the drapery is conveyed with only a few cursory strokes. The work is distinct in this respect from the more pictorial construction and carefully considered background of the Diana etching. The current title is only a slight modification of that adopted by Gersaint in his catalogue raisonné of 1751-'femme nue'.4 Gersaint, admittedly, also treated other, now thematically identified etchings, such as the Diana, as 'femmes nues', including these under the heading 'Sujets libres, Figures nues, & Figures académiques.'

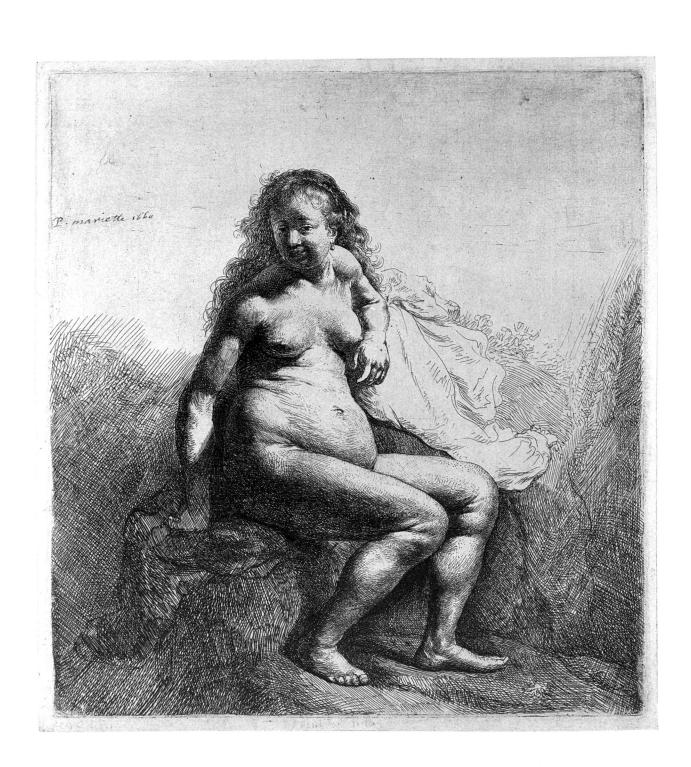

ground which it is not possible to define more precisely,5 though several sprigs of leaves indicate an outdoor setting. In this respect the work is fundamentally distinct from Rembrandt's drawings and etchings of the 1640s in which male nudes are clearly presented as studio models.6 This etching is linked with Diana at the bath not only through the almost identical dimensions—a plate size that Rembrandt appears to have used only for these two etchings. Furthermore, the two female figures are seated on their drapery with complementary turns of the torso, each rests one arm on a higher level of the bank, and each gazes directly at the viewer. Diana, however, protectively turns her body away from the viewer—for mortals were forbidden to gaze on her.7 In the case of the present etching one would, then, be less likely to think perhaps of an Old Testament subject such as that of Susanna or Bathsheba—a model of chastity or a moral exemplar—than of a figure from classical mythology, even perhaps the figure of a nymph from among Diana's maidens. It is unlikely that we will be able to determine how far the two etchings were intended to be seen as a pair. Wenzel Hollar, in any case, made a copy of only one of them. The omission of unambiguous thematic references—in the case of the Diana too these are also more clearly defined in the preparatory drawing than in the completed etching-might have been understood by Rembrandt's contemporaries as having been removed from its traditional iconographic context.8 If not the specific subject itself, then certainly its thematic associations, would have been immediately obvious to Rembrandt's contemporaries, though not to Gersaint more than a century later. Thus, neither did Wenzel Hollar feel the need to add attributes to the figure in his own copy.

Rembrandt's female nude sits on raised

In contrast to the Diana, which was preceded by a detailed preparatory drawing9 and, after tracing, executed in a relatively schematic manner, the etching in question impresses by its freer use of line. A clear contour, for example, is only found where light and shade meet each other directly, as on the woman's stomach. In other areas several outlines are set alongside each other and then rendered less distinct through the use of hatching running across them. In the region of the eyes, for example, planes which are not defined by an outline are filled in with hatching, which is used to create shadow, and is drawn right across the shapes. Within areas of shadow the forms are made less distinct at the edges. A systematic use of cross-hatching is eschewed,

in contrast to the procedure in the Diana etching. 10

In view of this approach it is not surprising that preparatory drawings have survived. 11 The differences to be detected between the two states of the etching are not in the composition, but entirely in the lighting. In state II new areas of shading are introduced. Certain individual passages of shadow in state I, for example on the woman's right foot, are burnished out, in order more effectively to contrast light and shade. Both the detailed modello and the pictorial composition of the Diana etching could well indicate a commissioned work. One is tempted to assume that Rembrandt later produced a second composition of a nude, mythological subject which was freer in every respect. As indicated by the copy made only a few years later by Wenzel Hollar, Rembrandt's contemporaries fully appreciated this version.

6b: Rembrandt, *Diana at the bath*. Berlin, Kupferstichkabinett smpk.

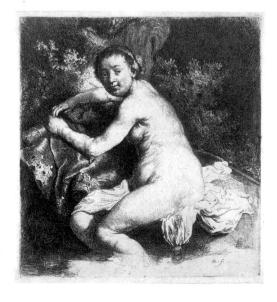

- 1. A. Pels, *Gebruik en misbruik des toneels*, Amsterdam, 1681, pp. 35–36.
- 2. B. 603.
- 3. B. 201, B. 204.
- 4. G. 190.
- 5. The literature follows Gersaint in speaking exclusively of a mound, even though the etching itself fails to define the setting fully.
- 6. See Cat. No. 21.
- 7. On the myth and its presentation as a painted *bistoria* in Rembrandt's œuvre, see Paintings Cat. No. 16.
- 8. The concept of 'Herauslösung' was introduced by Tümpel (1969) in his enquiry into the iconography of Rembrandt's biblical narratives.
- 9. Benesch 21; London, British Museum.
- 10. It is possible that in the case of the *Diana* one should once more consider the collaboration of studio assistants in the production of the etching. On this point, though not with regard to this etching, see Royalton-Kisch, 1984.
- 11. On questions in this area, see the discussion in Cat. No. 39, and also the ones regarding other etchings.

The Raising of Lazarus

Etching and burin, 366×258 mm; 10 states Signed: RHL van Ryn (I–IV), RHL van Ryn f. (V–X). c. 1632 B./Holl. 73; H. 96; White pp. 29–33

Berlin: V (314–1893) and VIII (132–16)* Amsterdam: III (O.B. 595) and VIII (O.B. 597) London: IX (1973 U. 823)

7a: Jan Lievens, *The Raising of Lazarus*. Brighton City Art Gallery.

7b: Rembrandt, *The Raising of Lazarus*. Los Angeles, County Museum of Art.

With a impressive gesture, Christ summons the dead Lazarus back to life. In the first stirrings of his resurrection, Lazarus struggles to sit up in his grave. The onlookers react with surprise and alarm.1 The etching, which dates from about 1632, is the largest made by Rembrandt up till that date; and it surpasses his earlier etched works in both emotion and baroque theatricality. It is the first of a series of prints in which Rembrandt—probably in daring competition with the work of Rubens-lays claim, through the use of a large scale, to the status of a painted representation of the subject. This aim is also suggested by the introduction of a black frame. While other prints by Rembrandt, such as the Ecce Homo (Fig. 38b) and The Good Samaritan, are not universally seen as the work of his own hand,2 The Raising of Lazarus has been accepted as an authentic work. The work-process may be described as complex in several respects.³ Not only is the etching known in a large number of states, ten in all, but it is also obvious that its original motivation was to surpass a painted composition by Jan Lievens (Fig. 7a), which Rembrandt may even have owned.4 Like Lievens, Rembrandt seems to have started on a painting of the Raising of Lazarus (Fig. 7b).5 During work on this painting he turned to treating the subject in the print medium.6 While Rembrandt took the principal arrangement of the composition in his painting from that adopted by Lievens (though with decisive modifications in the use of gesture and thus in the character of the narrative), in his etching he altered the composition as a whole. Christ is no longer viewed from the front but, rather, from behind and in lost profile. Light streams out from the central area of the

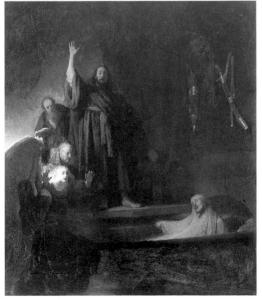

composition, so that the figures of Christ, of the man shrinking away on the left, and of the woman in the right foreground—Martha, the sister of Lazarus—are perceived by the viewer largely as silhouettes. This dramatic illumination reveals Rembrandt's attention to the work of the Utrecht Caravaggists, above all Ter Brugghen.

Research into Rembrandt's painting

technique suggests that the picture and the etching are intimately linked in their development. Rembrandt did not produce a reproductive print after his own painting; he evolved, rather, a distinct solution to suit each medium. Although most of Rembrandt's etchings survive in several states, we know of only a few genuine trial proofs printed before the completion of the full composition. Often the various states differ only in the correction of details. In the case of The Raising of Lazarus, however, working proofs have survived (they show unsmoothed plate edges, occasional interrupted contours, and spots of etching fluid) dating from a stage before the full composition, in its third state, was satisfactorily established on the plate. Although, from this point, Rembrandt maintained the basic arrangement of the scene, he nonetheless altered the figures of the onlookers in terms of both pose and gesture. The first alteration is drawn in on a impression of state III in London (Fig. 7c). After an intermediate state, IV, in which the frame is completely registered with cross-hatching, the changes to the figure are incorporated in state v. Here Rembrandt alters the pose of Martha. No longer shown bending back behind the grave in a pose corresponding to that of the man with his shrinking gesture, Martha is a sharp silhouette moving towards the resurrected Lazarus. The next re-working concerns the figure of the man with outstretched arms to whom Rembrandt gives a cap, the emphasis provided by its shaded part marking off the group of figures against the still brightly lit background. At the same time, a more distinct character is given to Lazarus's second sister, Mary Magdalen. In a third stage of alteration, the three men behind the abovementioned figures, were re-worked in order to give the group a greater relief-like compactness. The subsequent two states may be understood as final corrections.

It has frequently been observed that, as well as Lievens's composition, Rembrandt drew on other works, above all compositions by Raphael: Marcantonio Raimondi's engraving after Raphael's *Saint Peter preaching* being cited in this connection. It is doubtful, however, that really specific borrowings are to be detected here; one might, rather, ask if it

would not be more reasonable to speak of general similarities to the figurative style of Raphael—particularly in the case of Rembrandt's figure of Christ, both in its statuesque quality and in the firm, imposing character of its gesture. It is known that Rembrandt constantly added to his own collection of works of art, above all his collection of prints. It is thus possible that Muller's engraving after The Raising of Lazarus by Abraham Bloemaert may have provided Rembrandt with an artistic challenge.9 Rembrandt would certainly also have been familiar with the compositional solutions devised by his teacher, Pieter Lastman. 10 The number of specific models that Rembrandt may have used in evolving his own compositional solution (which, as the various states show, was only reached through the working process) is itself a reflection of his aim to present a new and exciting record of the Biblical episode. B.W.

7c: Rembrandt, The Raising of Lazarus, State III,

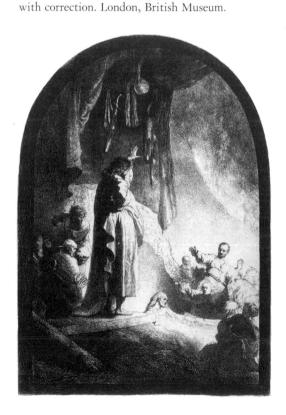

- 1. John 11: 1-44.
- 2. B. 81, B. 77; B. 90. On the *Ecce Homo* and the *The Decent from the Cross*, see Royalton-Kisch, 1984.
 3. Münz, 192 did not deny the possibility that Van Vliet may also have worked on the etching. Hind (No. 96) regards the composition, but not the later states, as authentic.
- 4. Now in the collection of the City Art Gallery, Brighton; Sumowski 1983, No. 1193. The 1656 inventory of Rembrandt's estate lists a painting of *The Raising of Lazarus* by Jan Lievens (*Urkunden* 169, No. 42. Lievens himself made a reproductive print of his painting—and according to the most recent considerations of Royalton-Kisch, it remains to be established whether this was made directly after the completion of the painting or at a later stage. In an as yet unpublished article, Royalton-Kisch also proposes a date different from that accepted in previous research for the drawing Benesch 17, suggesting that is was made in the mid-1630s, and thus after the production of the etching. Consideration of the drawing is therefore omitted from the present discussion.
- 5. Los Angeles, private collection, Corpus A30.
- 6. See Corpus A30, with bibliography.
- 7. Benesch 83 a, London, British Museum.
- 8. B. 44; Münz 192; discussed most recently in *Corpus* A₃0.
- 9. B. 18; see Berlin 1970, No. 73.
- 10. Mauritshuis, The Hague; also Sale: Dobiaschowsky, Berne, May 1990.

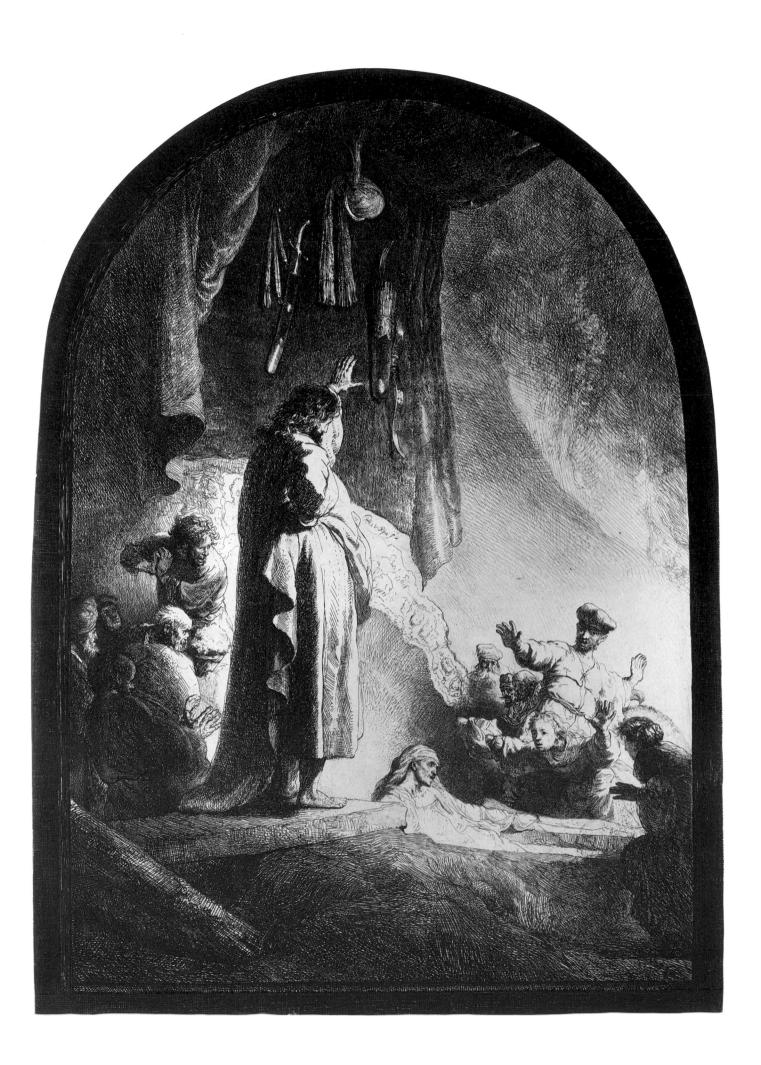

Joseph and Potiphar's Wife

Etching, 90 × 115 mm; 2 states Signed and dated: *Rembrandt f. 1634* B./Holl. 39; H. 118; White p. 36

Berlin: II (59–16)* Amsterdam: I (O.B. 78)

London: I (1933–9–9–11); II (F4–64)

8a: Antonio Tempesta, Joseph and Potiphar's Wife. London, British Museum.

Unambiguously bared, a woman lying on a bed attempts to pull back towards her a man who, defending himself, turns to flee. The print shows a scene from the story of Joseph who, after being sold to the Egyptians by his brothers, was employed in the house of Potiphar, treasurer to the Pharaoh. 'And it came to pass after these things, that his master's wife cast her eyes upon Joseph; and she said, Lie with me. But he refused, and said unto his master's wife, Behold, my master wotteth not what is with me in the house, and he hath committed all that he hath to my hand; There is none greater in this house than I; neither hath he kept back any thing from me but thee, because thou art his wife: how then can I do this great wickedness, and sin against God? And it came to pass, as she spake to Joseph day by day, that he hearkened not unto her, to lie by her, or to be with her. And it came to pass about this time, that Joseph went into the house to do his business; and there was none of the men of the house there within. And she caught him by his garment, saying, Lie with me: and he left his garment in her hand, and fled, and got him out.'1

In the Aniquitates Judaicae by Flavius Josephus, the episode was further embellished in order emphasise Joseph's self-control and his success in protecting his chastity against the women's urgent entreaty. It was possible to see the same interpretation of the subject in Antonio Tempesta's engraving (Fig. 8a)² that inspired Rembrandt.³ Rembrandt, however, reduces the indication of spatial depth and background detail to leave only the bed; the door is sketchily indicated, and there is no view through it to a landscape beyond. He has, indeed, 'increased the blunt realism according to the subject'.4 While the woman's recumbent posture, above all her bared pudenda, emphasises her lascivious intent, Joseph, by contrast, is vehemently abrupt in his movement as he turns away, overcome with disgust. While Joseph does not even touch the woman and shrinks back to rebuff her importunate demand, her own impulse is, quite literally, grasping. The use of chiaroscuro in the composition is especially determined by the moral exemplar the scene conveys: while the figure of Joseph is set against a light background, Potiphar's wife is shown against the darkly shaded area of the

So frank a treatment of the episode was later found disturbing. In a impression of the etching from the Mariette collection, for example, the impact is corrected by the addition of a cloth drawn in to cover the woman.⁵

In this work from 1634 Rembrandt uses two distinct styles of etching: the linear treatment

used for the left background and the figure of Joseph with very restrained shading, and an approach based on modelling through the accumulation of planes defined largely by light and shade, as seen in the body of the woman and in the treatment of the right background. Both methods were to retain a determining role in Rembrandt's work as an etcher.

B.W.

- 1. Genesis 39: 71-12.
- 2. B. 71.
- 3. Berlin 1970, No. 18.
- 4. Berlin 1970, No. 18.
- 5. Fitzwilliam Museum, Cambridge; see White 1969,
- p. 36.

The Angel appearing to the Shepherds

Etching, dry-point, burin and sulphur tint 262 × 218 mm; 3 states
Dated: (from II) 1634
B./Holl. 44, H. 120, White pp. 36–39

Berlin: III (471–1901)* Amsterdam: III (62: 19)

London: I (1973 U. 850); III (1868–8–22–662)

The darkness of the night is suddenly shot through with light. Men and animals scatter in terror. The brightly illuminated and imposing figure of the angel announces the message of Christmas; but only a few figures—such as the kneeling shepherd, who raises his arms in fright—even notice this. 'And there were in the same country shepherds abiding in the field, keeping watch over their flock by night. And, lo, the angel of the Lord came upon them, and the glory of the Lord shone round about them: and they were sore afraid. And the angel said unto them, fear not: . . . And suddenly there was with the angel a multitude of the heavenly host . . .'¹

Rembrandt succeeds here in capturing the full impact of the event. The deep black of the night sets off the glittering light of the divine apparition. The angel, a large-scale figure poised on a cloud-bank, calmly dominates the scene. This is in dramatic contrast to the alarm and tumult below. The reactions of those picked out by the light range from sheer terror to panic-stricken flight. Still in darkness, however, are the two shepherds clambering out of a hollow on the right—probably coming to see what is happening. The animals too are shown to react in various ways. Those caught in the stream of light scatter, while others remain quite unaffected. The dove of the Holy Ghost is depicted in the bright centre of the sky, which opens up into a funnel of light. Putti circle around the light. Rembrandt offers here a bravura exercise in scorci (foreshortening) and in variations of movement. In the valley below, lit up as if in a fairy-tale, one can make out a river, spanned by an imposing bridge. Figures standing in front of a fire reflected in the water are just detectable.

The evolution of the print is not recorded in surviving drawings, but two working proofs

from the unfinished plate exist (Fig. 9a).2 Rembrandt first established the entire composition on the plate with sketch strokes. As the same time he established the principal division of light and shade. The deepest blacks and all of the background were virtually completed at this stage. This approach is also found in other Rembrandt etchings, for example in The Artist drawing from the Model (Cat. No. 15). It is, however, important to note that such a procedure parallels that found in painters' working methods. Through establishing gradations of grey tones in his etching of The Angel appearing to the Shepherds, Rembrandt creates a scene that is not only painterly, but also composed in pictorial terms. With his impressive range of velvety-black tones Rembrandt here reaches the virtual limits of the technical possibilities of etching. First Rembrandt established the dark areas of the print through a fine network of hatching, and bit these lines deeply, then went over the plate-surface with the burin once again. By doing this he avoided sharp contours outlining dark areas. Rather, the forms are marked through areas made up of hatching of varying degrees of fineness. By this procedure, the atmosphere of the night is captured in a most suggestive manner.

The signed second state shows the composition at its most complete. In state III, finally, Rembrandt has shaded through additional hatching a number of details such as the lower branch of the large tree and the angel's wings. It has not, however, been previously remarked that Rembrandt is less specifically concerned here with aesthetic effect, than with the correction of technical aspects. Almost all the passages worked with additional hatching in state III, were apparently bitten with sulphur tint in state II.⁴ Rembrandt made a few trial proofs of this state⁵ and, not satisfied with the result, re-worked the areas concerned.

Night scenes had been popular in art since the sixteenth century. The paintings of Elsheimer exerted a considerable influence that had spread even more widely through their reproduction in prints by Goudt as well as through the engravings of Jan van der Velde that drew on these. In The Angel appearing to the Shepherds, as in many of his works, Rembrandt re-worked suggestions borrowed from earlier sources. Rembrandt's fleeing shepherds, for example, are to be found in a print by Sadeler after M. de Vos; and Rembrandt may also have known Saenredam's reproductive prints after Abraham Bloemart.⁶ Rembrandt himself developed his composition further in the painting of the Ascension (1636) commissioned

by Prince Frederik Hendrik.⁷ Even in drawings from a later period, Rembrandt revised this idea.⁸ The adoption of the compotition by other seventeenth-century painters⁹ testifies to the popularity of Rembrandt's print.

Although nocturnal scenes are found in some of Rembrandt's early paintings, *The Angel appearing to the Shepherds* is his first etched example. Rembrandt conceived of nocturnal scenes as an artistic challenge, which became important again in his late work.¹⁰

- 1. Luke 2: 8-10 and 13.
- 2. London; Dresden.
- 3. On this manner of working, see Van de Wetering: 'Painting materials and working methods', in *Corpus*, pp. 111–33, especially 29.
- 4. On this technical procedure, see Cat. No. 22.
- 5. Only three proofs of Π are known: these are now in Amsterdam, London and Vienna.
- 6. Berlin 1970, 41; Münz 199.
- 7. Munich, Alte Pinakothek, *Corpus* A118; Paintings Cat. No. 13.
- 8. Benesch 501; Benesch 502; Benesch 999, Schatborn 1985, No. 38; Benesch 1023, Schatborn 1985, No. 44. 9. Flinck, Louvre; Berchem, Louvre; Bout, Braunschweig.
- 10. See Cat. No. 37.

9a: Rembrandt, *The Angel appearing to the Shepherds*, State I. London, British Museum.

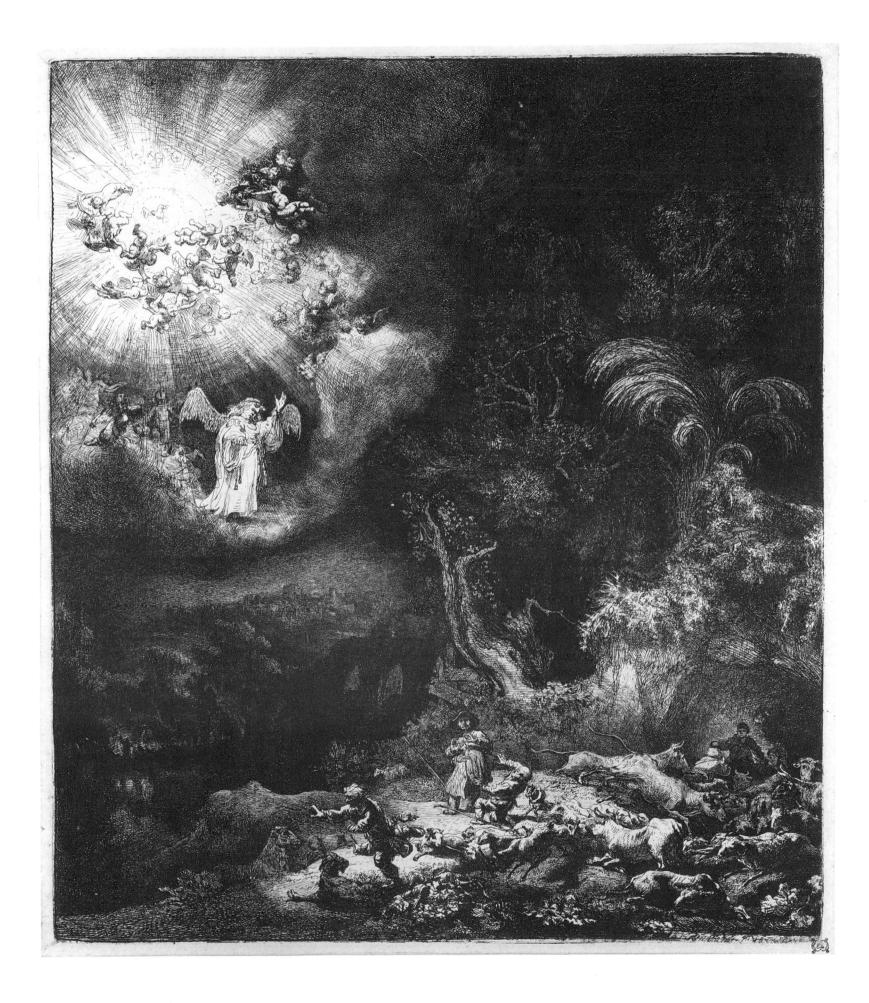

The Pancake Woman

Etching and drypoint, 109 × 77 mm; 3 states Signed and dated: *Rembrandt*. f 1635 B./Holl. 124; H. 141; White, pp. 156–58

Berlin: II (473–1901) Amsterdam: II (61–1056)* London: II (1973 U. 880)

10: State I

This small etching shows a popular subject of seventeenth-century Dutch genre. In the centre an old woman sits making pancakes in a large pan. This attracts the attention of a group of children: two boys, in the background, look at a coin which they will probably use to buy a pancake, while three children of various ages—one in a broad-brimmed hat already devouring a pancake with relish—look on as the old woman prepares the next batch. An inquisitive toddler is held back by his mother, and a boy in the foreground, watched by a black cat, tries to save his pancake from an over-eager dog.

The iconography of this subject may be traced back to the mid-sixteenth century. In scenes of the 'Fools' Kitchen' and the 'Feud between Carnival and Lent' from the circle of Pieter Bruegel the Elder one can find similar pancake women.1 In the seventeenth century the motif became a subject in its own right in Dutch genre painting, for example in the work of Willem Buytewech, Jan van de Velde and Adriaen Brouwer.² Rembrandt's etching is close in its composition to an engraving by Van de Velde (of about 1626) (Fig. 10a) and also to a painting by Brouwer (of about 1620-30) in Philadelphia that may have been owned by Rembrandt.³ The subject of the pancake woman was often treated moralistically. In Jan van der Veen's emblem book (1642), for example, the preparation of undercooked pancakes is used as a symbol for stupid jollity, and the idle chatter that corrupts good manners.4

A pen drawing of about 1635 by Rembrandt, now in the Rijksprentenkabinet in Amsterdam

10a: Jan van de Velde, *The Pancake Woman*. Berlin, Kupferstichkabinett SMPK.

(Fig. 10b), treats the same subject yet differs considerably from the etched scene in its composition. In the drawing, the pancake woman is seen almost from the front and she is placed right at the edge of the scene. In the etching—following the iconographic tradition for the subject—she is shown in pure profile at the centre of the sheet. Rembrandt appears to have taken account here of the fact that a more ordered arrangement was required in a print intended for sale.5 A pen drawing from about 1635, formerly in the Kunsthalle in Bremen, might have been made in connection with the etching (Fig. 10c).6 It shows a woman with five children in various poses. The mother, who holds a baby in her arms, has a certain similarity with the corresponding figure in the group in The Pancake Woman. There is also an almost identical a child, who turns its head and reaches away with bent, thrusting legs, on the left in the drawing and in the foreground of the

The motif of the sprawling boy appears to have been popular in seventeenth-century. Dutch art. It has not previously been remarked that Rembrandt is here citing a celebrated model: the *putto* skimming the waves in Raphael's *Triumph of Galatea*, a composition widely known through reproductive engravings by, among others, Marcantonio Raimondi and Hendrick Goltzius (Fig. 10d). Rembrandt did not transfer the figure mechanically, but rather keyed the splayed pose to a context in employing it to show the boy's effort to save his pancake from the eager dog. This motif—with other examples—shows to what extent Rembrandt drew on foreign models as well as

on sources found in works in his own collection; studies from life often played a minor role or served only as starting points for freely devised versions of a figure. In his scenes with children, in particular, which at first glance seem so closely observed from life, the stereotypical, formulaic record of certain figures and motifs stands out: these may be traced back to Rembrandt's reference to ancient sculpture, among other sources.⁹

Within the network of lines in the background, one can make out the mouth, potato-shaped nose and eye of a grimacing face. It remains open to question whether Rembrandt has here allowed a bizarre idea, appearing perhaps by chance in the etching process, to remain.¹⁰

In state I, which is rare, the pancake woman's dress and hat are principally indicated only in outline; in state II they are heavily hatched, in part with emphatic drypoint lines, so that the old woman now stands out more boldly from the band of children than in state I. H.B.

1. See, for example, the *Fools' Kitchen* of about 1560, a drawing from the Bruegel circle, in the Albertina in Vienna (Benesch 1928, p. 12, No. 75) and the engraving after it by Pieter van der Heyden (Holl. IX, p. 28, No. 48). In Bruegel's painting of 1560, *The Feud between Carnival and Lent*, (Vienna, Kunsthistorisches Museum), there is a pancake woman (Grossmann 1955, plates 6 and 8). On this subject see Trautscholdt 1961 and Lawrence, Kansas; New Heaven and Austin 1983/84, pp. 110 ff., Nos. 25–26.

2. On Buytewech see Haverkamp-Begemann 1959, pp. 107–8, Nos. 38–38a, Figs. 60 and 56; on Van de Velde, Holl. 148.

3. In the 1656 inventory of Rembrandt's estate there is mention of a painting by Brouwer with this subject; it remains, however, a matter of speculation as to whether this is to be identified with the picture in Philadelphia; see *Urkunden*, p. 190, No. 169; 'Een Stuckie van Ad. Brouwer, sijnde een koekebakker (A work by Ad. Brouwer, being a [pan]cake maker). On Brouwer's panel see Berlin 1984, p. 122, No. 20.

4. Amsterdam 1976, p. 87, No. 16, with illustration. 5. Benesch 409; Schatborn 1985, pp. 16–17, No. 6. See also Bruyn 1983, p. 57, who regards the Amsterdam drawing as a free variant on Brouwer's composition. 6. Benesch 402.

7. Schatborn 1975, p. 11. A drawing in the Louvre, Paris, Benesch 112, which shows a young boy and a dog in a similar way, albeit reversed, has on occasion been seen as a preparatory study for this group. This must, rather, be a copy drawn by another hand, after the etching; see Schatborn 1985, p. 16, No. 6, note 3. 8. Marcantonio Raimondi: B. 350; Hendrick Goltzius:

B. 270.

9. Bruyn 1983, especially p. 53. Meder points to the tradition, especially for scenes with children, of using models taken from ancient or contemporary works of art; Meder 1923, p. 402.

10. It has also been suggested that this face symbolises the childrens' fears, or images that could trigger those fears; Robinson 1980, p. 166.

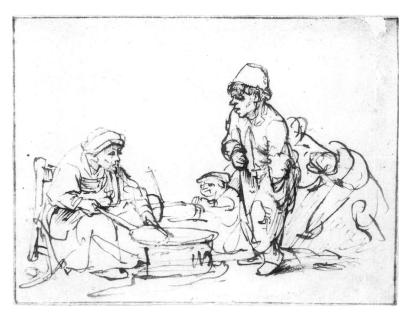

ΙΙ

The Fall of Man

Etching, 162 × 116 mm; 2 states Signed: *Rembrandt*. *f.* 1638 B./Holl. 28; H. 159; White, pp. 41 ff.

Berlin: II (48–16) Amsterdam: II (61:992) London: II (1843–6–17–16)*

Rembrandt's etching of 1638 may well be claimed as one of the most psychologically penetrating images of the subject of the Fall of Man in the history of art. In the Bible we read: 'Now the serpent was more subtle than any beast of the field which the Lord God had made. And he said unto the woman, Yea, hath God said, Ye shall not eat of every tree of the garden? And the woman said unto the serpent, We may eat of the fruit of the trees of the garden: But of the fruit of the tree which is in the midst of the garden, God hath said, Ye shall not eat of it, neither shall ye touch it, lest ye die. And the serpent said unto the woman, Ye shall not surely die: For God doth know that in the day ye eat thereof, then your eyes shall be opened, and ye shall be as gods, knowing good and evil. And when the woman saw that the tree was good for food, and that it was pleasant to the eyes, and a tree to be desired to make one wise, she took of the fruit thereof, and did eat, and gave also unto her husband with her; and he did eat.' (Genesis 3:

Adam and Eve are shown completely naked, in the state of paradisaic innocence, of which they only become aware after the Fall. Following iconographic tradition, Rembrandt shows the moment when Eve is about to give the apple to Adam; she seems to have persuaded him with her seductive voice. In reaching for the apple, Adam pauses, raising his right hand as if to remind Eve that God had forbidden them to eat from the tree of knowledge. His body, bent as if in pain, seems to be an expression of his awareness of guilt and his fear of punishment. Rembrandt shows Eve's tempter lurking in the tree, in the form of a dragon, not a snake. The bible says that it was only after the Fall that God the Father condemned the beast to crawl on the ground, which implies that it must have had another

10b: Rembrandt, *The Pancake Woman*. Drawing. Amsterdam, Rijksprentenkabinet.

10c: Rembrandt, Sheet of studies with a mother and five children. Drawing. Destroyed.

10d: Marcantonio Raimondi, after Raphael, The Triumph of Galatea.
Berlin, Kupferstichkabinett SMPK.

dragon in place of a snake was not unusual in the iconography of the subject. 1 Rembrandt was inspired by Dürer's scene of Christ in Limbo from the Engraved Passion (1512) (Fig. 11a).2 In adopting this motif, Rembrandt also adopted the further meaning it conveyed: it is possible that there is here an allusion to Christ's victory over Satan, who had seduced Adam and Eve, and thus to the Redemption of Humanity after the Fall.3

appearance until that moment. The use of a

As Adam and Eve are lit from behind, their bodies—with surfaces modelled by the play of light and shade—stand out clearly against the background. Possibly in order to emphasise Eve's role as seductress, Rembrandt places her at the centre of the scene—an exception in the iconographic tradition—and draws attention both to the apple and to her pudenda through their strong contrasts of light and shade.

full impact of the psychological conflict.

From the time of Van Eyck's Ghent

Altarpiece scenes of Adam and Eve had been associated with anatomically correct studies of the nude. The nude was often idealised, and Adam and Eve were shown as a young and handsome couple. Rembrandt has shown them quite differently. In the tradition of classicist art criticism, Gersaint and Bartsch censured the exaggerated naturalism and ugliness of Adam and Eve in Rembrandt's scene.4 They accused him of incompetence in drawing the nude, failing to see that Rembrandt had deliberatly employed these stylistic means to convey the

Rembrandt had previously treated the subject of the Fall in two drawings.⁵ The sheet in the Prentenkabinet of the Rijksuniversiteit in Leiden is a study for the etching (Fig. 11b). In it, Rembrandt experiments with two different means of conveying the tense relationship between Adam and Eve. In the left-hand sketch, executed in detail, Eve holds out the apple to Adam with one hand only, while he uses both hands in a gesture of selfdefence. The smaller sketch resolves the composition into the arrangement found in the etching: here Eve holds the apple to her breast with both hands, while Adam reaches one hand out towards it, while pointing upwards in warning with the other.6 The elephant seen trotting along in the sunny landscape of Paradise is based on the chalk drawings of elephants, made in about 1637 (see Drawings Cat. No. 13).7

The states of the etching differ only slightly from each other. In state I the upper edge of the over-grown stoney bank to the left of Adam is not yet marked in with an unbroken line. In the example of state I in London, Rembrandt has drawn in a tree stump to the left of Adam with black chalk. HB

1. See, for example, The Fall of Man by Hugo van der Goes, of about 1470, in the Kunsthistorisches Museum in Vienna; Panofsky 1953, Plate 298.

3. Tümpel 1970, No. 1.

4. Gersaint 1751, pp. 18-19, No. 29. 'Comme Rembrandt n'entendoit point du tout à travailler le nud, ce Morceau est assez incorrect, & les têtes sont tout-à-fait désagréables' (As Rembrandt did not understand at all how to draw the nude, this scene is rather incorrectly treated, and the heads are altogether ugly). B. 28.

5. Benesch 163-64.

6. Benesch 164; Schatborn 1986, pp. 30-31. The red chalk study of about 1637 of a Nude Woman with a Snake (as Cleopatra) in the Getty Museum in Malibu, shows a striking similarity with Rembrandt's Eve in its distribution of light and shade across the naked figure, and it might have served as a preparatory study for this; see Benesch 137; White 1969, p. 42; Goldner/ Hendrix/Williams 1988, p. 256, No. 114.

7. Benesch 457-460.

11b: Rembrandt, Sheet of studies with Adam and Eve, Drawing. Leiden, Prentenkabinet der Rijksuniversiteit.

11a: Albrecht Dürer, Christ in limbo. Berlin, Kupferstichkabinett SMPK.

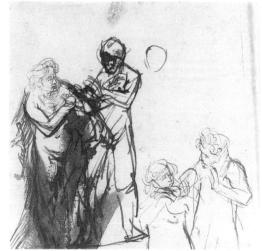

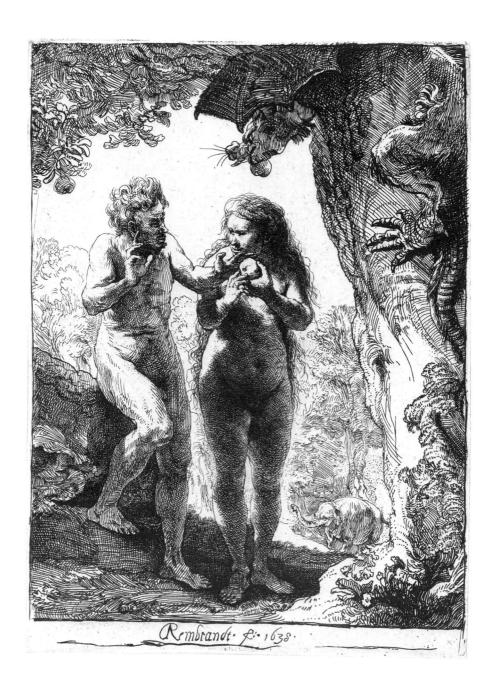

I 2

Sheet of sketches with a portrait of Saskia

Etching and drypoint, 127×103 mm; 3 states Signed: (only in II) *Rembrandt*; c. 1637 B./Holl. 367; H. 153; White, pp. 119–20

Berlin: I (493–16) II (494–16) Amsterdam: I (O. B. 769), II (62:120)* London: I (1848–9–11–189), III (1973 U. 892)

12: State I

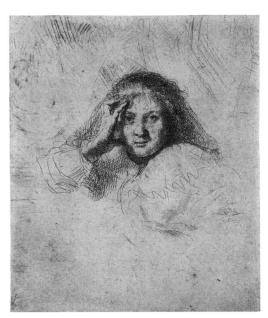

Rembrandt had been married since 1634 to Saskia van Uylenburgh and he often used his young wife as a model in allegorical, symbolic portraits as well as for free sketches. Several drawings and etchings show her in her sickbed; in 1642, after a long illness and at the age of only 30, Saskia died.¹

In the period 1636–37 Rembrandt made three etchings with head studies of Saskia (Fig. 12a).2 In the first state of B. 367 she is shown en face, looking out at the viewer and supporting her head with her right hand. Both head and hand are carefully modelled with fine hatching, but the arm and shoulder areas are only sketchily indicated. The apparent spontaneity of the execution and the alert presence of Saskia lead one to assume that Rembrandt worked directly on the plate in front of his model. The same directness of expression is conveyed in the 1633 silverpoint Portrait of Saskia in the Kupferstichkabinett in Berlin (Drawings Cat. No. 3).3 Here Saskia, four years younger than in the etching and newly betrothed to Rembrandt, is shown with a much brighter expression and her hand rests only lightly against her face (Fig. 12b). In the etching, on the contrary, she looks out broodingly and seems to lean her head heavily on her hand.

In state II, there are two heads as well as the barely legible signature; the carefully hatched

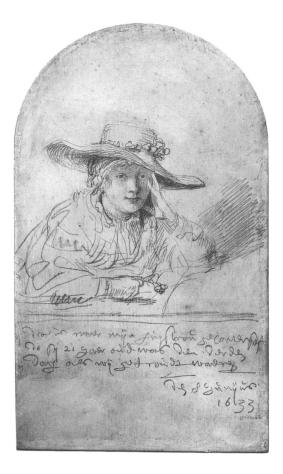

head at the lower right shows Saskia again, and the unfinished sketch immediately next to it, would also appear to be a record of her. This head, indicated with only a few strokes, provides an insight into Rembrandt's working method: first he made his sketch in the wax covering of the plate, then he carried it out in detail (see Introduction p. 8). In state III, the scratches on the upper part of the plate, and also the signature, have been smoothed away. A drawing, also dating from 1636-37, with four studies of Saskia, in the Museum Boymans-van Beuningen in Rotterdam, reveals a similar appearance.4 Rembrandt transferred the free character of the drawn sheet of sketches to the etching; the fact that he did not produce the etching in one process but, rather, prepared three states, questions the assumed 'random' quality of the head studies. Rembrandt must also have consciously etched the drypoint lines of the first two states—at least, he consciously allowed them to remain—in order to simulate the directness of a sketch (see Cat. No. 5). Even if Saskia's features are here recorded as in a portrait, the real purpose of the etching is different. The print-dealer Clement de Jonghe (see Cat. No. 30) had among his stock of printing plates several by Rembrandt, showing sheets of sketches, among them some of Saskia. This shows that works of this kind were desirable collectors' items, intended for the market.

H.B.

- 1. Among others Benesch 405, 425, 426; etching B. 369.
- 2. B. 365, 367, 368.
- 3. Benesch 427.
- 4. Benesch 360; Giltay 1988; p. 55, No. 109.
- 5. De Hoop Scheffer/Boon 1971, pp. 6 ff., No. 16 (probably the *Sheet of sketches with Saskia*, B. 365); No. 39 (probably the *Sheet of sketches with Saskia*, B. 367 or B. 368); No. 42 (probably the *Sheet of sketches with Rembrandt's Self-portrait*, B. 363).

12a: Rembrandt, *Sheet of sketches of Saskia*. Amsterdam, Rijksprentenkabinet.

12b.: Rembrandt, *Portrait of Saskia*. Silverpoint drawing. Berlin, Kupferstichkabinett SMPK.

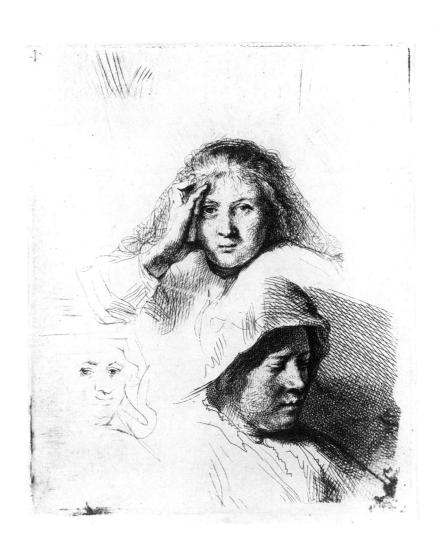

Self-portrait leaning on a stone sill

Etching and drypoint, 205 × 164 mm; 2 states Signed and dated: *Rembrandt f. 1639* B./Holl. 21; H. 168; White pp. 120–22

Berlin: II (1–16) Amsterdam: I with corrections (O.B. 37)*; II (O.B. 38) London: I with corrections (1868–8–8–3177); II (1868–8–22–656)

13a: Renier van Persyn, after Titian, '*Ariosto*'. Amsterdam, Rijksprentenkabinet.

13b: Rembrandt, drawing after Raphael, Baldassare Castiglione. Vienna, Graphische Sammlung Albertina.

In 1631, at the age of 24, Rembrandt etched his important self-portrait in daring competition with Rubens's self-portrait which had become widely known through a reproductive engraving.1 However, in 1639, Rembrandt made what is perhaps his most ambitious etched self-portrait. The next year he enhanced its significance by producing a painted version of the work.2 Again, Rembrandt referred to an important model from the past, probably indeed to two. Yet neither of these is an artist's self-portrait. Doubtless Rembrandt was intending to compete with, and to surpass, Titian's so-called Ariosto.3 At the end of the 1630s this painting is known to have been in Amsterdam, and, as demonstrated by drawings and reproductive prints (Fig. 13a), it was seen by artists there.4 In contrast to the current view, the sitter was then identified as the Renaissance poet Ariosto, whose influence may be traced in seventeenth-century Amsterdam.⁵ In contemporary texts, such as those by Karel van Mander, Titian himself was presented as a an ideal artist. Raphael too was especially praised, and his work recommended as suitable for imitation. Raphael's portrait of Baldassare Castiglione⁶ was in Amsterdam at the same time as Titian's Ariosto. Castiglione was the author of the Libro del Cortegiano, in which the ideal of the cultivated courtier had found its most striking formulation.

Rembrandt made a drawing after Raphael's portrait in April 1639 (Fig. 13b) during a sale of works from the collection of Alfonso López.⁷ In contrast to the other records of this work, however, such as the painted version of about 1620 by Rubens,⁸ or the comparable Dutch

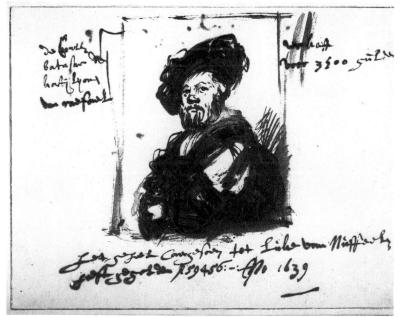

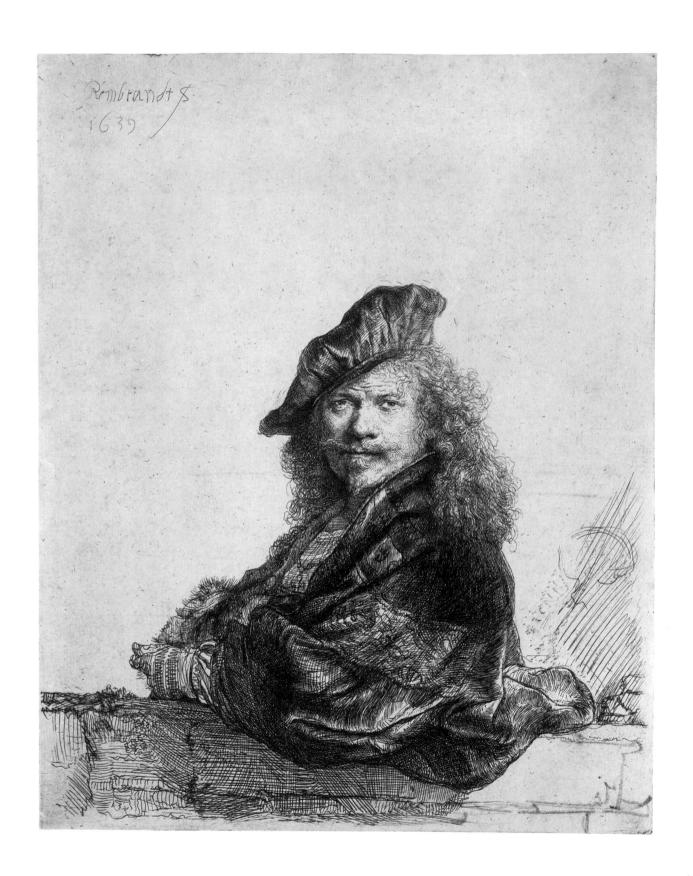

drawn copies and reproductive engravings,9 Rembrandt's drawing is by no means an exact copy. On the contrary, it is closer to the Venetian portrait type. No longer viewed frontally, the sitter looks over his shoulder at the onlooker. The angle and proportions of the head covering have also been altered. The question of whether Rembrandt made the drawing before or after his portrait etching has caused controversy. 10 It is probable that Rembrandt's Titianesque portrait type was influenced by his record of Raphael's painting. At first glance, it seems as if Rembrandt has transferred this model into his own formal language. The drawing would then belong to the evolutionary process that led to the Selfportrait of 1639.

Resting his left arm on a ledge and turning his head, Rembrandt looks directly at the viewer over his shoulder. He wears a beret, its diagonal slant repeated in his upturned collar, an arrangement that both frames the face and at the same time gives structure to the composition. His hair falls in the shadow of his body on the right, but curls luxuriantly down over his left shoulder. While artists were commonly shown wearing such berets, the luxurious, fur-trimmed costume, so voluminous that it drapes over the paparet, seems to be more than a simple indication of social rank.11 It must, rather, have been intended as a Renaissance costume, defining the portrait as all'antica. The size of the background is striking, its extent being emphasised through the placing of signature and date in the top left corner. Hatched strokes behind the shoulder indicate a dark area like a shadow. Nonetheless the figure is lit from the right.

The face turning towards the front, the cap, the turned-up collar, and the more marked integration of the hands taken from Raphael's work are combined by Rembrandt with Titian's picture structure characterised above all by the arm leaning on the ledge and the glance over the shoulder. Rembrandt evolved his self-portrait from a synthesis of the portraits by Titian and Raphael. The reference to tradition—to Raphael and Titian—must have been intended as a foil to the contemporary viewer's perception of this work. Rembrandt's solution should be understood in the sense of aemulatio.12 In theoretical discussions, this term is used to describe competition between artists. The artist selected as a model was seen to present a challenge and, at the same time, to be surpassed through a personal artistic interpretation. Rembrandt thus presents himself in his 1639 self-portrait in artistic competition with Titian and with Raphael—representatives of two distinct

schools of Italian Renaissance painting. The self-portrait functions here not only as a representation of a personalised expression, but also as a programmatic formulation of the artist's identity and profession.

Although not documented through drawings, the etching provides evidence of Rembrandt's extrordinarily careful elaboration of this work. The etching is altered in its second state only in an apparently minor detail: The cap band continues right around the head. State I, with the more spontaneous effect of its nuances, was evidently corrected in the interest of greater formal unity. Six proofs of the first state are known, to all of which Rembrandt has added corrections. 13 These make it clear that Rembrandt was trying out further possible means of introducing greater firmness into the composition. Thus, in one proof, in London (Fig. 13c), Rembrandt strengthened the pilaster that had merely been suggested, while in another proof, in Amsterdam, he added further detail to the wall at the lower right. Only the corrections to the cap, however, were incorporated in the next state. Rembrandt had been interested, even before the first surviving state, in the exact shape of the cap. Traces of fine lines clearly used by Rembrandt to sketch outlines before he elaborated the image, reveal that a more drooping shape had at first been envisaged. The final correction may thus be seen as a result of careful experiment.

The next year (1640), Rembrandt made a painted version of the portrait after the print which he had probably intended for sale. ¹⁴ The similarities with Titian's painting are clearer in the painted image, which reverses that of the etching. Among Rembrandt's pupils, this iconographic solution is repeatedly adopted for artists' self-portraits. ¹⁵ Rembrandt's innovation, developed in a spirit of competition, was evidently judged to be a model in its own right.

1. B. 7; Fig. 12 in the introduction.

- 2. National Gallery, London, *Corpus* A139; Paintings Cat. No. 32.
- 3. National Gallery, London.
- 4. Copy by Theodor Matham in the Herzog Anton Ulrich-Museum, Braunschweig; copy by Joachim Sandrart in the Fondation Custodia (F. Lugt collection), Instuitut Néerlandais, Paris; reproductive engraving by Reinier van Persyn, Holl., XVII, No. 15. See New York 1988, No. 25.
- 5. See De Jongh 1969.
- 6. Now in the Louvre, Paris.
- 7. Albertina, Vienna, Benesch 451; Urkunden 71.
- 8. Courtauld Institute Galleries, London.
- 9. Copy by Sandrart (Louvre, Paris), engraved by Reinier van Persyn (Holl. XVII, No. 41).
- 10. While De Jongh 1969, in particular, has argued that the drawing was made after the etching, Chapman 1990 has recently argued that the etching followed the drawing.
- 11. Chapman 1990, pp. 71 ff.
- 12. De Jongh 1969; Raupp 1984, pp. 168–81; Chapman 1990, pp. 69–78.
- 13. Amsterdam (2), London, Madrid (2), Melbourne.
- 14. Paintings Cat. No. 32.
- 15. Ferdinand Bol, Govert Flinck, Frans Mieris; see Corpus A139.

13c: Rembrandt, Self portrait leaning on a stone sill. State 1, with corrections. London, British Museum.

14 The Death of the Virgin

Etching and drypoint, 409 × 315 mm; 3 states
Signed and dated: *Rembrandt f. 1639*B./Holl. 99; H. 161; White pp. 43–46

Berlin: III (316–1893)* Amsterdam: I (62:2) London: I (1973 U. 898)

In a stately bed a woman lies dying. Around her is a large assembly of mourners. The heavens open; an angel, surrounded by putti, steps down from the clouds. While not recounted in the Bible, the story of the death of the Virgin had already been widely known since the early Middle Ages, primarily from the account in the Golden Legend. The death of the Virgin is an important theme in catholic iconography. For Calvinists, however, worship of the Virgin was forbidden. As in the case of the etching Rembrandt made two years later, The Virgin and Child in the Clouds,1 and The Virgin and Child with the Snake (Cat. No. 36), it would seem that this work was intended for the Catholic connoisseurs in Amsterdam.

The point of departure for Rembrandt's print was the corresponding episode in Dürer's etched Life of the Virgin, produced between 1502 and 1510 (Fig. 14a).2 A year earlier, in 1638, Rembrandt had bought a set of Dürer's series at auction.3 Rembrandt sought to surpass Dürer even in the dimensions of his etching, for Dürer's woodcut measures 295 × 210 mm. While Dürer shows the death of the Virgin as a liturgical ceremony in the presence of only the twelve Apostles, Rembrandt depicts a large group of mourners, including both men and women, an arrangement found in the earlier engraving by Philip Galle after Pieter Breughel.⁴ It would appear that Dürer's composition was already known to Rembrandt indirectly, through a work by Dirk Crabeth.⁵ Specific aspects of Rembrandt's composition, such as the altered spatial arrangement, would seem to have been prompted by what Rembrandt found here.

The effect of his wife's illness⁶ on Rembrandt is shown both in a poignant sheet of etched sketches (Fig. 14b)⁷ and in the artist's rendering of the Virgin. While none of the sketches should be understood as a preparatory drawing for the etching, it is probable that observations made from the model left their mark on Rembrandt's treatment of the scene, giving the figure of the Virgin as authentic an appearance as possible. Departing from iconographic tradition, Rembrandt introduces the figure of a doctor, who takes the Virgin's pulse, a motif familiar from other death-bed scenes.⁸

Rembrandt varies the crowd of mourners thronging around the bed through their different expressions of sorrow. Individual figures stand out from the group because of their imposing appearance. Especially striking is the figure of the priest who, accompanied by a server, approaches at the left of the death bed. Both figures, indeed, find a loose parallel in Dürer's print where in the foreground one of the apostles kneels and holds a crucifix, and Peter, identified by his mitre as the first bishop of Rome, stands in the left background. In Rembrandt's print, however, the figure of the priest does not participate in the religious ceremony. The dress of the figures is something of an orientalising fantasy costume, intended to place the event in the ancient Jewish Middle East. Among several figures who indicate the time-honoured sanctity of the event is the man sitting in the left foreground in front of the boldly illuminated bible. Lastly, prominent because of their size, the lamenting woman in front of the bed and the brightly-lit figure whose outstretched arms lead the eye on to the high curtain, set the tone of strongly expressive sorrow. The enormous curtain, which would

seem out of place as the furnishing of an interior as Dürer shows it, is employed by Rembrandt as a symbol of majesty. It is also possible that it symbolises a boundary between the earthly and heavenly kingdoms. In addition to establishing distinct groups among the figures—those who mourn and those whose presence alludes to the sanctity of the event—Rembrandt adds a third group of figures: the angels and *putti* belonging to the heavenly realm. Three types of space seem to be adopted: the 'normal' space of the interior, an intermediate, 'sanctified' space, and the space of the heavenly sphere.

Rembrandt's range of techniques is exciting to behold, for it embraces both a painstaking record of details and a bold sketchy style. Only the lighting is minimally altered in the three states of the etching: the chair in state II, for example, is heavily shaded with dry-point while the foreground bedpost in state III is more strongly shaded. In any case, it is possible that Rembrandt rejected his first design for The Death of the Virgin, and then executed the design of the print as we now know it on a new plate. Impressions of the Landscape with the three trees (Cat. No. 19) show traces of a reworking of the plate which appears to be a compositional outline for The Death of the Virgin. 10 If this is indeed the case, this would constitute clear evidence that Rembrandt based some of his compositions not on detailed preparatory drawings, but rather on hasty sketches drawn directly on to the plate. B.W.

14a: Albrecht Dürer, *Death of the Virgin*. Berlin, Kupferstichkabinett SMPK.

14b: Rembrandt, *Sheet of studies*. Amsterdam, Rijksprentenkabinet.

- ı. B. 61.
- 2. B. 93.
- 3. *Urkunden* No. 56. See Cat. No. 11; on Rembrandt's adoption of elements from the work of Renaissance masters such as Dürer and Lucas van Leyden, see also the commentary on the *Ecce Homo* (Cat. No. 38).
- 4. See Campbell 1980.
- 5. Glass painting in the Oude Kerk in Amsterdam; see White 1969, p. 45.
- 6. For example, Benesch 379, Schatborn 1985, No. 12, Amsterdam.
- 7. B. 369.
- 8. Tümpel 1969, p. 194.
- 9. Campbell 1980, p. 4.
- 10. Campbell, 1980.

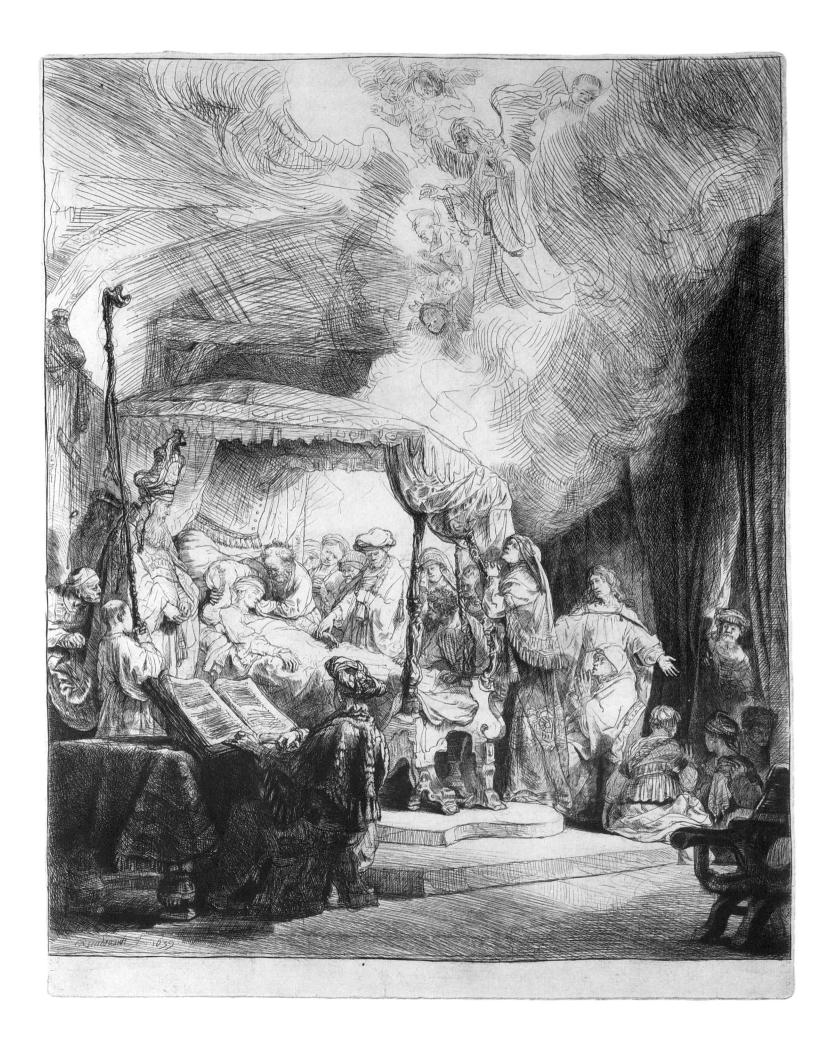

15

The Artist drawing from the Model (Allegory of the Glorification of Drawing)

Drypoint, etching and burin, 232×184 mm; 2 states; c. 1639 B./Holl. 192; H. 231; White, pp. 160 ff.

Berlin: II (279–16) Amsterdam: II (1962:66) London: II (1973 U. 995)*

15a: Pieter Feddes van Harlingen, Pygmalion.

15b: Jacopo de' Barbari, Allegory of Fame and Victory. London, British Museum.

VOLGHT. NIET PRINGION.
DESCHEN, LIEPO HEPT VERWON.
DOER EEN BEEID VANSIN VERVEN.
EN KUE NEMT ZELL NIET VERV.

The sheet produced in about 1639 is only partially executed: the background, where one can see just the upper section of an easel, a bust on a high pedestal and suggestions of an arch, is carefully worked out in various kinds of hatching, while the remainder of the scene is only shown in a few sketchy drypoint strokes. An artist, whose facial features recall those of Rembrandt is engaged in drawing a nude female model who stands on a low footstool with her back to the viewer. The position of the model's supporting leg and her leg at rest, her pose and the turn of her head suggest the inspiration of a statue of Venus from Antiquity. The model has a cloth draped over her left arm, and she holds a long palm spray in her right. In both the left and right corners of the scene, there are suggestions of a chair. The canvas on the easel and the props on the wall—a shield, a sword and a feathered hat, objects owned by Rembrandt which appear in his works—show that the setting is an artist's studio.

With regard to the composition and the figure of the model, there are certain parallels with an etching made earlier by Pieter Feddes van Harlingen (Fig. 15a). This shows Pygmalion, the sculptor from Antiquty who, falling in love with a female statue he had himself made, begged Venus to breathe life into the figure. In the eighteenth century Rembrandt's sheet too was given the title *Pygmalion*. Rembrandt's artist, however, is not shown as if overcome

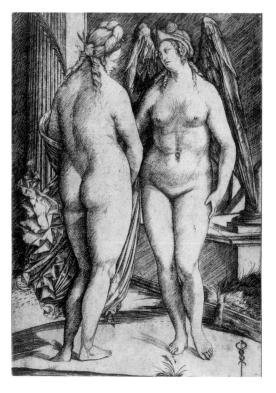

with love for his own creation, but looks at the model in order to record her on the paper.

Scenes of artists at work in their studios were a common motif in the seventeenth century. The most famous examples are Las Meninas of Velázquez and Vermeer's Art of Painting. The central element of this motif, the relation of artist to model, was usually treated allegorically; thus, for example, the artist shown by Vermeer is painting Clio, the Muse of History, and his scene may thus be understood as an allegory on the Glory of History Painting. Rembrandt's model holds a palm spray, the symbol of fame. Rembrandt's immediate source—as also that of Feddes van Harlingen—must have been the corresponding figure in an engraving by Jacopo de' Barbari of about 1498-1500, showing the Allegories of Fame and Victory (Fig. 15 b).4 The palm spray in the hands of an undraped female figure could, however, also indicate that Rembrandt here intended to show the Allegory of Veritas (Truth). The embodiment of Fame or Truth is also, in an extended sense, the artist's model here: as the Muse that inspires him. The real subject of this sheet is, therefore, the Glorification or the Truth of Drawing.⁵ From the Renaissance, disegno—meaning both a drawing and an idea—was regarded as the basis of all the arts, because it was the most direct embodiment of the artist's conception. Rembrandt illustrates this theoretical connection by showing the draughtsman sitting in front of the canvas on his easel. For it is only after making the preparatory sketch that the painter—and here Rembrandt is probably alluding to himeself-reaches for brush and palette, in order to transfer to the canvas, with the help of colours, the theme he has observed.6 In this conceptual context, the bust in the background might perhaps be understood as a symbol of Sculptura.

The old title of the etching probably had its source in the classicist art criticism of the late seventeenth and the eighteenth centuries, which censured self-love in artists (Rembrandt too was seen to be guilty of this) through the image of Pygmalion.⁷

But why was the plate left unfinished? By this time Rembrandt enjoyed widespread fame in Europe as an etcher. He might have deliberately published the unfinished plate in order to reveal to the public his own printmaking technique.⁸ It is possible that Rembrandt intended to incorporate in the unfinished sheet a challenge to his pupils to enter into artistic competition with their master by nobly completing the studio scene on which he had embarked.⁹ It is also probable that the plate was not further worked up on

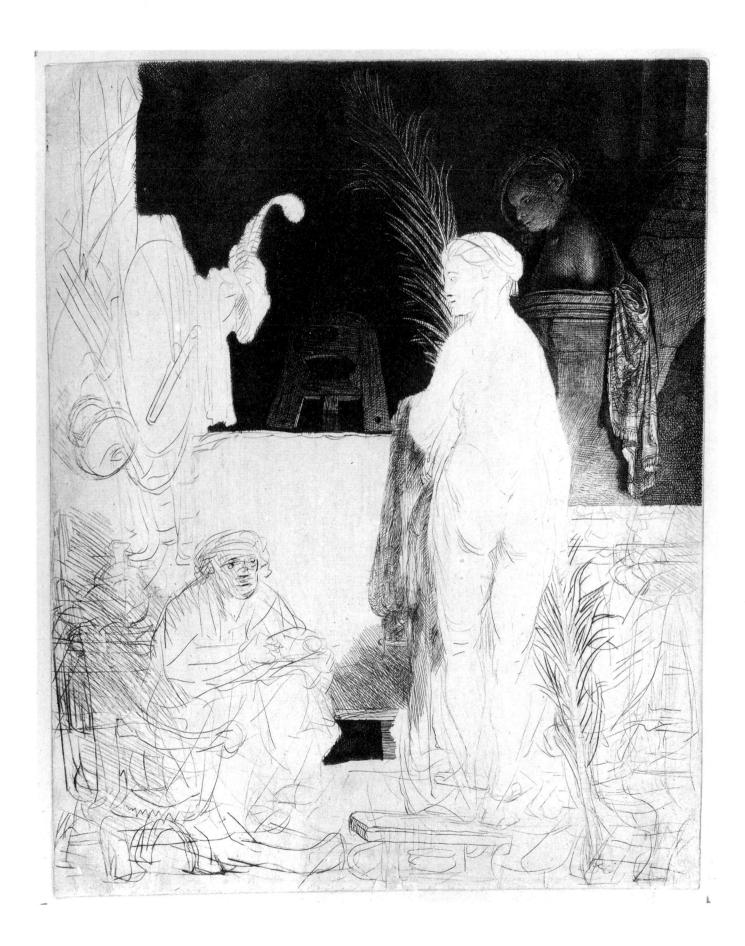

inconsistencies in the composition. It is not absolutely clear, for one thing, how the draughtsman is sitting; he seems to sit near the chair rather than on it, as the four chair legs are scratched on to the plate to his left. Curious uncertainties are revealed in the allegorical figure's two pairs of legs. One pair is too long in proportion to the rest of the body, but the feet are correctly placed on the footstool, while the other pair of legs is in proportion to the body, but floats unsupported in the air. The elongated legs supported by the footstool are more weakly sketched-in.

In state I, the uncertain record of the

account of deficiencies in the drawing and

model's feet is even more obtrusive; here the footstool is only lightly marked in (Fig. 15c). In the related drawing in London, which shows the composition in reverse and on about the same scale, the model's pose is fully resolved (Fig. 15d). The confused tangle of lines at the right of the etching is also lacking here, being replaced by the base of a pillar. This indicates that the drawing was only made during the preparation of the etching and, indeed, after this had reached state II, presumably with reference to a counter-proof bearing the reversed imprint of the etched composition.¹⁰ It is evident that Rembrandt sketched the scene directly on to the plate without any preparatory study, and only later, and with the help of the London drawing, attempted to correct his rather botched composition.

The fact that the etching was published as a fragment is witness to collectors' appreciation of such unfinished sheets. They would have seen them as works in which the artist's first

thoughts were revealed. Unfinished engravings had already been published by Hendrick Goltzius and Jacob Matham; in these it almost appears as if the scenes depicted were deliberately left in a fragmentary state.¹¹

In the rare state I, in which the drypoint passages are still very strong, the upper part of the easel and the drapery on the model's arm are not yet hatched; between the draughtsman and his model, and in front of the blank canvas on the easel, there is a small printing press. The London example of this state reveals black pencil corrections in Rembrandt's hand on the turban-like head covering of the bust as well as on the chimney or pillar to the right; in state II hatching is added in these areas.

Hind gave a late dating to the unsigned etching, around or after 1648, but it must have been made earlier, in about 1639.

- 1. Holl. 21; Saxl 1910, pp. 42 ff.
- 2. Ovid, Metamorphoses, X, 243 ff.
- 3. Yver 1756, p. 61, No. 184.
- 4. B. 18, Hind 26; Saxl 1910, p. 43; Amsterdam 1985–86, pp. 66 ff., Nos. 53–55.
- 5. Emmens 1968, p. 160.
- 6. It is not possible to deal exhaustively here with the complex content of the scene. See Held 1961, pp. 73 ff., Figs. 1–2 on a painting by Guercino with a related subject, in which the Father of Drawing shows his daughter, the Allegory of Painting, a sketch from which she then executes the scene shown in the picture.
- 7. Emmens 1968, pp. 159 ff.
- 8. In this connection, Emmens argued that the uncovered bust in the background alluded to this function; Emmens 1968, pp. 160 ff.
- 9. Emmens 1968, pp. 160 ff. It is perhaps worth considering, once again, whether the rather weak finished part of the etching, already ascribed by Francis Seymour Haden to Ferdinand Bol, really was executed by Rembrandt himself and not, rather, by one of his pupils; Haden 1877, pp. 41–42.
- 10. On the drawing, see Benesch 423; Schatborn 1986, pp. 18–19. The correct identification has been established by Martin Royalton-Kisch, who will publish it in the catalogue of the London Rembrandt drawings now in preparation. Münz attributed the etching, as also the related drawing, to Gerbrand van den Eeckhout; Münz 1952, Vol. II, pp. 182–83, No. 339. Two counter-proofs of the etching survive, one in Cambridge and one in Vienna.
- 11. Three engravings of this kind by Goltzius are known: *The Adoration of the Shepherds*, Holl. 15; *The Massacre of the Innocents*, Holl. 17; and a *Standing Female Allegory*, Holl. 54.

15c: Rembrandt, *The Draughtsman drawing the Model*. State I. London, British Museum.

15d: Rembrandt, *The Draughtsman drawing the Model*. Drawing. London, British Museum.

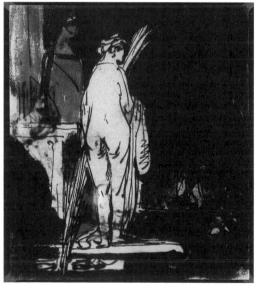

Portrait of the Preacher Cornelis Claesz. Anslo

Etching and drypoint, 188 × 158 mm; 2 states Signed and dated: *Rembrandt f. 1641* B./Holl. 271; H. 187; White pp. 124–25

Berlin: 1 (78–1887)* Amsterdam: II (O.B. 524) London: II (1973 U. 945)

Cornelis Claesz. Anslo (1592–1646), a cloth merchant successful in both domestic and overseas trade, was a member of the 'Waterlandse Gemeende' (Waterland congregation) in Amsterdam. This was a liberal group in comparison with the rather stricter Mennonites, who had taken their name from the Frisian Anabaptist, Menno Simonsz. However, the Waterland congregation also held that the spoken word had absolute priority over the visual image in the transmission of Christian faith. The group had no ordained preachers and preferred, rather, to select from among its number those gifted in expounding the Scriptures. In Amsterdam, Anslo presided as spiritual adviser and preacher at the Grote Spijker, the congregation's chapel on the River Singel. Cornelis Anslo was distinguished, apparently, by his talent as a speaker, but equally by his deep religious faith and, at a time of often dogmatic religious opinion in Amsterdam, by his tolerant attitude towards Baptists of differing persuasions. A double portrait of 1642 shows Anslo with his wife, Aeltje Scholten Gerritsdr. (Paintings Cat. No. 33).1

The portrait etching of 1641 shows Anslo expounding the word of God to an imaginary listener, with his eyes not looking directly at the observer. His right hand, holding a pen, rests on an upturned book, while with his left hand he points to a large open volume of the Scriptures. His dress-fur collar, ruff and hat-demonstrates that he belongs to the wealthy bourgeoisie. Behind him, a picture is turned to face the wall, apparently having been removed from the illusionistically painted nail above. As Busch has shown, Rembrandt is alluding here to the dispute over the relative importance of word and image in the imparting of the message of Salvation, a question unambiguously resolved in this case in favour

of the written and spoken word.² One might however ask if it is mere chance that the etching is signed on the reversed painting.

The preparatory drawing (Fig. 16a) matches the etching in both its dimensions and (though reversed) in its composition, and it reveals signs of tracing.³ Because it has been so carefully executed, one may assume that it served not only as preparatory material for the artist, but also as a *modello* to be submitted to the patron.⁴ Very few of Rembrandt's drawings which were intended for direct transfer to the etching plate survive.⁵ In the case of other portrait etchings, for example the *Posthumous portrait of the preacher Sylvius* (Cat. No. 22), where preparatory drawings have survived, no *modelli* are known.

While the figure of Anslo is transferred in almost every detail from the drawing, the backgrounds show alterations in several respects. Most important is Rembrandt's addition of the picture taken down from the wall. The arrangement of light and shadow in the etching eschews specific emphasis in favour of very evenly distributed illumination; and the execution is more schematic than in the case of other portrait etchings.

The first state shows a minimally altered picture area, which in state II is enlarged both below and, to a small degree, at the left, thus the image as a whole is expanded to fit the size of the plate. A few shadows are marked in more precisely with drypoint.

This portrait of Anslo bears no text, nor does it reveal any space for the insertion of a handwritten panegyric. However, on both the mounting of the preparatory drawing and on a proof of state II in London, there is an epigram by Joost van den Vondel, arguably the most important Dutch poet of the baroque era, in a seventeenth-century hand:

'Ay Rembrandt, mael Kornelis stem. Het zichtbre deel is 't minst van hem; 't Onzichtbre kent men slechts door d'ooren. Wie Anslo zien wil, moet hem hooren'.6

(Ah Rembrandt, paint Cornelis's voice the visible is the least important part of him One can experience the invisible only through the ears

Whoever wants to see Anslo, must hear him.)

Scholars have been much concerned with the relationship between Rembrandt's print and this poem. Emmens proposed that the text be understood as a reference to the etching, and that it was the import of this text that had spurred Rembrandt to lay more stress on the word in his painting.⁷ This theory has been

disputed on several grounds.8 It is especially striking that, even in the etching, Anslo turns towards an invisible listener with his mouth slightly open, that is to say, speaking, thus clearly stressing the word and the voice. In addition, it is necessary to consider the purpose of poems of this sort. They conform to a literary tradition of their own, rather than making direct reference to contemporary artistic practice. 'Regarding Vondel's lines it has to be suggested that Rembrandt was well aware of the poet's ill-will towards him, but had on the other hand—and according to his commission—shown in his picture the priority of the word over the image, at least the divine word, and in this respect being fully in accordance with Vondel.'9

B.W

- 1. Berlin, Corpus A143.
- 2. Busch 1971.
- 3. Benesch 758; London, British Museum.
- 4. A comparable *modello* for the figure of Anslo in the Berlin double portrait also survives, Paris, Benesch 759. 5. An early example is the etching of *Saint Paul*, B. 149, and the related drawing Benesch 15; see also the *Diana* etching B. 201 and the drawing Benesch 21, as well as the portrait etching of *Jan Six* (Cat. No. 23).
- 6. Urkunden No. 100.
- 7. Emmens 1956.
- 8. Busch 1971; Corpus A143.
- 9. Busch 1971, p. 199.

16a: Rembrandt, *Cornelisz Claesz. Anslo.* Drawing. London, British Museum.

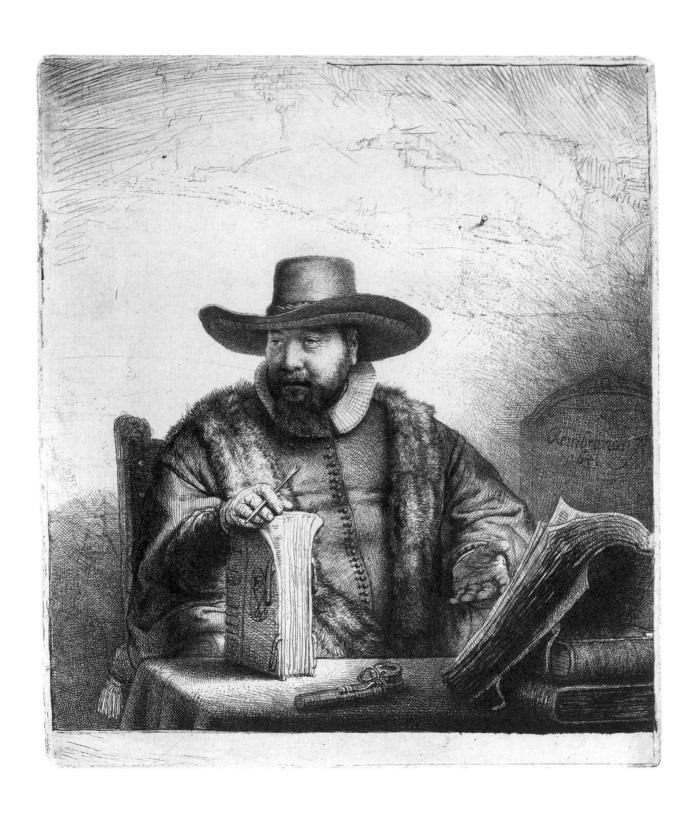

Ι7

The Flute-Player

Etching and drypoint, 116 × 143 mm; 4 states Signed (from II): *Rembrandt*. f 1642 B./Holl. 188; H. 200; White, pp. 164 ff.

Berlin: II (182–1878) Amsterdam: II (61:1096)* London: III (1973 U. 958)

In 1642, the year Rembrandt finished painting The Nightwatch, he etched a small-scale genre scene that was known, until the eighteenth century, by the misleading title Till Eulenspiegel (L'Espiègle).1 A young man is seen lying on the bank of a stream, his crook shows him to be a shepherd. An owl is perched on his shoulder, and in his hands he holds a flute. He seems to have only just broken off playing and is now eyeing the legs of his young companion. She wears a broad-brimmed straw hat and is seen plaiting flowers into a garland. In the background, sheep and goats crowd towards the water. At first glance this seems to be a pastoral love scene. Influenced by pastoral poetry such as P.C. Hooft's Granida (1605), scenes with shepherds, or pastorals, were very popular in Holland from the 1620s. Central to such scenes was the joyful gathering of shepherds to sing and make love.2 Rembrandt only rarely treated this subject: apart from halflength portraits of Saskia as Flora in the Costume of a Shepherdess, only a few drawings and etchings with a bucolic theme are known.3

The Flute Player, nonetheless, breaks with the tradition of pastoral scenes in containing motifs that disturb the normally peaceful, idyllic character. The young man's face, in contrast, to the tradition for such figures, is ugly, almost vulgar; Rembrandt may have been inspired here by the figure with a flute in a woodcut after Titian.⁴ The vulgar character of the shepherd is supported by the way in which he surreptitiously and voyeuristically peers up the girl's skirt. The owl on his shoulder, which appears to be wearing a collar with fool's bells, is an old symbol of folly and sinfulness. The

young man is seen to point his flute towards the revealed crotch of the shepherdess, and not by chance: the flute was often described in contemporary commentaries as a phallic symbol. In a pastoral scene by Abraham Bloemaert (1627), in the Niedersächsische Landesgalerie in Hannover (Fig. 17a), a shepherd pushes his flute, in an equally unambiguous manner, under the skirts of his female companion.5 The floral garland may be understood in direct relation to the motif of the flute. Since the Middle Ages, the making of floral garlands had served as a metaphor for entering into an amorous relationship. The garland itself, however, was also a symbol of the female genitalia, or of the virginity that a girl declares she is ready to sacrifice by offering a garland to her lover. The purse of the shepherdess too may be understood, in this context, as a sexual symbol. The lascivious allusions in this scene are finally stressed through the presence of the sheep and the goats, as these animals were widely associated with sexual excess. Rembrandt repudiates the traditional pastoral scene in exaggerating the erotic aspects of the subject through bold sexual symbols and allusions. Iconographically, the Flute Player may be traced back to the moralising love scenes in German and Netherlandish prints of the fifteenth and sixteenth centuries, although it is impossible to point to a specific model. It seems that Rembrandt wished to comment satirically on the pastoral genre.6

The head emerging from the bushes towards the upper right corner remains a mystery: is it a faun or a wood spirit peeping out? But why,

17a: Abraham Bloemaert, *Shepherd scene*. Hannover, Landesgalerie.

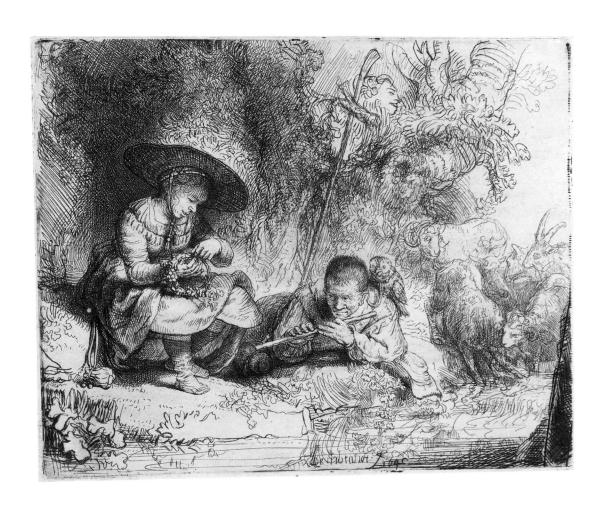

then, is its gaze turned away from the main scene? Or is this all that remains of a figure from an earlier scene, worked in part on the plate and then abandoned?7 As the face appears in a corner, one might assume that an originally larger plate had been cut down. It seems that Rembrandt valued the charm of bizarre motifs of this sort, looking as if they had come about by chance. In the Virgin in Glory (B. 61), for example, he allowed an etched head of the Virgin to remain in the proofs (visible upside down in the Virgin's dress).8

In the four states of the Flute Player it is above all the relation of light and shade that is varied. In state 1, shadows lie across the hat of the shepherdess; in the signed and dated state II these are thoroughly lightened and reworked as delicate foliage. In state III, the area above the hat is once again substantially darkened with drypoint lines. In state IV, changes in the foreground can be detected, and the face in the bushes has been removed. In all four states certain areas, for example in the bushes behind the shepherd, show a fair amount of surface tone.

In the Berlin example of state I, and long unnoted, there are pen additions in grev inkin one place also in brown wash—on the shepherd's costume, on his face, on the right corner of the girl's skirt as well as on the ground visible at the right between the shepherd's shoulders and the goats (Fig. 17b). The London impression of state I shows almost the same corrections. Thicker shading is tried out with the brush additions; these must be in Rembrandt's hand as, in state II they are followed in the additional drypoint hatching lines on the plate.

H.B.

- 1. Gersaint 1751, pp. 148-49, No. 180.
- 2. On this, see McNeil Kettering 1977.
- 3. Corpus A93, A112; Benesch 424, 748; B. 189, 220.
- 4. McNeil Kettering 1977, p. 35, Fig. 19, p. 39.
- 5. Braunschweig 1978, pp. 48 ff., No. 3.
- 6. It is difficult to be precise about the meaning of Rembrandt's scene. Emmens interprets it as the artist's commentary on the pastoral inspiration of poetry. He claims however, that, in the vulgar character of the scene, Rembrandt was not referring to the high lyrical form of poetic inspiration, but rather to the lower, erotic form of inspiration which served the poeta vulgaris (Emmens 1968, pp. 147 ff.). White assumes that Rembrandt is illustrating a particular pastoral poem (White 1968, p. 164).
- 7. McNeil Kettering 1977, p. 21, note 7.
- 8. On this matter in general see Robinson 1980.

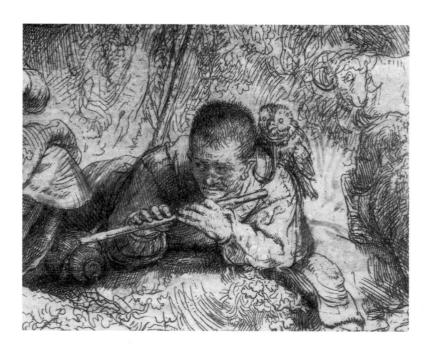

17b: Detail of Cat. No. 17, State 1. Berlin, Kupferstichkabinett SMPK

Etching and drypoint, 145×184 mm; 2 states Signed and dated: *Rembrandt f. 1643* B./Holl. 157; H. 204; White, pp. 165 ff.

Berlin: I (240–16) Amsterdam: I (61:1081)* London: I (1910–2–12–364)

One of the oddest records of everyday life among Rembrandt's prints is this scene of a tethered pig lying on the ground with its trotters tied. A boy walks past, laughing, with a pig's bladder in his hands, while an old man is seen making ready to slaughter the animal. In his right hand he holds a basket and what appears to be a cleaver, in his left a bent wooden stick which will be used to hang the slaughtered pig up on a bar. A wooden trough hangs on the wall. A small boy, supported by his mother, looks at the animal with slightly anxious surprise.¹ Another laughing boy, wearing a hat, is indicated in the background.

Scenes of pig slaughtering, for example in late medieval book illumination, were originally incorporated into series of the months of the year, mostly representing the month of December. November was illustrated by pig fattening.² Late autumn was the traditional time for slaughtering, as the animals had been fattened during the summer and early autumn. In Dutch, November was also known as slachtmaand (the slaughtering month), and during November the parkensfest (pig festival) or varkenskermis (pig fair) was celebrated.3 The calendrical tradition endured into the seventeenth century. In a series of months of the year by Cornelis Dusart (about 1690) pig slaughtering represents November.⁴ By this time, however, the subject had taken on a certain independence as a genre scene. An etching by Adriaen van Ostade (Fig. 18a), from about the same time as Rembrandt's print, shows the event without integrating it into a series of months.⁵ Children, looking on with amusement or scepticism, were a traditional element in scenes of pig slaughtering. Rembrandt's scene, however, departs from iconographic tradition in one significant respect. It does not show the slaughter itself,

18a: Adriaen van Ostade, *The Pig Killers*. Berlin, Kupferstichkabinett SMPK.

but rather the moment preceding it. Interest is focused on the pig, which seems to have resigned itself to its tragic fate; almost smiling, and without a trace of agitation, it lies there peacefully.

The laughing boy holds an inflated pig's bladder as if it were a toy. This motif was exceptionally popular in Dutch painting, mostly in slaughter scenes.⁶ Like the soap bubble, the animal bladder is found in contemporary emblem books as a symbol of earthly transience: Homo Bulla-man is like a bladder, puffed up with wind only to burst.⁷ The pig's bladder in Rembrandt's etching could be pointing to the animal's inescapable fate, but perhaps also in a wider sense to that of man. In contemporary literature and art, pig slaughtering was treated as an allusion to earthly transience in the widest sense: 'You that see fit to slaughter your oxen, pigs and calves, think of God's verdict on the Day of Judgment'.8

A sheet of studies from life in the Louvre in Paris (Fig. 18b) shows two pigs, of which the recumbent one is similar in many respects to the one in the etching, though one could not speak here of a preparatory drawing in the strict sense.⁹

Rembrandt has almost exclusively etched the plate. While the background figures are marked in sketchily, the pig is precisely drawn, even down to the details of its hide. Here, Rembrandt has strengthened the contours with a few drypoint lines. In state II, of which only one example—in London—is known, a few strokes were added to the toddler's ear, to the face of the boy with the pig's bladder, and in particular to the pig.

- 1. This group of mother and child was often used by Rembrandt (see Cat. No. 10); Schatborn 1975, p. 10.
- 2. For example, in the Breviarum Grimani, c. 1510-20.
- 3. Lawrence, Kansas; New Haven and Austin 1983/84, p. 176, No. 48.
- 4. B. 30, Holl. 30.
- 5. B. 41, Holl. 41; Lawrence, Kansas; New Haven and Austin 1983/84, pp. 176 ff., No. 48.
- 6. Amsterdam 1976, p. 116, No. 24.
- 7. Amsterdam 1976, pp. 44 ff., No. 4.
- 8. Amsterdam 1976, pp. 116 ff., No. 24, (from a source from 1667). 'Ghy die naer u welbehagen Os en Swijn en Kalf doet slaen; Denckt hoe ghy ten Jongsten Dage Voor Godts Oordeel sult bestaen'.
- 9. Benesch 777. Schatborn 1977, pp. 10–11. Paris 1988/89, p. 36, No. 25.

18b: Rembrandt, *Sheet of studies with two pigs*. Drawing. Paris, Musée du Louvre, Département des arts graphiques.

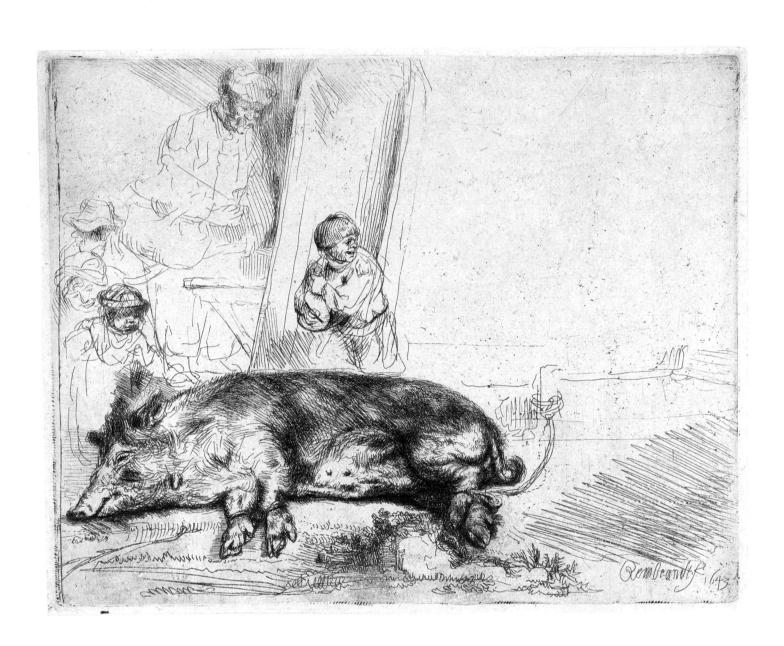

Landscape with three trees

Etching, worked over with engraving and drypoint; in places, sulphur tint etching 213 × 279 mm; 1 state
Signed and dated: (barely visible) *Rembrandt f.* 1643
B./Holl. 212; H. 205; White, pp. 198 ff.

Berlin: (303–1898) Amsterdam: (O. B. 444)* London: (1868–8–22–678)

19a: Rembrandt, *The Shepherd and his family*. Amsterdam, Rijksprentenkabinet.

19b Detail of Cat. No. 19.

The Landscape with three trees is Rembrandt's largest and, on account of its painterly execution, perhaps most celebrated landscape etching. The view, from about eve level, is of the gentle slope of a hillock with three large trees, and of a broad low plain with a silhouetted city in the distance. The foreground is in dark shadow, while the landscape in the distance is brightly lit. The trees are shown against the light and form a powerful contrast to the sky, which has lightened in this region. Thick parallel hatching strokes run across the upper left corner. Whether, as has mostly been assumed, these are intended to represent a shower, remains to be established, as comparable etching clusters in the Three Crosses (see Cat. No. 35) are used to embody rays of light. It is equally uncertain whether a turbulent, stormy sky is really shown here, as has usually been claimed by commentators. In that case it would be difficult to explain why the figures, for example the farmers and cowherds in the plain, do not react to the storm. In spite of the turbulent sky, the landscape exudes complete calm. The treetops sway only slightly in the wind; and sun and cloud, bringing light and shadow, seem to pass swiftly, in turn, over the earth. To this extent Rembrandt has, indeed, recorded the effects of weather—perhaps the atmosphere of morning or evening, with a rising or setting sun—but not a storm in the real sense.1

In the left foreground we can see a fisherman with a woman sitting beside him; to the right, hardly detectable in the thick bushes on the

slope of the hillock, there are two lovers. Along the ridge of higher ground, a horse and cart are moving slowly along, carrying several passengers; and nearby there is a seated man who is drawing. The motif of the draughtsman in the landscape was often used in the sixteenth century in the circle of the Netherlandish Mannerists, for example in the work of Lukas van Valckenborch or Paulus van Vianen. Rembrandt made this his central subject in an etching of 1642-43.2 The draughtsman seen in the Landscape with three trees, however, differs from the traditional treatment of this motif in one key respect: he is not looking at the landscape that is shown in the scene that the viewer of the etching beholds, instead he looks to the right where the landscape, hidden from the viewer, is apparently sunnier. Rembrandt is perhaps alluding here to the notion that the landscape artist is inspired more by his inner imagination than by the direct observation of nature.3 Lying behind the trees, brightly lit by the sun, is a farmhouse.

It is probable that Rembrandt has here reworked his own impressions of the region around Sint-Anthoniesdijk (Diemerdijk) or around Haarlemmerdijk, not far from Amsterdam, which itself seems to be visible, silhouetted in the distance.4 The Three Trees, however, is not intended to be a reliable, topographical view but, rather, a freely composed one. In a far greater measure than in Rembrandt's other landscape etchings with motifs from the environs of Amsterdam or Haarlem (see Cat. No. 20, 28 & 32), the present etching shows an idealised landscape and, indeed—because of the trees pushed into such an exposed position in the scene and the dramatically presented sky-even a 'heroic' landscape. Rembrandt's success in capturing the atmosphere, and the different appearance of illuminated and shadowed regions, recalls the ideal landscapes of the French painter active in Rome, Claude Lorraine, whose work may have inspired Rembrandt's treatment of the Landscape with three trees.⁵ Also evident are connections to pastoral landscapes with rural, idyllic scenes of shepherds, that had been very popular in Holland since the 1620s.6 The man and woman by the water—as in Rembrandt's small etching, The Shepherd's Family (Fig. 19a)7 —are shown as a shepherd and shepherdess, the broad-brimmed straw hat of the seated woman and the basket by her side (Fig. 19b) being the traditional attributes of a shepherdess (see Cat. No. 17). A clear erotic component is added through the introduction of the pair of lovers in the bushes on the slope—hidden in the manner of the couple in Rembrandt's Omval of 1645.8 The barely-visible goat near to them,

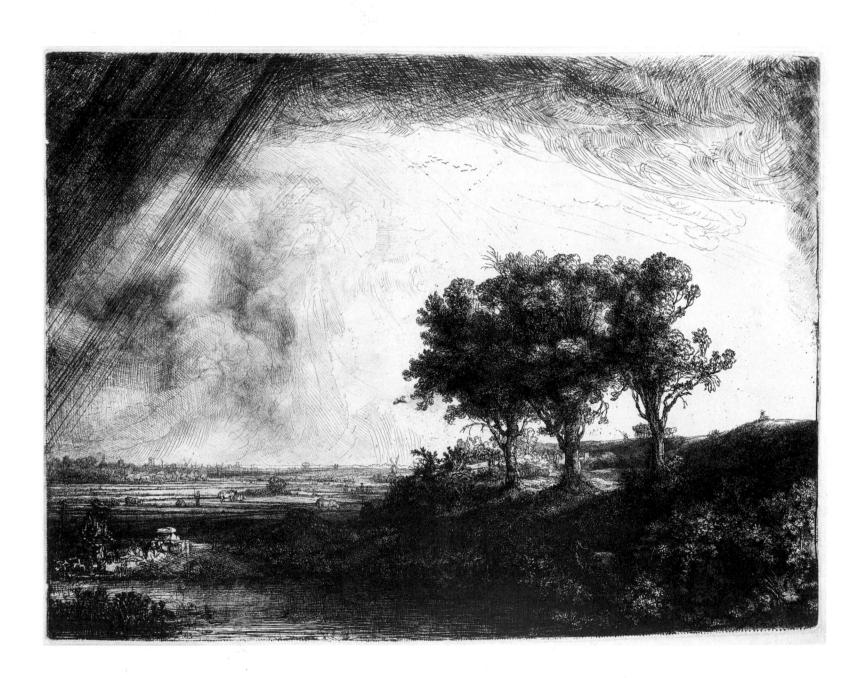

a symbol of unbridled sexuality, stresses the erotic strain of this scene (see Cat. No. 17).9

The Three Trees is close to Rembrandt's landscape paintings of the late 1630s and early 1640s, for example the Hilly Landscape in the Herzog Anton Ulrich-Museum in Braunschweig (Fig. 19c).¹⁰ Rembrandt very deftly transfers the contrast of light and shade found in the coloured painting to the black and white print. Most of the sheet is etched, although parts of the foreground and of the sky are worked over with engraving and with drypoint. This is the earliest of Rembrandt's landscape etchings to be so extensively worked with drypoint. 11 The view of lowland, so reminiscent of the work of Hercules Seghers, has a grainy, painterly surface tone, obtained through the use of sulphur tint; and this enables Rembrandt to bring out the most delicate nuances of light and shade.

The treatment of the cloud-covered parts of the sky developed from an earlier scene, on the same plate, with a Death of the Virgin. If one turns the sheet on its side, traces of an angelic aureola can be detected, resembling that in the Death of the Virgin of 1639 (see Cat. No. 14). Quite cleary, Rembrandt had tried out a first version of this subject and then rejected it. He polished most of the plate smooth, in order to start work on it anew while retaining, in part, his rendering of the clouds. This procedure is also revealed in the occasional small strokes and spots from the earlier scene that remain around the trees. 12 Similarly, the cumulus cloud appearing in the background emerged as a chance product of the previously etched lines. 13 H.B.

- 1. The description of this sheet as a stormy landscape could have arisen because of the way the etching was interpreted by artists: in a reproductive engraving by William Baillie from the end of the eighteenth century, the landscape is supplemented with, among other additions, a flash of lightning, and it appears much more dramatic than it is in the original; see Campbell 1980, pp. 19 ff., Fig. 21.
- 2. B. 219; Washington 1990, pp. 85 ff., No. 7.
- 3. Washington 1990, p. 241, No. 75.
- 4. Lugt 1920, p. 146; Filedt Kok 1972, p. 126; Campbell 1980, pp. 14 ff.
- 5. Rembrandt must have known Claude Lorraine's etchings, which were published since about 1630. Their compositions are often arranged in a similar manner to that found in Rembrandt's etching, with a group of trees on higher ground and a distant view over lower country; pastoral elements are also to be found in the work of Claude Lorraine. See Mannocci 1988, Nos. 8,
- 6. McNeil Kettering 1977.
- 7. B. 220.
- 8. B. 209.
- 9. McNeil Kettering 1977, p. 38. The goat is clearly visible on the counterproof in Boston; Washington 1990, p. 242, note 17.
- 10. Corpus A137; Schneider 1990, p. 175, No. 3.
- 11. White 1969, p. 200.
- 12. Campbell 1980, pp. 10 ff.
- 13. A comprehensive essay on the *Three Trees* has recently appeared, in which the landscape is interpreted, after examination of its geometrical structure and of the figures with symbolic significance, as an expression of the 'Verstandeskultur des 17. Jb.' (seventeenth-century cult of the intellect), a 'jardin d'intelligence' (nursery of intelligence); see Werbke 1989.

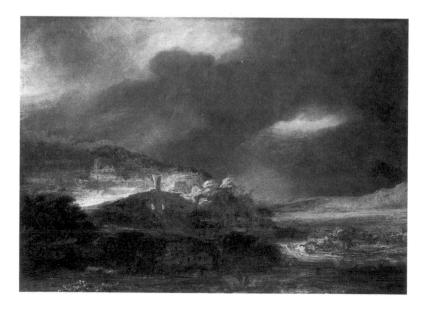

19c: Rembrandt, *Mountain Landscape*. Braunschweig, Herzog Anton Ulrich-Museum.

Six's Bridge

Etching, 129×224 mm; 3 states Signed and dated: *Rembrandt f* 1645 B./Holl. 208; H. 209; White, p. 202.

Berlin: III (301–16) Amsterdam: III (O. B. 268) London: III (1868–8–22–674)*

The sketchy quality of this etching conveys the impression of a drawing made directly from nature on a warm, sunny summer's day. A river crowded with boats flows in a broad curve from the right into the background. A bridge at the point where the river bend appears to continue over a side canal. On the bridge there are two men who seem to be deep in discussion; and beyond one can see the roofs of village houses and the spire of a church. The old title Six's Bridge stems from the inventory drawn up by Valerius Röver in 1731 and from an eighteenth-century inscription—'den Heer Six en Brugh'—on the example in the Rembrandthuis in Amsterdam.¹ Gersaint uses this title in his 1751 catalogue raisonné of Rembrandt's etchings. The traditional identification is not correct, however. The estate of Jan Six was near Hillegom; but the tower in the left background of the etching appears to be that of Ouderkerk on the Amstel, not far from Amsterdam; the view must have been obtained from near to the estate Klein-Kostverloren on the Amstel which, at the time of the etching, belonged to Albert Coenraadsz. Burgh, one of the Burgomasters of Amsterdam.2

Gersaint also relates an anecdote, in which Rembrandt, on a visit to the estate of his friend Jan Six, bet Six that he could draw on a plate the view from the house of his friend, in the time that a servant would take to collect from a neighbouring village the mustard that had been lacking from the table. Rembrandt, who always carried wax-covered plates with him, won the bet.³ Gersaint's apochryphal story is witness to the aesthetic judgment of the eighteenth century, in which the sketchy quality of Rembrandt's etched landscapes, recalling the spontaniety of a drawing, was admired in its own right. Since the Renaissance, the ability to make a sketch in

a few well-placed lines met with the highest admiration from writers on art and from collectors; indeed such a sketch was often judged to be of more value than a carefully prepared, finished drawing, as the former revealed the artist's first thoughts. The appreciation of swift execution is implied in the story.4 Gersaint was thus adopting a traditional topos of artistic theory; in relating his apochryphal tale of the origin of the print, he must have had an older artistic anecdote in mind.5 It is also difficult to believe in Gersaint's claim that Rembrandt always carried with him a sketch block of prepared copper plates, allowing him to draw on the plate while he was in front of his subject. Six's Bridge with several other etchings, was often counted as an example of a landscape etching naer het leven, that is to say drawn directly from nature, because of this supposition.6 The low viewpoint, the exclusion of any middle ground, and the fragmentary record of the sailing boat that is cropped at the right edge certainly do prompt one to think of a direct record of nature. Nonetheless, it is clear that a conscious artistic purpose is at work here, for the composition is devised in a very well-thoughtout manner: through the complementary positioning of the trees and the boat, as well as of the balustrade of the bridge on the left and the figures on the right, the two halves of the sheet have a pleasing balance.

We only know of one drawing made by Rembrandt directly from nature (Fig. 20a)

which serves, with slight changes and additions, as the model for an etching (Fig. 20b) (drawing in the Rijksprentenkabinet, Amsterdam).7 However, there are further landscape drawings which are directly connected with printed sheets, that is to say drawings that record views that have then been etched in a modified form (see Cat. No. 28 & 34).8 From this evidence one can conclude that Rembrandt always carried out his landscape etchings in the studio, but referred, in doing so, to landscape studies drawn naer het leven. Both etching and drypoint require, from the very beginning of the process (whether marking lines in the wax or scratching the plate), so high a measure of control that, purely from the technical viewpoint, it would be most improbable for work on the plate to be carried out en plein air.9 It is possible that Rembrandt consciously selected this 'spontaneous' character recalling a landscape sketch for Six's Bridge, because he was aware how highly such sketches were appreciated by collectors. 10

In state II, only the hat of the man in the foreground is lightly hatched; in state III, also that of the man talking to him.

- 1. Van Gelder/Van Gelder-Schrijver 1938; Filedt Kok
- 2. Lugt 1920, pp. 114 ff.
- 3. The key passage reads: '... & comme Rembrandt avoit toujours des planches toutes prêtes au vernis, il en prit aussi-tôt une, & grava dessus le Paysage qui se voyoit du dedans de la salle où ils étoient: en effet, cette planche fut gravée avant le retour du Valet'. Gersaint 1751, pp. 162–63, No. 200 and p. XXVIII. 4. Held 1963, pp. 88–89.
- 5. Carlo Malvasia (1678) records a similar anecdote: the painter Elisabetta Sirani was said to have been so inspired by the account of a scene of the Baptism of Christ that she reached at once for paper and so swiftly recorded her own *Baptism of Christ* that this was finished before the end of the conversation; Held 1963, p. 88.
 6. Amsterdam 1983, p. 7. Washington 1990, p. 26. Schneider cites as examples for etchings probably made directly from nature: *Six's Bridge*, B. 208; *View of Amsterdam*, B. 210; *Farmhouse with the Draughtsman*,
- Field, B. 234. On B. 234, see also Cat. No. 28.
 7. Benesch C41; Schatborn 1985, pp. 68–69, No. 30.
 8. Washington 1990, pp. 207 ff., Nos. 58–59; pp. 253

B. 219; The Fence in the Wood, B. 222; The Goldweigher's

ff., Nos. 81–84. 9. Emmens 1968, pp. 155 Slatkes 1973, p. 260. 10. Held 1963, pp. 86–87.

20a: Rembrandt, *Cottage with paling*. Drawing. Amsterdam, Rijksprentenkabinet.

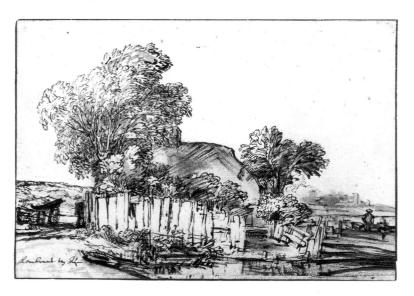

20b: Rembrandt, Cottage with paling. Amsterdam, Rijksprentenkabinet.

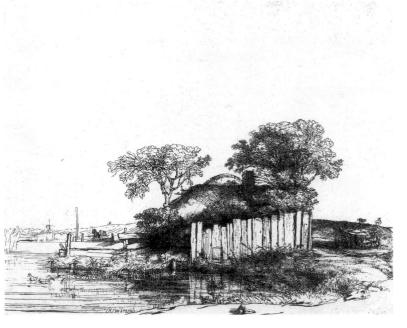

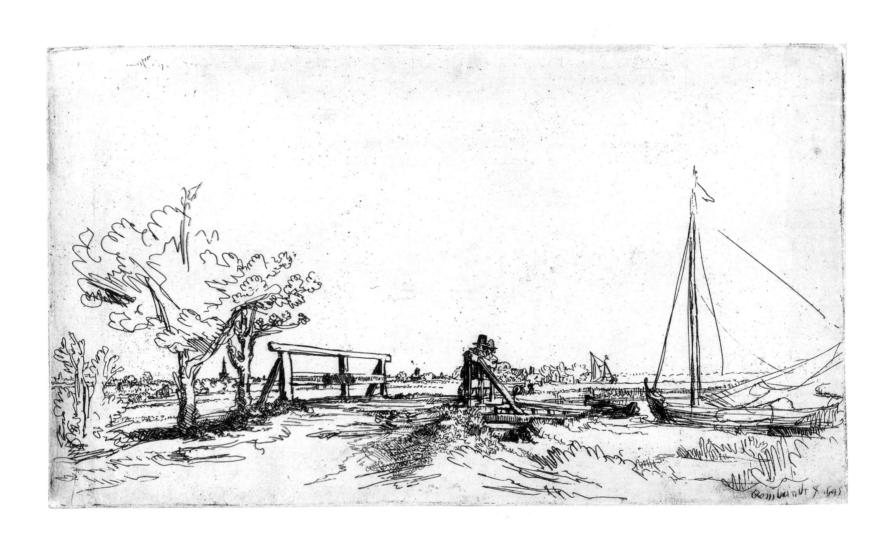

Two male Nudes and a Mother and Child ('Het Rolwagentje')

Etching, 194 × 128 mm; 3 states c. 1646 B./Holl. 194; H. 222; White, pp. 178 ff.

Berlin: I (171–1898) Amsterdam: II (O. B. 251)* London: I (1973 U. 983)

21a: Rembrandt pupil (?), Standing male nude model. Vienna, Graphische Sammlung Albertina.

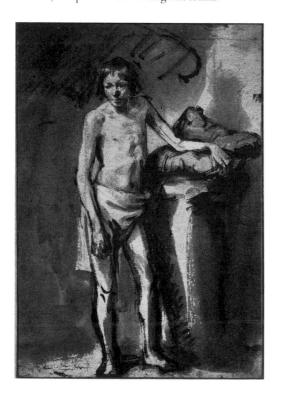

In 1646 Rembrandt made three etchings with male nudes, which were studies from the same model (Fig. 21b). The etchings are identical in style and technique, yet one differs from the others in including a background scene. In the foreground we find two male nudes, one seated, the other standing. Behind, Rembrandt has sketchily indicated the figure of a mother teaching her child to walk with a walking frame.

During his long career, Rembrandt often employed various pupils and assistants, and traditionally, drawing from the model counted as part of the young artist's training. Four drawings by Rembrandt's pupils record the same model as seen in the etchings.2 Three of these drawings show the same standing boy as in the etching with the walking frame. As he is recorded from a slightly different viewpoint in each case, one may conclude that three pupils—or even more—as well as the teacher drew from the model at the same time. The drawing in Vienna is closest to the etched figure (Fig. 21a).3 The reversal occasioned by printing shows that Rembrandt himself drew directly on the prepared copper plate during the studio sitting.4

Rembrandt's etchings with male nudes were probably planned as models for the instruction of his pupils. The French art critic, d'Argenville, reported in 1745 that Rembrandt had produced a small teaching manual: 'Son livre à dessiner est de dix à douze feuilles' (His drawing (instruction) book has ten to twelve pages).5 Not a single example of this has survived, but it is certainly possible that Rembrandt assembled a drawing instruction booklet of this sort from etched illustrations. Among these would have been sheets with nude models and perhaps also studies of heads (see Cat. No. 5).6 The similarity of Rembrandt's models to both the nude figures in surviving drawings by pupils, and to models in contemporary drawing instruction manuals, supports the assumption that these works served as models in Rembrandt's studio. In 't Light der teken en schilder konst (Guide to Drawing and Painting) (1643) by Crispijn de Passe II, we find, for example, a seated male nude (Fig. 21c) in the same pose as that of the seated model in the etching B. 196 (Fig. 21b).⁷

What, though, in this context, is the meaning of the background scene? Is this a sheet of studies in which thematically unconnected scenes are brought together because of their aesthetic appeal? In 1751, Gersaint had already declared that he could find no thematic connection between the motifs: '... y ayant plusieurs choses gravées, qui, quoique finies, n'ont aucun rapport entre

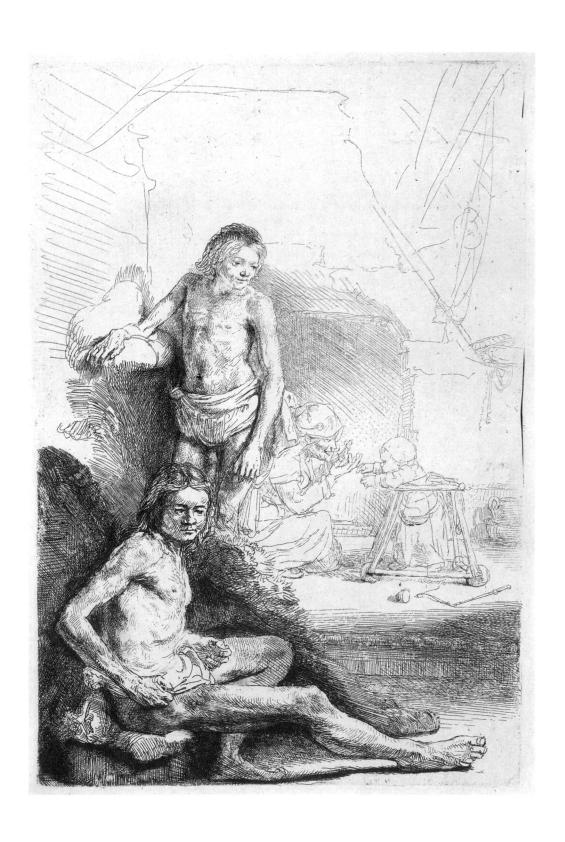

elles' (showing several engraved motifs which, though finished, have no connection with each other).8 On occasion, the child and woman have been interpreted as Rembrandt's son Titus and the child's nurse Geertje Dircks.9 The background scene, however, is not in itself without significance: in an extended sense, it points to the role that the nude model plays in the teaching of drawing.10 The child in its walking frame was used in seventeenth-century literature and emblem books as a symbol of man growing to maturity only through learning and exercise. Franciscus Junius and Joost van den Vondel compared the constant exercise of training artists with a small child's laborious attempts to walk. The sketched scene in the background thus alludes to the role of the model sheets: the young pupil is presented with nude models, who he is to draw, and at the same time he is advised that art is to be mastered only through constant exercise: Nulla dies sine linea-no day should pass without drawing—so went the saying. Rembrandt's etching The Artist drawing from the Model also takes as its subject the significance of study from life and of the art of drawing (see Cat. No. 15). Despite their didactic intent, Rembrandt's works were also desired collectors' pieces.11

The differences between the states are not significant; in state I several white spots of

etching fluid, especially on the figure of the seated model, can be seen; in state II they have been covered over with fine, short hatching lines. State III underwent further small reworkings. A maculature and a counterproof, in both cases of state I, have also survived. H.B.

- 1. B. 193, 194, 196.
- 2. Benesch A 48, A 709, A 55, 710; Amsterdam 1984–85, pp. 4 ff. and pp. 30 ff., Nos. 18 ff.
- 3. Benesch IV, 709; Amsterdam 1984–85, p. 33, No. 21.
- 4. The same goes for the two other etchings with male nudes. The fourth pupil's drawing in this group shows a seated boy similar to the corresponding model in the etching B. 193, here also reversed; Benesch A 48; Amsterdam 1984–85, pp. 30–31, Nos. 18–19.
- 5. Emmens 1968, p. 157.
- 6. Emmens 1968, p. 158; Bruyn 1983, S. 57.
- 7. Emmens 1968, Figs. 36-37; Bolten 1985, pp. 27 ff.
- 8. Gersaint 1751, p. 152, No. 186.
- 9. For example in Münz 1952, Vol. II, p. 80, No. 136.
- 10. On this, see Emmens 1968, pp. 154 ff.
- 11. Amsterdam 1984-85, pp. 6-7.

21b: Rembrandt, Seated male nude model. Berlin, Kupferstichkabinett smpk.

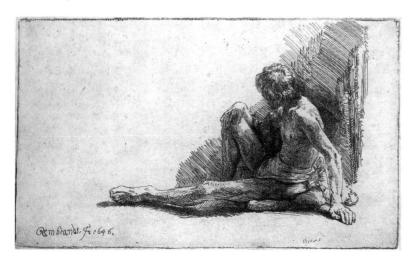

21c: Crispijn de Passe II, Seated male nude model, from 't Light der teken en schilder konst, Plate XXVI.

Portrait of the Preacher Fan Cornelisz. Sylvius

Etching, drypoint, burin and sulphur tint 278 × 188 mm; 2 states Signed and dated: *Rembrandt 1646* B./Holl. 280; H. 225; White pp. 127–28

Berlin: II (372–16) Amsterdam: II (62:107)* London: I (1973 U. 984)

Translations of the Latin inscriptions read: 'My hope is Christ. Johannes Cornelisz. Sylvius, Amsterdamer, filled the function of preaching the holy word for forty-five years and six months. In Friesland, in Tjummarun and Firdgum, four years; in Balk and Haring one year; in Minnertsga four years; in Sloten, Holland, six years, in Amsterdam twenty-eight years and six months. There he died, on 19 November 1638, 74 years of age.'

'Thus is how Sylvius looked—he whose

eloquence taught men to honour Christ / And showed them the true path to heaven. / We all heard him when with these lips / He preached to the burghers of Amsterdam. Those lips also gave guidance to the Frisians. / Piety and religious service were in good hands / As long as their strict guardian looked over them. / An edifying era, worthy of respect on account / Of Sylvius's virtues; he tutored full-grown men In catechism until he himself was old and tired. He loved sincere simplicity and despised false appearance. / He did not attempt to ingratiate himself / To society with outer display. He put it this way: Jesus can better be taught / By living a better life / Than by raising your voice. / Amsterdam, do not let his memory fade; he edified you / Through his righteousness and represents you

'This man's gift I cannot paint any better. / I attempt to emulate him, but in verse I fail.' P. S. [Petrus Scriverius]¹

illustriously to God.'

C. Barlaeus

Jan Cornelis Sylvius (1564–1638), who 'preached the holy word for forty-five years and six months' as a member of the reformed congregation, embarked on his church career with a long series of country posts in Friesland. In Amsterdam from 1610, Sylvius was pastor at the city hospital from 1619 to 1622, before becoming minister at the Oude Kerk. During the course of his 16 years in office, there were many passionate disputes about church policy and administration, in which the remonstrants finally prevailed. The fact that Sylvius was able to retain his place on the church council until his death, despite the quarrels between the Reformed Church and the Remonstrants, may have owed much both to his tolerance and to his liberal attitude in political and religious matters.

In 1595 Sylvius married Saskia's elder cousin, Aaltje van Uylenburgh. In 1634 Sylvius acted as proxy for Saskia, who was then still living in Friesland, at her official betrothal to Rembrandt in Amsterdam. It may have been on the occasion of his engagement to Saskia in 1633 that Rembrandt produced his first portrait of the cleric (Fig. 22a).² This shows Sylvius in his study, in concentrated mood and with his hands laid, one over the other, on the open Bible. Two years later Sylvius and Aaltje were godparents to Rembrandt and Saskia's first child, and in 1638 Sylvius performed the baptism of their second child.

In 1646 Rembrandt etched a second, posthumous portrait, which shows Sylvius within an oval frame surrounded by an inscription and with an obituary added below. Significantly, the inscription does not come from the hand of a scholar who belonged to the Reformed Church. Caspar Barlaeus, whose 14-line Latin poem honours equally the piety, virtue, simplicity and eloquence of the cleric, was a Remonstrant, as was the author of the succinct commemorative poem, Petrus Scriverius.³

Only two of Rembrandt's portraits have added inscriptions, the other being the portrait of Johannes Uytenbogaert of 1635,4 which is presumed to be the first 'official' portrait by Rembrandt who had previously produced etchings of members of his own family. As the early portrait of Sylvius also shows the sitter without an inscription, it would seem that Rembrandt portrayed him there as a relative. It was, however, usual in the seventeenth century for portraits to bear inscriptions; and it would thus seem that the later portrait of Sylvius uses an official formula.⁵ It is possible that, in producing the posthumous etching of 1646, Rembrandt was trying to strengthen his relations with Saskia's family.6 These had

swiftly deteriorated after Saskia's death in 1642, although Rembrandt remained dependent on the Uylenburghs. Although it is also possible that the portrait was commissioned,7 there is no record of such a commission. An attempt to follow the evolution of the posthumous portrait of Jan C. Sylvius is, not least, dependent on the dating of the two preliminary sketches; for it is only from this moment that one can establish Rembrandt's preoccupation with the portrait.8

The first of the two preparatory drawings marks out the basic elements of the composition (Fig. 22b). In the London drawing the figure does not lean out of the frame, but the drawing shows the forward-leaning pose which engages with the viewer, though still lacking the crucial distribution of light and shadow and the dramatic use of the frame-cutting figure (Fig. 22c). In contrast, for example, to the drawing for the portrait etching of Anslo (Cat. No. 16), the London drawing is not finished in the manner of a *modello*, but is rather sparing in its indication of the intended appearance of the portrait.

The ensuing etching strengthened the theatrical effect. Sylvius leans forwards in an illusionistic movement out of the frame, so that a bold shadow is cast by his hand gesturing as if to accompany his words, by his profile and by the book in which he is careful to keep his place. In Dutch painting there are a number of earlier examples of such an illusionistic use of an oval frame; 11 however and in the case of Rembrandt's etching it can be shown that there is a specific model—the engraving made by Jan van der Velde after the portrait of Petrus Scriverius painted by Frans Hals (Fig.

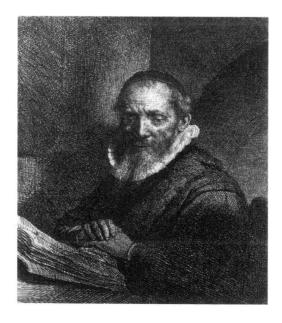

22a: Rembrandt, *Portrait of the Preacher Jan Cornelis Sylvius*. Berlin, Kupferstichkabinett SMPK.

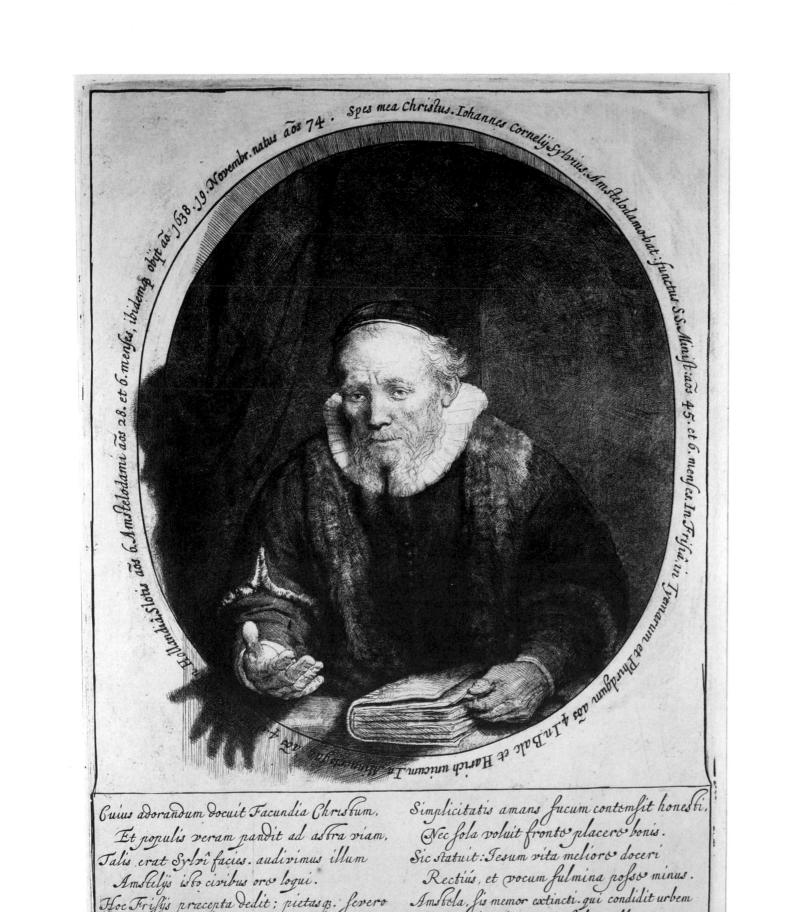

Guius adorandum docuit Facundia Christum, Et populis veram pandit ad astra viam, Talis erat Sylvi facies. audivinus illum Amstelijs is to civibus oro logui. Hoc Frisis pracepta dedit; pietas g. severo Relligiog. Diu vindico tuta Fotit. Praluxit, veneranda fuis virtutibus, atas. Erudytg, infos fofsa fenecta viros.

Simplicitatis amans fucum contemfit honesti,

Nec fola voluit fronto placero bonis.

Sic statuit: Jesum vita melioro doceri

Rectius, et vocum fulmina posso minus.

Amstela, sis memor extincti qui condidit urbem

Moribus, hanc ipso fulsit illo Deo.

C. Barlaus.

Hand amplius deprædico illius dotts,

Quas amulor, frus tragué perseguor versu.

22b: Rembrandt, Study for the Portrait of Jan Cornelis Sylvius. Drawing. Stockholm, Nationalmuseum.

22c: Rembrandt, Study for the Portrait of Jan Cornelis Sylvius. Drawing. London, British Museum.

22d). ¹² As Petrus Scriverius was one of the two authors of the inscriptions in Rembrandt's etching, it would seem that he might have drawn Rembrandt's attention to this portrait. This may explain the most significant of the differences between the London preparatory drawing and the final etching—the use of the figure gesturing out of the frame. At the same time the innovations made by Rembrandt become more evident through comparison with the earlier work by Frans Hals, dated 1626. Rembrandt has transformed the calm gesture recorded by Hals into a most lively one. Sylvius directly addresses the viewer.

Rembrandt has achieved a subtle gradation of grey tones by creating a network of fine lines. The technique employed for the rendering of the face and the texture of the frame is particularly striking. Here Rembrandt uses a special method of etching—sulphur tint. Grains of sulphur, suspended in an oily liquid, are applied to the plate.13 Rembrandt used this technique on several occasions in the 1640s,14 and it is possible that he may also have done so even earlier.15 The richly rendered grey tones, achieving the effect of a soft wash, were greatly praised in the early eighteenth century as a precursor of the mezzotint process which was then just coming in to fashion. Houbraken, for example, drew particular attention to the

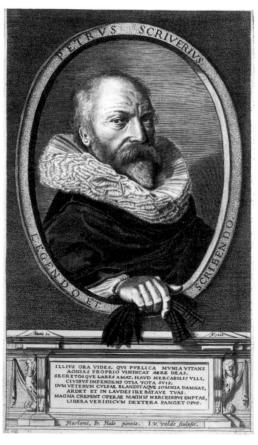

delicate and brilliant softness of the shading achieved through this technique. ¹⁶ B.W.

- 1. English translation cited from the English edition of Schwartz (1985), p. 185.
- 2. B. 266.
- 3. On the two scholars, see Schwartz 1987 and also Kauffmann 1920.
- 4. B. 279.
- 5. Amsterdam 1986/87, pp. 15 ff.
- 6. Amsterdam, 1986/87, p. 23.
- 7. Schwartz 1987, p. 135, for example, supports this view, arguing that the etching was possibly made on the occasion of the marriage of Wendela de Graeff and Willem Schrijvers (Scriverius).
- 8. The evolution of the first sketch (Benesch 762a) has repeatedly been fixed in the period 1639–40 (Welcker 1954, Boon 1956; see White 1969, p. 127). If this dating is correct, art-historical research would no longer have to explain the late and very markedly posthumous award of the commission of the Sylvius etching but, rather, the fact that Rembrandt allowed more than five years to elapse between the sketch and the completion of the etching.
- 9. Benesch 762a; Stockholm, Nationalmuseum.
- 10. Benesch 763; London, British Museum.
- 11. For example, the portrait of the musician Jan Pietersz. Sweelinck, ascribed to Gerrit Pietersz. Sweelinck (1566–1616) now in the Gemeente Museum in The Hague; see Slatkes 1973.
- 12. The painting by Frans Hals is now in The Metropolitan Museum, New York; see also Washington 1989, No. 20.
- 13. For discussion on this technique, see White, and Boston 1980/81, No. 97. I regard as correct the unequivocal assessment of the technique of this last item as an etching procedure, a conclusion also supported by examination with a microscope.
- 14. See the Landscape with the three trees (Cat. No. 19). 15. For example, The Angel appearing to the Shepherds (Cat. No. 9).
- 16. Houbraken 1718, p. 271.

22d: Jan van der Velde, after Frans Hals, *Petrus Scriverius*. Amsterdam, Rijksprentenkabinet.

23 Jan Six

Etching, drypoint and burin, 244×191 mm; 4 states Signed and dated: (from II) *Rembrandt f.* 1647 B./Holl. 285; H. 228; White pp. 130–32

Berlin: III (369–16) Amsterdam: I on Japanese Paper (O.B. 578)* London: III (1973 U. 986)

A notary's certificate of 1655 remarks of an apparently unexecuted portrait etching to be made for Otto van Kattenburch that it was to equal in quality the portrait etching of Jan Six. The proud sum of 400 gilders is cited as the estimated price: '. . . en conterfeytsel van Otto van Kattenburch, twelck de voorsz. van Rijn sal naer 't leven etsen, van deucht als het conterfeytsel van d'Heer Jan Six, ter somme van f 400, 0'.1

It seems that the portrait etching of Jan Six was commissioned by the sitter. Jan Six (1618–1700) came from a noble Huguenot family which had fled at the end of the sixteenth century from Saint Omer in France to Amsterdam, being active there in both the textile trade and silk dying. Until about 1652 Jan Six had carried on the family business, in 1656 he became a lawyer specialising in marital disputes. In 1691 he was made a burgomaster of Amsterdam.

Six devoted a considerable part of his time to the arts, in particular poetry. He was a member of the so-called 'Muiden Circle' that gathered around the successful man of letters, Pieter Cornelisz. Hooft (1581–1647), and which had, at times, also invited the poet Joost van den Vondel to its meetings.² Like Rembrandt, Jan Six was a passionate collector of works of art (Dutch and Italian Masters, antique sculpture, engraved gems etc.). In about 1640 Six, like Hooft, had travelled to Italy. Although his taste tended rather towards the classical artistic ideal, Six is known to have purchased paintings by Rembrandt, for example *John the Baptist preaching* (Paintings Cat. No. 20).³

A series of drawings and etchings in particular allow one to assume that Rembrandt and Jan Six enjoyed a friendly relationship that, at times, went beyond a mere business connection. Documentation such as letters has not survived. A year after the 1647 portrait etching of Jan Six, Rembrandt created the title page for Six's tragedy Medea.4 Two drawings for Six's Pandora, an album amicorum of the sort then in use in Humanist circles, and dated 1652. A variety of symbola amicitiae, dedications, poems, emblems and, in particular, portraits of celebrated authors and artists, served to embody the idealised presence of friends as well as the memory and the strengthening of friendship. For Six, the devotee of Italian art, Rembrandt produced two drawings with classical themes: Homer reciting verses, which bears the dedication 'Rembrandt aen Joanus Six' (From Rembrandt to Johannes Six),5 and Minerva in her Study (Drawings Cat. No. 31 A & B).6 In 1654, Six married Margaretha Tulp, daughter of the anatomist and burgomaster Nicolaes Tulp, one of Rembrandt's first patrons in Amsterdam. It was probably in the same year that Rembrandt painted the portrait of Jan Six that is still in the collection of the Six family.7

The work process of the portrait etching dated 1647 is documented in three drawings. The earliest of these (see Drawings Cat. No. 23, here Fig. 23a)⁸ shows the sitter looking relaxed and suave. Leaning on the window ledge, he looks at the viewer, a dog jumping up to his knee. It appears, however, that this arrangement failed in the end to meet with the sitter's approval. In a small, sketchy study, the pose of the figure is altered,⁹ and it is then elaborated in a thoroughly composed preparatory drawing (Fig. 23b).¹⁰ This last drawing has been traced on to the copper-plate, indicating that it served as an direct *modello*.

In his portrait etching, Rembrandt managed not only to acknowledge the social status of Jan Six, but also to present him as a cultivated man of letters and an art collector. This becomes especially clear in comparison with earlier portraits, for example the engraving of Scriverius after the portrait by Frans Hals (Fig. 22d). There the pose of the sitter reveals none of the virtues praised in the inscription: 'This is the portrait of a man who shunned office, / protected the Muses with his own money / and who loved the seclusion of his house . . .'.11 Pose and text complement each other. In Rembrandt's portrait of Jan Six, on the other hand, praise of the scholar and a record of his social position are incorporated into the visual presentation. This etching does not require an added explanatory inscription.

At the window, framed by a heavy curtain—a traditional motif associated with worthiness in formal portraits—and thus standing in the light, Jan Six leans, reading a book. The unmarked paper surface used for the

window is skilfully integrated into the composition and leads the viewer's attention to the face of the sitter. It is possible that the elegance of the pose points to the ideal of the educated courtier that had found its literary formulation in the *Libro del Cortegiano* of Baldassare Castiglione. 12 Books and manuscripts on the chair in the foreground as well as the painting on the wall—provided with a curtain as was usual in the seventeenth century—acknowledge the sitter's erudition and connoisseurship. The sophisticated iconography allows one to assume an intensive dialogue between the artist and his patron.

Although the first state of the etching (only known in two examples in Amsterdam and Paris) is not signed and is apparently a trial proof, it shows the completed composition, apart from later corrections of detail. The work is striking for the richness of its technical execution. With the use of a fine network of hatching, worked up with the burin and, in certain places, with drypoint, Rembrandt achieves subtle gradations of the velvety black and grey tones. This artful execution stresses the high standard to which Rembrandt was working—as if in competition with a painted portrait—apparently as requested by Jan Six. Thus, as Röver wrote in 1731, he possessed impressions of burgomaster 'den ouden burgemester Jan Six, een van de allerraarste van alle de printen van Rembrandt, omdat de familie deze plaat en affdrukken altijt onder zig heeft gehouden en de printen overal a tout prix opgekogt'13 (the old Jan Six, [which was] one of the rarest of Rembrandt's prints because the family [of Six] still owned the plate and sold

the prints everywhere at the full price) (Fig. 23c).
B.W.

- 1. Urkunden 163. The appreciation of this etching is already documented within Rembrandt's lifetime in the form of a panegyric by Lascaille (Urkunden 223).
- 2. See R. P. Meijer 1971, pp. 104 ff.
- 3. Corpus A106.
- 4. B. 112.
- 5. Benesch 913.
- 6. Benesch 914.
- 7. Bredius 276.
- 8. Benesch 767, Amsterdam, Six collection.
- 9. Benesch 749 verso, Amsterdam Historisch Museum.
- 10. Benesch 768, Amsterdam, Six collection.
- 11. English translation cited from English edition of Schwartz (1985), p. 25.
- 12. On this, see Smith 1988.
- 13. Van Gelder/Van Gelder Schrijver 1938, p. 4. The plate is still in the possession of the Six family (Six 1969, p. 69).

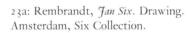

23b: Rembrandt, Jan Six. Drawing. Amsterdam, Six Collection.

23c: The etching plate for the Portrait of Jan Six. Amsterdam, Six Collection.

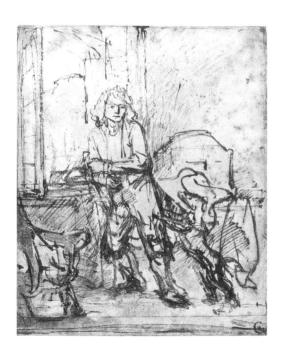

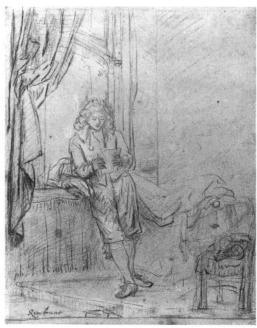

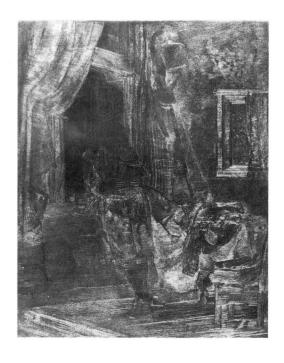

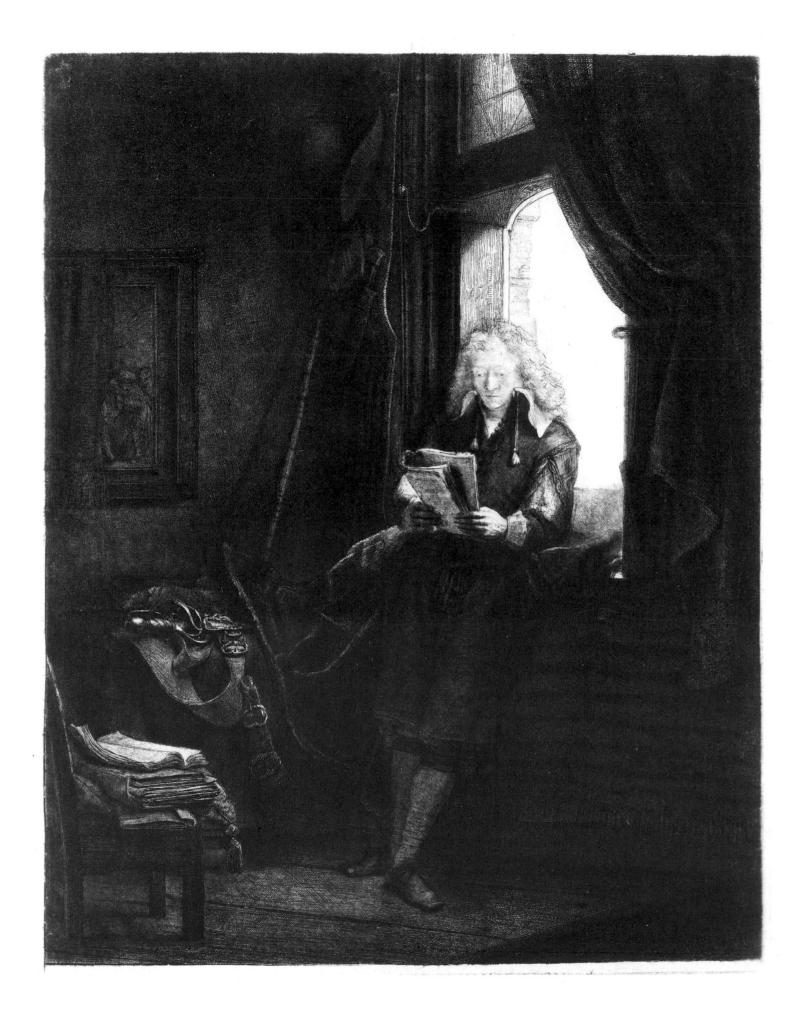

Saint Jerome beside a pollard willow

Etching and drypoint, 180 × 133 mm; 2 states Signed and dated: (only in II) *Rembrandt. f.* 1648. B./Holl. 103; H. 232; White, pp. 206 ff.

Berlin: I (155–16) Amsterdam: I (O. B. 168)* London: I (1973 U. 996)

24a: Rembrandt (?), *The pollard willow*. Drawing. Turin, Biblioteca Reale.

Rembrandt, who was a Protestant, treated a great many biblical subjects; yet scenes with saints worshipped by the Catholic church are rarely found in his work. Only the figure of Saint Jerome, who appears in a number of Rembrandt's etchings, preoccupied the artist over many years (see Cat. No. 31).1 Rembrandt would have been fascinated by the combination of the ascetic and the scholarly in the life of this saint and Church Father. On account of his self-denving way of life—for several years he retreated to the wilderness to live as a hermit—and his translations and expositions of the Bible, he had become an honoured model for scholars and Humanists both north and south of the Alps during the Renaissance. As one of his attributes, Jerome is accompanied in pictorial representations by a lion, out of whose paw, according to legend, he had pulled a thorn.

Rembrandt shows the saint cut off from the world in a peaceful, sunny landscape. Jerome sits, absorbed in his writing, next to the gnarled stump of a willow at the water's edge, more a philosopher and learned author than a hermit doing penance. In front of him lie a skull and a crucifix—alluding to the expectation of Salvation in the life to come and to the saint's piety—and next to him lies his cardinal's hat. The lion looks out from behind the tree trunk. In the background, indicated with only a few strokes, a hilly landscape rises up with a waterfall cascading down it.

The plate was worked in two clearly separate stages. The central motif, the willow stump and a few sprays of grass and reeds, were etched first; and the remaining elements of the picture—the saint with his desk, the lion and the large, lower branch of the willow—were added with drypoint in the second working. In addition, drypoint reworkings are to be found on the base of the trunk and on the reed in the foreground. It thus seems as if the study of a dormant willow was the starting point for the scene, and one might speculate that the figure of the saint was only added as an afterthought, perhaps because Rembrandt regarded the subject of a single tree as too trivial for an etching intended for sale. This thesis is supported by the fact that a drawing in the Biblioteca Reale in Turin records a very similar willow stump, significantly in reverse (Fig. 24a).2 The attribution of the drawing, however (which scholars have usually regarded as a study for the tree in the etching) is no longer secure; and the fact that comparable willow stumps are also to be found in the Omval (1645) and Saint Francis (1657) etchings³ indicates that the tree found in the Saint Jerome is not necessarily to

be seen as a study from nature.

There is also iconographic evidence that the scene was conceived from the start as a unified whole. The ancient tree stump with new shoots of greenery, accompanied by a crucifix, was a traditional motif in scenes with Saint Jerome, where it symbolised the renewal of life.⁴ Rembrandt apparently first intended to show the crucifix attached to the tree trunk, but then decided to show it lying on the desk behind the skull; for somewhat below the short branch that could have served to show the bar of the cross, traces of a re-working of the plate can be seen. Rembrandt's *Jerome* is, however, closer to iconographic tradition than is often assumed.

As in the later Jerome scene of 1654 (see Cat. No. 31), here too Rembrandt was re-working Venetian models. An engraving by Marcantonio Raimondi after Titian, or a reversed reproductive engraving by Agostino Veneziano after that, may have served as his inspiration. In these the saint is shown seated in a similar manner at a desk fastened to a tree trunk.⁵

State I has the strongest drypoint passages, especially in the foliage of the projecting branch and in the reeds in the foreground. In state II, printed with less drypoint burr, the foreground is somewhat altered, and the signature and date are added; as well as this, both the lion's head and several reed stems are modelled with delicate short strokes.

н.в.

- 1. B. 100-6.
- 2. Benesch 852 a; White 1969, Vol. I, p. 206; Vol. II, Fig. 313; Washington 1990, pp. 164 ff., No. 41, note 1. 3. B. 209, 107.
- 4. Kuretsky 1974; Wiebel 1988, p. 112.
- 5. Marcantonio Raimondi: B. 102; Agostino Veneziano: B. 103. See also Washington 1973, pp. 396–97, Fig. 19–6. Dürer's dry-point print B. 59 is often cited, though in my view without any real justification, as a model for Rembrandt's *Jerome*; see, for example, Washington 1990, pp. 164 ff., No. 41.

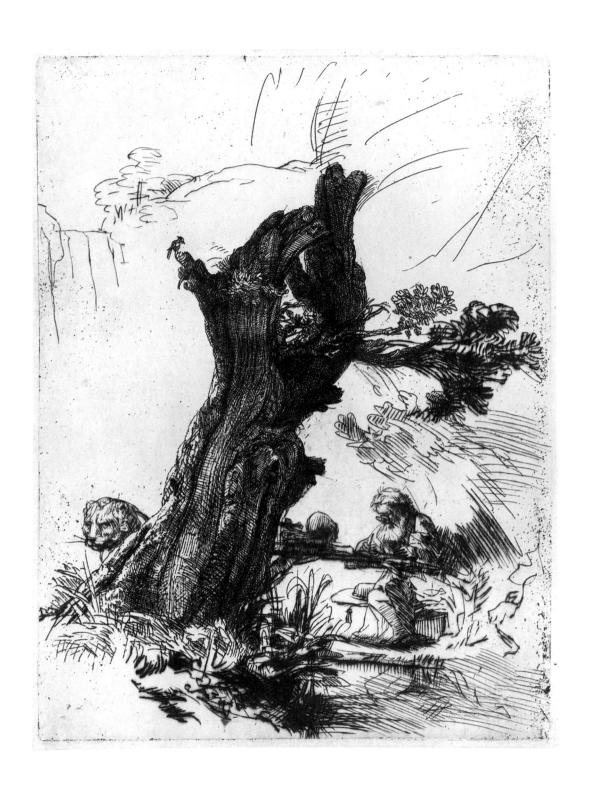

25 Self-portrait drawing at a Window

Etching, drypoint and burin, 160×130 mm; 5 states, the last 2 probably not by Rembrandt Signed and dated: (from II) *Rembrandt*. f 1648 B./Holl. 22; H. 229; White pp. 132–34

Berlin: I (305–1898)*; II (2–16)* Amsterdam: I on Chinese paper (O.B. 39); II (62:9)

London: I (1855-4-14-260);

II (1910-2-12-357)

After his ambitious self-portrait of 1639 (Cat. No. 13), it was not until 1648 that Rembrandt made another etched self-portrait. Particularly in comparison with the earlier work, this representation of the self seems to have an unpretentious air. Nonetheless the half-length portrait with the view through a window to one side reflects a traditional portrait type that, in varying forms had been used increasingly by artists since the fifteenth century.

Rembrandt looks at the viewer with unswerving directness. He shows himself working. The copper plate—or, possibly, as a reference to the superiority of disegno in art theory—the drawing sheet on which Rembrandt is at this moment working, rests on a thick book.1 While, in his self-portrait of 1636 (Fig. 25a)² the artist is indeed similarly depicted engaged in drawing—though there, he is shown in a double-portrait with his wife Saskia—in the present etching he is not dressed to emphasise his social rank. On the contrary, he wears a simple hat and a plain smock. This outfit is also seen in a drawing from a few years later (about 1655/60), one of Rembrandt's few full-length self-portraits (Fig. 25b).3 A Dutch inscription, probably not from before the eighteenth century, is added to this sheet: 'Getekent door Rembrandt van Rijn naar sijn selves, sooals hij in sijn schilderkamer gekleet was' (Rembrandt van Rijn, drawn by himself, as he was usually dressed when in his studio).4

In the etched self-portrait, it is not only

25a: Rembrandt, *Self-portrait with Saskia*. Berlin, Kupferstichkabinett SMPK.

25b: Rembrandt, *Self-portrait*. Drawing. Amsterdam, Museum het Rembrandthuis.

25 State I

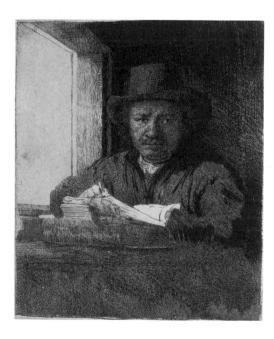

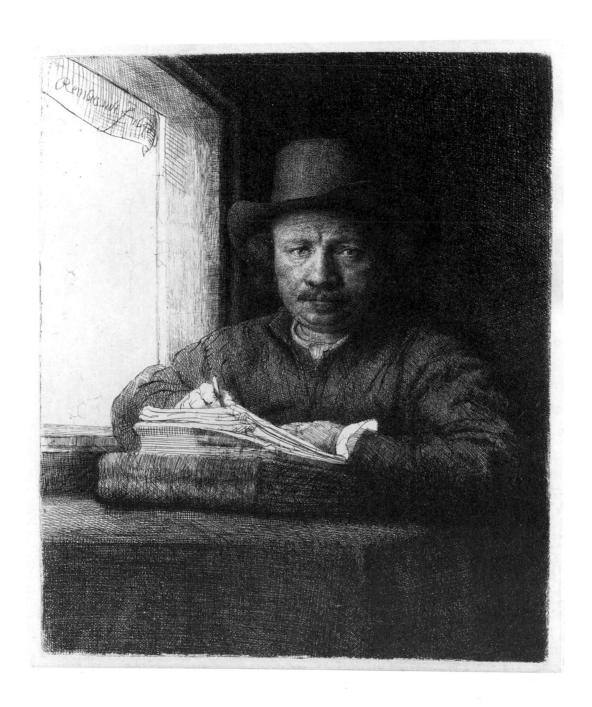

composition and lighting that focus attention on Rembrandt's face. The detailed and sensitive record of physiognomy provokes greater interest in contrast to the more summary treatment of both the torso and the setting. The light, entering from the left through the window, is closely studied in its effects. Trial proofs of the unfinished plate (state I) give an insight into Rembrandt's working method. To begin with, the composition as a whole is bitten, with the distribution of light and shadow. The evidence of some burnishing-out of the worked plate, for example below the artist's right hand, indicates that corrections have been made. While the face is already modelled in detail at this stage, the other forms are at first recorded only as simple shapes. Rembrandt has included the deepest blacks with heavy drypoint strokes. Not until the second state does Rembrandt fully establish the gradual changes within the passages of shadow, using further bitten crosshatching and lines applied with the burin and with drypoint. Rembrandt signed this version and only made some final, minor corrections in state III. Only three states of the etching come from Rembrandt's hand; and the decorative provision of the landscape in the view from the window in the two other known states is probably a later addition.

Keen attempts have been made to find traces of biographical information in Rembrandt's facial expression in this portrait. It has been claimed that after his luxurious and selfconscious way of life in the 1630s, Rembrandt was deeply marked by Saskia's death but gradually found a new inner calm. Such interpretations will always depend on personal associations. We should also probably see in this portrait a comment on the artist's own position. Rembrandt has here defined his selfrepresentation in direct reference to his activity as a draughtsman. This form of artist's selfportrait is taken up once again in an etching dated 1658 and now generally accepted by Rembrandt's hand (Fig. 25c). 5 Obviously, even in Rembrandt's late work, with its quite distinct style, the self-presentation of the artist as a draughtsman, as invented in the 1648 etching, was still found to be appropriate. B.W.

1. On the discussion of this matter, see most recently Chapman 1990, p. 82, with bibliography.

2. B. 19.

3. Rembrandthuis, Amsterdam, Benesch 1171.

4. A French inscription on the mounting makes the same claim; Filedt Kok 1972, No. 1.

5. Holl. S 279. Only two impressions of this etching are known (Vienna, Albertina and Paris, Dutuit collection).

25c: Rembrandt, *Self-portrait*. Drawing. Vienna, Graphische Sammlung Albertina.

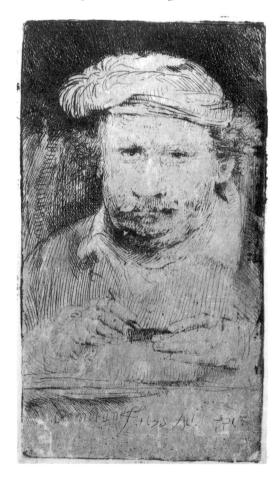

26a: Jan Steen, *The Burger of Delft and his daughter*. Penrhyn Castle, Lady Janet Douglas-Pennant.

The Hurdy-Gurdy Player and his Family receiving Alms

Etching, slightly worked over the burin and drypoint, 165 × 128 mm; 3 states Signed and dated: *Rembrandt. f. 1648*. B./Holl. 176; H. 233; White, pp. 167 ff.

Berlin: I (13–1892)* Amsterdam: I (62:65) London: I (1868–8–22–673)

In both drawings and prints from the 1640s, Rembrandt took up again the beggar subjects that had so fascinated him as a young artist in about 1630, during his Leiden period (see Cat. No. 3).1 The etching of 1648 shows a young woman with a walking stick and a basket, carrying a baby in a sling on her back. She reaches out her hand to take alms from an elderly man who appears at the open door of a house. Next to the woman, and viewed from the back, is a boy in a broad-brimmed hat, and beyond the woman stands an old man. While the domestic realm of the alms-giver, even the gutter in front of his house, is shown in detail, the area associated with the pedlar family is left vague.

The etching has been given the rather inaccurate title Beggars at the Door of a House since Gersaint's reference to it (1751).2 From the point of view of iconography, the scene belongs to another tradition, that of the wandering hurdy-gurdy player.³ The shoulder and hat of the boy mask a hurdy-gurdy. This, and the bagpipes, were the musical instruments traditionally associated with pedlars. The hurdy-gurdy was played above all by the blind; and in the etching the curiously blank stare of the old man must be intended to show him to be blind. The subject of the blind hurdy-gurdy player whose wife collects alms goes back to the sixteenth century and was probably popularised at the start of the seventeenth century by David Vinckboons in Amsterdam.4 Rembrandt himself had treated this subject before, in two etchings of about 1634-35 and of 1645.5

Rembrandt's scene of 1648 is distinct from his beggar scenes of about 1630 (see Cat. No. 3) not only stylistically but also in terms of content.⁶ Constantin Huygens, in his *Zede-printen* (Descriptions of Customs) made fun of

lazy beggars who used the raucous din of the bagpipes and the hurdy-gurdy as a way of forcing people to give them money.7 The title page of Jan Joris van Vliet's beggar series of 1632 takes as its subject the giving out of alms, and in its title at least-By 't geeve bestaet ons leeve (Our life depends on [your] gift)—seems to suggest criticism of charity for lazy beggars.8 In Rembrandt's etching, however, the young woman and the old man are not presented as caricatures; indeed, they almost appear respectable. They certainly wear poor people's clothes, but not the rags and tatters of beggars, such as one finds in the earlier scenes. Clearly, these are not inveterate wandering pedlars, but rather the needy who have fallen into poverty through no fault of their own. Rembrandt treats them objectively, and without any satirical implications: he presents the act of charity as it is advocated in the Bible (Matthew 25: 31-46).

In the Zedekunst (Art of Customs), published several times during the sixteenth century, the Haarlem Humanist and writer Dirck Volkertsz. Coornhert had emphasised the difference between poverty encountered through a man's own guilt and with the aim of cheating others, and poverty honestly come by.9 Charity played an important part in public life in Holland. But only needy town dwellers profited from it, and not the rootless pedlars scattered throughout the countryside. 10 Rembrandt appears to show a rich citizen's private act of charity towards a poor fellow citizen. Through this sociable act, the giver and the receiver of alms are linked in the context of social convention, although they remain clearly separated by the doorstep of the

The subject of street vendors and musicians, shown standing in the street at the edge of the domestic sphere of the citizen, is often seen in Dutch painting in the mid-seventeenth century. Rembrandt's etching itself had some influence on the treatment of this subject. Jan Steen's painting of 1655, for example, shows a rich man with his daughter on the outer step of a house, in front of which a poor woman is asking for alms; the woman's pose and gestures are taken from Rembrandt's scene (Fig. 26a).¹¹

From the point of view of both style and content, a chalk drawing of about 1647–48 in the Amsterdam Historisch Museum (Fodor collection), also showing a needy family, is closely connected to Rembrandt's etching (Fig. 26b). The people here, however, are differently arranged to those in the etching; the blind man, who stands on the left, carries a hurdygurdy. The family turns the right, seemingly towards someone giving alms, who would be needed to complete the scene. This might be

an initial preparatory study for the etching. 12

The differences between the states are only slight; they principally concern the shading on the door arch above the head of the alms giver. H.B.

- 1. See, among others, Benesch 721 and 750-51.
- 2. Gersaint 1751, p. 141, No. 170.
- 3. On this, see the study by Hellerstedt 1981.
- 4. Hellerstedt 1981, pp. 17 ff. Various versions of the subject by Vinckboons show the old hurdy-gurdy player surrounded by village children, while his wife begs for alms at the door of a house.
- 5. B. 119, 128.
- 6. Stratton 1986; Lawrence, Kansas; New Haven and Austin 1983/84, pp. 81 ff., No. 16.
- 7. Huygens 1623-24, p. 212.
- 8. B. 73.
- 9. Stratton 1986, p. 79; Braunschweig 1978, pp. 133 ff., Nos. 28–29.
- 10. Schama 1987, pp. 570 ff.
- 11. Schama 1987, pp. 573 ff., Smith 1988, pp. 54 ff., Fig. 57.
- 12. Benesch 749 r; Broos 1981, p. 55 ff., No. 13. On the verso of the sheet there is a sketch showing Jan Six reading (see Cat. No. 23).

26b: Rembrandt, *The Hurdy-Gurdy Player and his Family*. Drawing. Amsterdam, Historisch Museum.

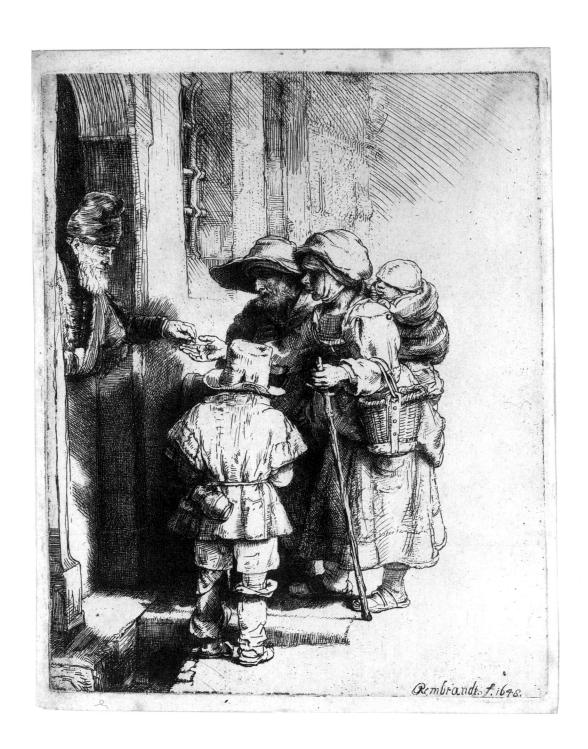

'The Hundred Guilder Print'

Etching, drypoint and burin, 278×388 mm; 2 states Unsigned and undated; c. 1647/49B./Holl. 74; H. 236; White pp. 55-65

Berlin: II on Japanese paper (302–1898) Amsterdam: I on Japanese paper (O.B. 601)* London: I on Japanese paper (1973 U. 1022)

Inscriptions on the reverse of the example in Amsterdam:
(in brown ink)
'Vereering van mijn speciale vriend Rembrandt

(also in brown ink but in another hand) 'ici-dessous est decrit en pierre noire vereering van mijn speciaele

tegens de Pest van m. Anthony'1

vriend Rembrand, tegens de pest van M. Antony.

Rembrand amoureux d'une estampe de M. A. savoir la peste, que son ami J. Pz. Zoomer, avoirt de fort belle impression, & ne pouvant l'engager a lui vendre, lui fit present, pour l'avoir, de cette estampe-ci, plusrare & plus curieux encore que l'estampe que l'on . . . oine de Hondert Guldens Print, par les addition dans clair obscur qu'il y a dans celle-ci, dont il n'y a eu, suivant le raport qui m'en a ete fait, que tres peu d'impressions, dont aucune n'a jamais été vendue dutemps de Rembrand, mais distribuées entre ses amis.'

Gersaint, the author of the first printed catalogue raisonné of Rembrant's etchings (1751), praised the Hundred Guilder Print as the best etching from the master's hand. He drew particular attention to the variety in Rembrandt's record of human expression, which was shown 'avec tout l'esprit imaginable'.2 Houbraken too celebrated the work as supreme, but as a result of his own artistic ideals and of his view of Rembrandt, he regarded it as unfinished. 'This is particularly clear in the so-called Hundred Guilder Print, at the treatment of which we can only wonder, because we cannot understand how he [Rembrandt] could have worked this up from what was originally nothing but a rough sketch . . . '3

The title *Hundred Guilder Print* is not given by Rembrandt himself.⁴ Already used in the eighteenth century, it provoked a number of fanciful explanations. Gersaint, for example, reports—probably following the inscription on the Amsterdam example—that the artist had been able to give this etching to a Roman art dealer in exchange for several engravings by Marcantonio Raimondi which, together, were valued at a hundred guilders.⁵

The original significance of the work was obscured by the title *Hundred Guilder Print* until the end of the nineteenth century when its meaning was reconstructed.⁶ The subject is not a single episode ('suffer the children come unto me' or 'the healing of the sick'), but rather the whole of the nineteenth chapter of the Saint Matthew's Gospel.⁷ This interpretation was supported by the later discovery of a poem by H. F. Waterloos (a contemporary of Rembrandt), inscribed on an impression in Paris:

'Aldus maalt Rembrants naaldt den zoone Godts na 't leeven;

en stelt hem midden in een drom van zieke liên:

Op dat de Werelt zouw na zestien Eeuwen zien,

De wond'ren die hij an haar allen heeft bedreeven.

Hier hellept Jezus handt den zieken. En de kind'ren

(Dat's Godtheyt!) zaalicht hij: En strafftze die'r verhind'ren

Maar (ach!) den Jong'ling treurt. De schriftgeleerden smaalen

't Gelooff der heiligen, en Christi godtheits straalen.'

(And so Rembrandt drew from life, with his etching tool,

The Son of God in a world of sorrow, Showing how, sixteen centuries ago, He gave the sign of His miracles. Here Jesus' hand helps the sick. And to the children

(Mark of Divinity!) He gives His blessing, and punishes those that hinder them.

Yet (oh!) the young man wails. And the scribes sneer

At the faith in Holiness that crowns Christ's Divinity).

Rembrandt stresses the varied nature of the miracles performed by Christ, in amalgamating different episodes from the account in the Bible. The viewer is introduced to the crowded scene through the diagonal arrangement of the composition and, above all, through the use of lighting. The darkness that appears to deepen behind the figure of Christ evokes the suggestion of a monumental, arched structure. Christ's nobility, however, is enacted as the Redeemer shines forth against the depths of this darkness.

The Hundred Guilder Print is striking for the variety of printing techniques Rembrandt uses. Its large scale is apparently matched by its ambition to compete with painting; and the graphic range of etching is united with its painterly scope in an unusually broad spectrum. In this respect, the work cannot be compared directly with any single work from Rembrandt's printed œuvre. Related examples among the etchings of the period around 1640 may be found for the figures on the left treated in cursory outlines.9 The participants on the right, however, are characteristic of work from no earlier than the second half of the 1640s in their shading, which is elaborately modelled with short, delicate lines. 10 For this reason, there is unanimity regarding a date of 1647/49 for the completion of the print. There has, however, been disagreement as to when Rembrandt started work on the plate. Was the Hundred Guilder Print produced in its totality in about 1647/49, incorporating earlier stylistic means, or should one, rather, posit an interruption in the work, and date Rembrandt's first version to the late 1630s?¹¹

Those arguing for an early dating have eagerly pointed to Rembrandt's dated oil sketch of 1634 for John the Baptist preaching. 12 At first glance, the similarity of the compositional arrangement seems convincing—the view is led diagonally into the picture and the protagonists are arranged diagonally to the picture plane. However, the compositional principle of the London painting of 1644, Christ and the Woman taken in Adultery, 13 is on the whole nearer to that of the Hundred Guilder

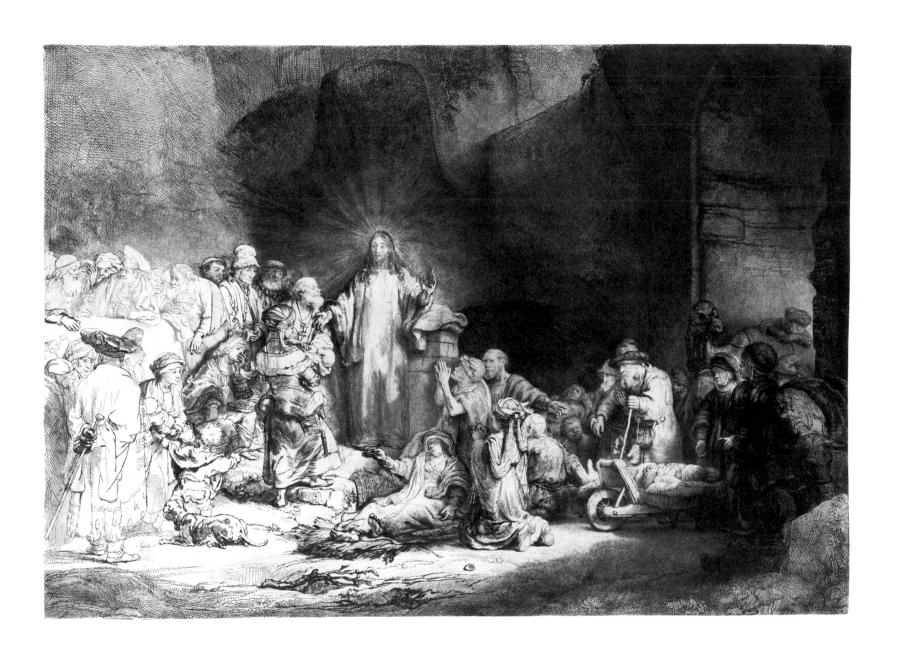

Print. Here one finds the arrangement of figures as if in 'relief', and the careful control of both the view and the lighting across the figures seen from the back to the meeting of Christ and the woman kneeling in front of him.

The surviving states of the etching give no insight into the process of its development. The alterations in state II are concerned only with minor details. The less resolved passages are more insistently enclosed through finer incised hatching strokes (the back of the donkey's neck, the area of the right background behind Christ's head). Nevertheless, the various traces of alterations, clearly reveal Rembrandt's intensive work on the plate.14 Christ's face and the position of his arms are re-worked; and even his right foot was originally placed somewhat higher. The woman with a child in her arms was initially posed stepping forward more vigorously. None of these visible traces of the working process points to an alteration of the composition as a whole or to a full re-arrangement of any individual figure.

Various preparatory drawings were made for the figures that are crucial in the arrangement of the composition and in guiding the viewer's attention. The sick woman on the bier¹⁵ held particular interest for Rembrandt (Fig. 27a), and he worked out this whole group in a sheet now in Berlin (Fig. 27b).¹⁶ In further surviving studies one can see the blind man,¹⁷ the man with an outstretched arm,¹⁸ and the woman with a child in her arms who stands in front of Christ.¹⁹ These drawings and the etching must be assessed in relation to each other. The drawings have, accordingly, been dated from the late 1630s to, more recently, about 1647.²⁰

The basic compositional arrangement of the etching is not affected by any of these figure-studies.

The repeatedly stated assumption that one of Rembrandt's painted study heads for Christ is a preparatory work for the face of Christ in the Hundred Guilder Print can now be dismissed.21 It would be most unusual for Rembrandt to make an oil sketch in preparation for a single figure in a multi-figure etching. The surviving heads of Christ are, moreover, now all given a later date (about 1655/56), and to a large extent no longer ascribed to Rembrandt.22 In the Hundred Guilder Print, on the contrary, Rembrandt used the type of Christ that is characteristic of his work in the 1640s²³— the type described by contemporaries, such as Waterloos in his poem, as 'een Christus tronie nae't leven' (a face of Christ from life)'.24

In summary, we can say that neither the visible traces of alterations made on the plate nor the surviving drawings lead to the conclusion that Rembrandt fully re-worked in about 1647/49 a version of the *Hundred Guilder Print* he had made in the 1630s. Nonetheless, neither are the variations within the finished work satisfactorily explained by the theory that Rembrandt used a new style to complete the unfinished parts of a plate he had long abandoned.

One of the strands of tradition to which research has as yet paid too little attention constantly describes the *Hundred Guilder Print* as extraordinarily rare. In the inventory drawn up by de Burgy, for example, it is called 'extraordinairement rare'; Gersaint too calls it 'very rare'; and, finally, the Amsterdam

27a: Rembrandt, *Studies of a sick woman.* Drawing. Amsterdam, Rijksprentenkabinet.

27b: Rembrandt, *A group of figures*. Drawing. Berlin, Kupferstichkabinett SMPK.

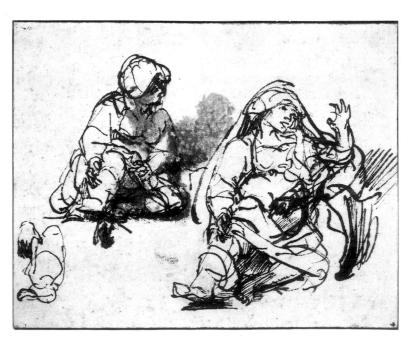

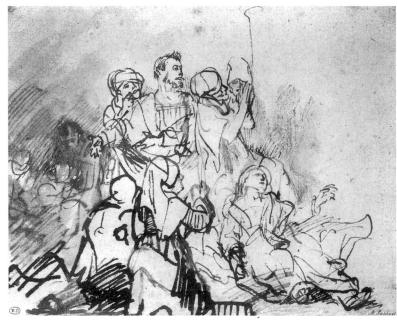

impression is similarly celebrated: 'deze is een alder eerste en dus raarste druk van deze plaat ... '25 (this is one of the first, and very rare, impressions of this plate). When Captain Baillie re-published the print in 1775 heavily re-worked, he added the inscription: 'The Hundred Guilder-Print. Engraved by Rembrandt about the year 1640 after a few Impressions were printed was laid by and thought to be lost.'

The second inscription on the reverse of the impression in Amsterdam perhaps offers an explanation for this: here it says that Rembrandt had not made this work for the art market, but rather presented it as a gift of friendship. Even the unusual portrait of Aert de Gelder, now in Leningrad,26 in which the sitter appears with an impression of the Hundred Guilder Print in his right hand, could play a part in this tradition. In this connection, one might also consider again the fact that Rembrandt, surprisingly, did not sign the Hundred Guilder Print. Thus one might imagine that Rembrandt is making a pragmatic demonstration of the totality of his abilities as an etcher. The printing styles used here range from the sketchiness that Houbraken mistook for unfinished work, to the tonal gradations of painterly chiaroscuro values that are possibly to be understood as experimental competition with the new mezzotint technique.27 The variety of methods in print-making should not, in this case, be understood to indicate that Rembrandt evaluated the work over several years, but rather as a record of Rembrandt's reference to his own œuvre—a deliberate display of virtuosity. B.W.

- 1. See Urkunden 266, there claimed to be the handwriting of the Amsterdam art collector Jan Pietersz. Zoomer. This identification has been opposed by Dudok van Heel 1977, p. 98.
- 2. Gersaint 1751, No. 75, pp. 6 ff.
- 3. '. . . als inzonderheid aan de zoo genaamde honderd guldens prent en andere te zien is, waar omtrent wy over de wyze van behandelinge moeten verbaast staan; om dat wy niet konnen begrypen hoe hy het dus heeft weten uit te voeren op een eerst gemaakte ruwe schets . . .' Houbraken 1718, p. 259.
- 4. See also Cat. No. 33.
- 5. Gersaint p. 60; see Dudok van Heel 1977, p. 98.
- 6. Jordan 1893.
- 7. On the significance and the iconographic tradition see, most recently, Tümpel 1986, pp. 255-61.
- 8. Urkunden 266. Haak 1969, 214.
- 9. The Presentation in the Temple, B. 49; The Triumph of Mordechai, B. 40; see also Cat. No. 14.
- 10. See Cat. No. 26.
- 11. This argument is put forward at length by White 1969, pp. 55-65.
- 12. Gemäldegalerie, Berlin; Paintings Cat. No. 70. See White 1969, p. 57.
- 13. Bredius 566.

- 14. See White 1969, pp. 62 ff.
- 15. Amsterdam, Benesch 183, Schatborn 1985, No. 21; Benesch 388, Sale: Sotheby, London, 1970.
- 16. Kupferstichkabinett, Berlin, Benesch 188.
- 17. Louvre, Paris, Benesch 185.
- 18. Courtauld Institute, London, Benesch 184.
- 19. Pushkin Museum, Moscow, Benesch 1071. It is possible that in this figure Rembrandt made use of the insights obtained from his very varied studies of mother and child from the late 1630s. A drawing in Rotterdam (Benesch 288) shows—albeit not in reversed form-striking similarities with the figure in the etching. An impression in the British Museum has black chalk corrections in the figure of the standing woman with the child.
- 20. Schatborn 1985, No. 21.
- 21. See White 1969, p. 61.
- 22. The Hundred Guilder Print has been discussed in connection with, among others, the painting in the Fogg Art Museum, Cambridge/Mass. (Bredius 624A; Tümpel 1986, Cat. 79). Only the work in Berlin (Bredius 622, Tümpel 1986, Cat. 78, Paintings Cat. No. 20) is still assumed to be by Rembrandt. See also Bredius 626 / Tümpel A20; Bredius 621 / Tümpel A17; Bredius 624 / Tümpel A19.
- 23. This type can be seen, for example, in the 1648 painting of Christ at Emmaus. Louvre, Paris, Bredius 578.
- 24. See also the sale inventory of 1656. Urkunden 169.
- 25. Urkunden 266.
- 26. See, most recently, Chapman 1990, Fig. 170.
- 27. See the considerations of Holm Bevers in the introduction to this catalogue.

28

Landscape with the Goldweigher's Field

Etching and drypoint, 120 × 319 mm; 1 state Signed and dated: Rembrandt. 1651. B./Holl. 234; H. 249; White, pp. 213 ff.

Berlin: on Japanese paper (97-1887)

Amsterdam: (1962:91)

London: (1973 U. 1037)*

Berlin: II (242-16)

The most panoramic of Rembrandt's landscapes is the Landscape with the Goldweigher's Field. The long, narrow sheet shows the view, looking down from higher ground, over the area around Haarlem. In the left background the city of Haarlem can be seen in silhouette, dominated by the medieval Grote Kerk. The centre of the middle ground is taken up by the Saxenburg estate of Christoffel Thijsz., and to the right of this is the church of Bloemendaal.¹ In the fields in front of this there are people bleaching linen.

Somewhat later in about 1670, the view from the dunes not far from Haarlem of the bleaching fields and the city with the Groote Kerk in the background was a favourite subject of Jacob van Ruysdael. In the early seventeenth century, Hendrick Goltzius had already made several panoramic landscapes of the area around Haarlem, drawn from observation—a milestone in the development of the naturalistic Dutch landscape.2 Rembrandt must have been inspired by comparable panoramas by Hercules Seghers. The etching by Seghers, View of Amersfoort (of about 1630) has a long, narrow shape similar to that of Rembrandt's etching (Fig. 28a); moreover, the view is taken from higher ground, and the horizon line is high, above the vertical mid-point of the sheet.3

The old title of Rembrandt's etching derives from the inventory made by Valerius Röver (1731); it is also the title used by Gersaint.4 It alludes to the tax-collector Johan Uytenbogaert, whom Rembrandt had portrayed as a goldweigher in the etching B. 281. It appears, however, that the landscape etching shows the estate of Christoffel Thijsz. Rembrandt had bought his house in the Sint-Antonisbreestraat from him in 1639. As he still owed a great deal of money to Thijsz in 1651, the etching of the view of his estate might have been made to appease him.5

The fields, the groups of trees, and the houses in The Goldweigher's Field are almost reduced to abstract forms. As far as the eye can see, the landscape is ordered through a series of intersecting diagonal lines. A sense of depth is sparked by the emphatic inky, black drypoint passages distributed across the sheet. The whole foreground forms a long, curved line, creating an optical impression that the landscape is slowly turning around an imaginary point in the distance. A drawing by Rembrandt in the Museum Boymans-van Beuningen shows a similar view of Haarlem from a slightly altered and higher viewpoint.6 This study from nature was not used as direct preparatory material for the etching; but Rembrandt may have referred to it, without slavishly transferring the details. The foreground, which is left blank in the drawing, stands out in the engraving through the use of powerful drypoint strokes; this was also perhaps a device to increase the impression of depth in the landscape to counteract the breadth of the view.7 The drawing, in which the church of Bloemendaal is placed on the left and the city of Haarlem in the right background, corresponds to topographical reality; and it is surprising that, in producing the plate, Rembrandt did not take the reversal of left and right into account. The fact that there are six surviving counterproofs (Fig. 28b)—showing the landscape in mirror image, and thus topographically correct-might indicate that Rembrandt later became aware of this.8

The Landscape with the Goldweigher's Field exists in only one state, though the proofs of this state vary a great deal according to the degree of burr still found along the drypoint lines and the amount of surface tone; the proofs on Japanese paper are also striking for their varying appearance.

H.B.

1. Lugt 1920, p. 157, note 1. Van Regteren Altena 1954. The identification of the individual groups of building's has been disputed. Van Regteren Altena thinks that the large building with a tower on the right is the manor house of Thijsz., while other commentators interpret this building as the church of

2. Reznicek 1961, Vol I, pp. 131–32, pp. 427 ff., Nos. 400, 404–5; Vol. II, Figs. 380–81, 351.

3. Haverkamp-Begemann 1973; Holl. 30.

4. Gersaint 1751, pp. 182-83, No. 226.

5. Van Regteren Altena 1954, p. 9; Washington 1990, p. 260. No. 84.

6. Benesch 1259; Giltaij 1988, p. 78, No. 21; Washington 1990, pp. 258–59, No. 83.

7. The marked panoramic elongation of the view, the curvature of the foreground, and the striking effect of distortion of the image in the corners of the sheet through the velvety tone of the dry-point burr, all prompt one to think of the view through a wide-angle lens. It would be tempting, though risky, to speculate as to whether Rembrandt had perhaps conceived the Landscape with the Goldweigher's Field with the help of such lenses. The use of lenses to help with picture construction played an important part in the work of pupils of Rembrandt such as Carel Fabritius and Samuel Hoogstraten; and Constantin Huygens was interested in optical instruments. There is no evidence, however, that Rembrandt himself used lenses; see Wheelock 1977, especially pp. 206 ff. 8. Schneider does not exclude the possibility that the

8. Schneider does not exclude the possibility that the etching was itself made from observation; Washington 1990, pp. 26, 31 (note 40) and 261, No. 84. On this, see Cat. No. 20.

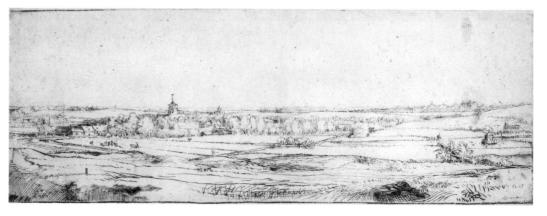

28a: Hercules Seghers, *View of Amersfoort*. Amsterdam, Rijksprentenkabinet.

28b: Rembrandt, *The landscape with the Goldweigher's field.* Counterproof. London, British Museum.

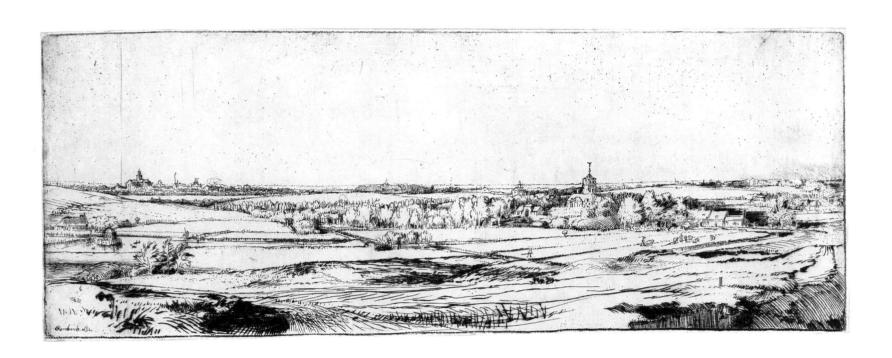

The Shell (Conus marmoreus)

Etching, re-worked in drypoint and burin 97 × 132 mm; 3 states Signed and dated: *Rembrandt. f. 1650.* B./Holl. 159; H. 248; White, p. 169

Berlin: II (242–16)

Amsterdam: I (O. B. 241), II (O. B. 242)* London: I (1973 U. 1035), II (1973 U. 1036) The only still-life among Rembrandt's prints—and one of few examples of still-life in his work as a whole—is the small etching of a conical shell.

Rare mussel and mollusc shells, brought back to Holland from exotic lands by the great trading companies, were popular collectors' items in the seventeenth century. The collecting of mussel shells had almost become an obsession.1 On account of their beauty and value, these objects were seen to embody the transition from Nature (Natura) to Art (Ars), or their union. Conchylia (the shells of molluscs) and other natural objects were to be found alongside man-made works of art in the collections amassed by princes and displayed in a Kunst- or Wunderkammer. A Kunstkammer of this time is described as follows: 'In our Kunstkammer we now delight to look at the empty shells and houses of the most beautiful and rarest conchylia in their many wonderous shapes and beauties; these are the work of nature and yet, at the same time, they seem like the product of art; we are both diverted by the sight and prompted by it to praise the Creator of these

works.' The writer adds that the greatest artist could not compete with the richness of colour to be found in these natural images.² The *Kunstkammer* was also a feature of life in the cities of Holland. The objects from Rembrandt's own encyclopaedic *Kunstkammer* are well documented in the inventory of 1656, and among them were the shells of mussels and molluscs.³

Conchylia are to be found in records of such collections, for example in the case of the *Kunst*-and *Wunderkammer* of Frans Francken the Younger.⁴ Almost as if disengaged from such scenes, there are the rare pure still-lifes with shells painted by Balthasar van Ast (Fig. 29a), in which many prized conchylia from distant lands are displayed.⁵ Shells are found also in flower paintings and *vanitas* still-lifes where, as symbols of natural beauty that are also very fragile, they point to the transience of all that is earthly.⁶

Rembrandt shows a conical shell (conus marmoreus), which comes from the East Indies. He appears to have been moved above all by the play of light and shade on the rounded

29 State I

29a: Balthasar van Ast, *Still life with shells*. Rotterdam, Museum Boymans-van Beuningen.

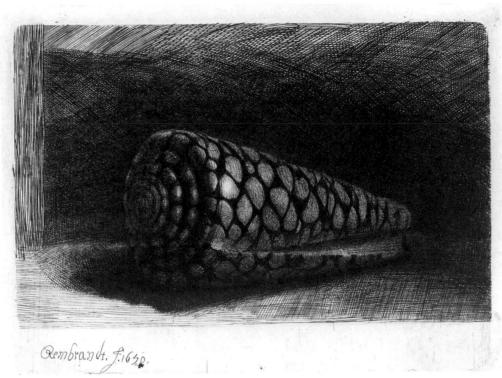

surface of this lovely creation; and it almost seems as if he wished to show that art could still use its own means to rival nature. It is in any case clear that Rembrandt's etching is not a scientific illustration in the manner of the shells depicted by Wenzel Hollar that are often invoked as direct models for Rembrandt's sheet. Hollar's series might have served as inspiration only for the idea of taking a single shell as the subject of an engraving (Fig. 29b).⁷

State I—executed in drypoint over an etched outline—shows the shell isolated in front of a background that is left white. The shell casts a shadow, without occupying a real space; and this contradiction may have prompted Rembrandt to shade in the background in state II and to suggest a cabinet or shelf, so that the shell now seems to lie on a board. Reworking with the burin on the surface of the shell reduces the highlights of state I. In state III (only surviving proof in Amsterdam) Rembrandt has extended and more sharply defined the central spiral form that in state II appears rather flat.

Just like a real mollusc shell, Rembrandt's conus marmoreus would have been acquired by collectors as an item fit for a Kunstkammer. H.B.

1. On this see, in particular, Schneller 1969, pp. 119 ff. The fashion for collecting shells was censured in Roemer Vischer's *Sinne-poppen*. The picture of shells, bears this emblem: 'Tis misselijck waer een geck zijn gelt aen leijt' (it is disgusting [to see] what a fool will pay good money for); see Bergström 1956, pp. 156–57; Boston 1980/81, pp. 91 ff., No. 54.

- 2. Scheller 1969, p. 120.
- 3. Urkunden, p. 199, No. 190, item 179.
- 4. Scheller 1969, Figs. 5-8.
- 5. Bergström 1956, pp. 70 ff., Fig. 60.
- 6. Bergström 1956, pp. 154 ff.
- 7. A conus imperialis from Hollar's series has been seen as a model for Rembrandt: see Pennington 1982, p. 337, Nos. 2187–224, in this case No. 2195. Van Regteren Altena 1959, pp. 81 ff.

29b: Wenzel Hollar, *Conus Imperialis*. Berlin, Kupferstichkabinett SMPK.

30

The Print-Dealer Clement de Jonghe

Etching, re-worked with burin and drypoint 207 × 161 mm; 6 states
Signed and dated: *Rembrandt f 1651*.
B./Holl. 272; H. 251; White, pp. 135 ff.

Berlin: II (359–16)* Amsterdam: III (O. B. 527) London: II (1843–6–7–158)

The etching was first cited as a portrait of Clement de Jonghe in the inventory drawn up by Valerius Röver in 1731, and it has generally been accepted as such. Rembrandt must have known Clement de Jonghe well. Born in Schleswig-Hollstein in 1624 or '25, he came to Amsterdam in about 1650 according to some sources, and in about 1656 according to others. He was active there as a publisher of, and dealer in, engravings, maps and books.1 His first shop was at the weighhouse on the Nieuwmarkt, and in 1658 he moved to a new address, Kalverstraat 10, near the Dam, the centre of the Amsterdam art trade. Among other things, De Jonghe published engravings and etchings by Roelant Roghman and Jan Lievens, and he must have had access to a large stock of printing plates. Nevertheless, it seems that his business did not really flourish. After De Jonghe's death in 1677, his son took over the business; in 1679 he drew up an inventory of his father's estate. Here, among other things, 74 etched plates by Rembrandt are cited by their titles.2 Surprisingly, in view of what one might have expected, the plate with De Jonghe's own portrait was not in the printdealer's estate. This, as has often been observed, could argue against the identification of the sitter as De Jonghe.3

The print dealer is dressed in a cloak and a broad-brimmed hat that lightly shadows his face: he is sitting in a chair in front of a white, undefined background. No reference at all is made to a profession or activity (see the very different case of Cat. No. 16). De Jonghe faces the viewer and looks at him, but he is pushed slightly away from the centre of the sheet, towards the left, where he leans his elbow on the arm of his chair. On his left hand, which hangs almost nonchalantly, De Jonghe wears a glove, the traditional sign of a nobleman.⁴

Rembrandt, who made portraits throughout his life, only rarely used the three-quarter length form.⁵ This type had its roots in Venetian art, for example in the work of Titian, Tintoretto, Veronese and Lorenzo Lotto, where it was first developed in 'official' portraits for persons of high rank, but became more widely used.6 Rembrandt had himself seen Venetian paintings; but in the case of this etching, he might, nonetheless, have been inspired by a Flemish model, perhaps the Portrait of Martin Ryckaert by Anthony van Dyck, that appeared in engraved form in 1646 in the Iconografie (Fig. 30a).7 For, even in Venetian painting, there are hardly any models for the sitter being both seated and boldy placed facing the viewer in a comparable manner. It is this that gives extraordinary presence to Clement de Jonghe in the etching. Yet, at the same time, the severe frontality of the figure—ultimately deriving from the hieratic image of Christ-establishes a distance between the sitter and the viewer. The subject—whether or not he is indeed the print-dealer Clement de Jonghe-must have commissioned the plate from Rembrandt, and himself chosen the tense pose that expresses both his retiring nature and his official and social rank.

The plate exists in six states, all of which were considerably altered in the region of the eyes and mouth, with corresponding changes in De Jonghe's facial expression: in one case he seems to be smiling, then again somewhat sullen, elsewhere almost peering out drowsily. In state 1 the facial expression is extraordinarily clear and transparent (Fig. 30b), and yet it

seems almost like that of an old man, which must have led to the transformation into the features of a youngish man in state II. States I and II show the sitter in front of a white background; in state III a simple, rounded arch was introduced; and in state IV this was emphasised with hatching (Fig. 30c).

- 1. The biographical details regarding De Jonghe vary. It has been claimed that the print-dealer was born in Braunschweig and was active in Amsterdam from about 1650 (De Hoop Scheffer/Boon 1971, p. 4); elsewhere, Schleswig-Hollstein is cited as the region of his birth, while the start of his activity in Amsterdam is given as c. 1656 (Amsterdam 1986–87, pp. 58–59, No. 42.
- 2. De Hoop Scheffer/Boon 1971.
- 3. Van Eeghen 1985 and Voûte 1987 take issue with the traditional attribution. On account of a certain similarity in physiognomy and dress between the sitter in the etching and those of Jan Six in the celebrated painting of 1654 in the Six collection, Amsterdam (Bredius/Gerson 276), Voûte puts forward the argument that this etching also shows Jan Six. Whatever the truth of the matter, the identity of the sitter in the etching does now have to be reconsidered.
- 4. Smith 1988, p. 46.
- 5. On this point in general, see Chapman 1990.
- 6. Chapman 1990, pp. 93 ff.
- 7. Chapman 1990, pp. 93-94, Fig. 137.

30a: Anthony van Dyck, *Portrait of Martin Ryckaert*. Berlin, Kupferstichkabinett SMPK.

30b Rembrandt, *Clement de Jonghe*. State I. Amsterdam, Rijksprentenkabinet.

30c: Rembrandt, *Clement de Jonghe*. State IV. Amsterdam, Rijksprentenkabinet.

MARTINVS RYCHART
VNIMANVS, PICTOR RVRALIVM PROSPECTVVM ANTVERPLÆ,
die von 39d parie.

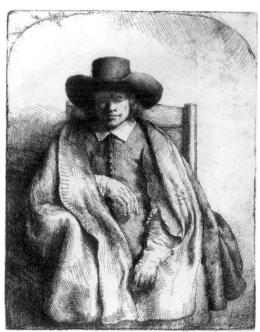

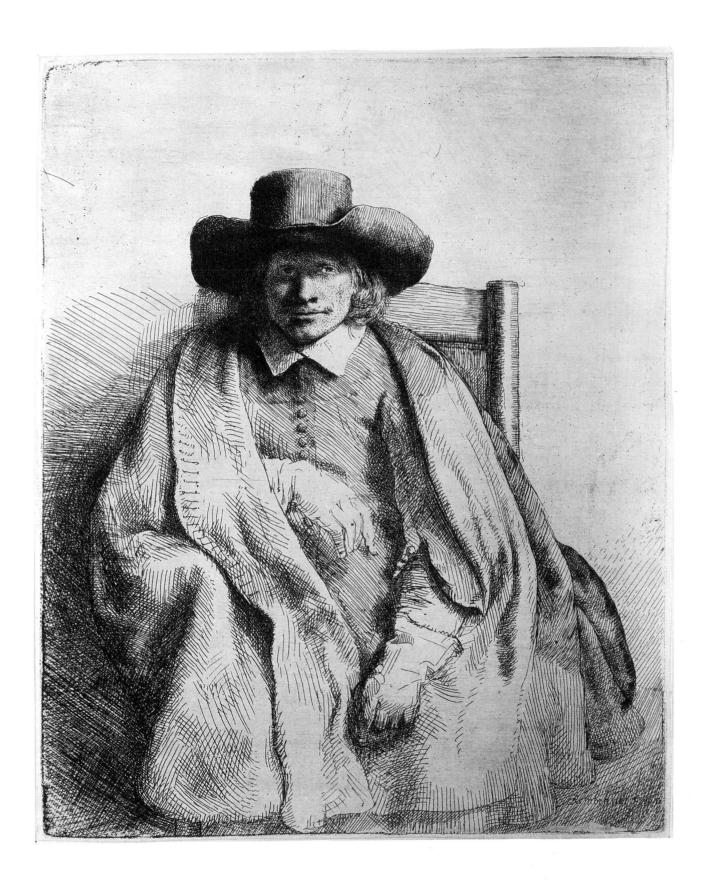

3 I Saint Jerome in an Italian Landscape

Etching and drypoint, with some sulphur tint, 259×210 mm; 2 states c. 1653-54 B./Holl. 104; H. 267; White, pp. 220 ff.

Berlin: I on Japanese paper (444–1908)* Amsterdam: I on Japanese paper (O. B. 184) London: I on Japanese paper (1973 U. 1151)

31a: Cornelis Cort, *St Jerome*. Amsterdam, Rijksprentenkabinet.

31b: Rembrandt, St Jerome reading in a landscape. Drawing. Hamburg, Kunsthalle.

One of the finest examples of Rembrandt's endeavours to capture light and atmosphere in the 1650s is the etching from 1653-54 showing Saint Ferome in an Italian Landscape. The saint sits, turned towards the viewer, on a large rock, and appears absorbed in his reading; next him stands a lion, looking towards the background which shows a hilly landscape with a group of buildings. Without the presence of the lion, it would not be obvious that this is a scene of Saint Jerome, for the other traditional attributes—crucifix and skull—are missing and, instead of the usual cardinal's hat, the saint wears a sort of sunhat as protection against the dazzling light, while he reads. The sandals which he has removed might at first be taken for a genre motif; but they may be found in the iconography of this subject and symbolise the saint's readiness to meet God.1

The scene is enlivened by the play of light and dark on the sheet. Parts of the hilly land in the background are caught in bright, almost harsh light, others lie in deep shadow. Gersaint and Bartsch thought the sheet unfinished, not recognising that Rembrandt, in leaving the foreground substantially free, and indeed only sketchily treated, wished to indicate a bright summery light.²

The subject of Saint Jerome shown in meditative mood in a charming landscape, more as a philosopher than as a penitent, may be traced back to sixteenth-century northern Italian and Venetian painting.³ Rembrandt could have taken his cue from a composition by Titian known through an engraving by Cornelis Cort (1565) (Fig. 31a).⁴ In both cases, the foreground scenery establishes a powerful diagonal thrust into the picture-space, and beyond this the view opens on to a

hilly landscape with human settlements. The immediate source for Rembrandt's figure of the saint could have been an engraving by Giulio Campagnola which shows Saint Jerome reading (1503-4).5 Rembrandt's background landscape too, with its apparently northern European buildings, was inspired by corresponding landscapes in engravings and woodcuts by Giulio and Domenico Campagnola.6 Considered as a whole, the present sheet, with its light-flooded, atmospheric landscape, owes much to Rembrandt's intensive study, during the 1650s, of Venetian painting. A sheet of about equal size with a reversed study for the etching is in the Kunsthalle in Hamburg (Fig. 31b).7 It reveals that Rembrandt had originally planned to show the rocky ledge and the saint in shadow, but discarded this plan in favour of a brightly lit foreground (see Drawings Cat. No. 26).

The early proofs of state I, mostly printed on japanese paper, show extremely powerful drypoint passages, above all in the area of the bushes in the middle ground as well as on the lion's mane, with the effect of further intensifying the opposition of warm light and deep shadows. In state II, the bridge piers at the right edge are worked over with drypoint strokes. Several examples of this state are printed on a rough paper of a grey-brown colour, similar to packing paper—in English known as 'oatmeal paper' or 'cartridge paper'.

1. Wiebel 1988, p. 96.

2. Gersaint 1751, pp. 90-91, No. 104.

3. See Wiebel 1988, pp. 123 ff.

4. Bierens de Haan 1948, p. 141, No. 134; Wiebel 1988, p. 123, Fig. 57.

5. Hind 7; Washington 1973, pp. 396–97, Fig. 19–7.
6. See, for example, the group of buildings, inspired by Dürer, in the above cited engraving by Giulio Campagnola, Hind 7. Further examples in Washington 1973, pp. 390 ff., Chapters XIX–XX. Rembrandt's familiarity with northern Italian models from the circles of Titian and Campagnola is shown by the fact that he copied a landscape drawing by Titian, and also worked over a landscape drawing in his own possession that has often been attributed to Domenico Campagnola (Benesch 1369). See Washington 1990, pp. 156 ff., Nos. 38–39.

7. Benesch 886; Schatborn 1986, pp. 22-23.

'The Hundred Guilder Print'

Etching, drypoint and burin, 278×388 mm; 2 states Unsigned and undated; c. 1647/49B./Holl. 74; H. 236; White pp. 55–65

Berlin: II on Japanese paper (302–1898) Amsterdam: I on Japanese paper (O.B. 601)* London: I on Japanese paper (1973 U. 1022)

Inscriptions on the reverse of the example in Amsterdam:

(in brown ink)

'Vereering van mijn speciale vriend Rembrandt tegens de Pest van m. Anthony'¹

(also in brown ink but in another hand) 'ici-dessous est decrit en pierre noire vereering van mijn speciaele vriend Rembrand, tegens de pest van M. Antony.

Rembrand amoureux d'une estampe de M. A. savoir la peste, que son ami J. Pz. Zoomer, avoirt de fort belle impression, & ne pouvant l'engager a lui vendre, lui fit present, pour l'avoir, de cette estampe-ci, plusrare & plus curieux encore que l'estampe que l'on . . . oine de Hondert Guldens Print, par les addition dans clair obscur qu'il y a dans celle-ci, dont il n'y a eu, suivant le raport qui m'en a ete fait, que tres peu d'impressions, dont aucune n'a jamais été vendue dutemps de Rembrand, mais distribuées entre ses amis.'

Gersaint, the author of the first printed catalogue raisonné of Rembrant's etchings (1751), praised the Hundred Guilder Print as the best etching from the master's hand. He drew particular attention to the variety in Rembrandt's record of human expression, which was shown 'avec tout l'esprit imaginable'.2 Houbraken too celebrated the work as supreme, but as a result of his own artistic ideals and of his view of Rembrandt, he regarded it as unfinished. 'This is particularly clear in the so-called Hundred Guilder Print, at the treatment of which we can only wonder, because we cannot understand how he [Rembrandt] could have worked this up from what was originally nothing but a rough sketch . . . '3

The title *Hundred Guilder Print* is not given by Rembrandt himself.⁴ Already used in the eighteenth century, it provoked a number of fanciful explanations. Gersaint, for example, reports—probably following the inscription on the Amsterdam example—that the artist had been able to give this etching to a Roman art dealer in exchange for several engravings by Marcantonio Raimondi which, together, were valued at a hundred guilders.⁵

The original significance of the work was obscured by the title *Hundred Guilder Print* until the end of the nineteenth century when its meaning was reconstructed.⁶ The subject is not a single episode ('suffer the children come unto me' or 'the healing of the sick'), but rather the whole of the nineteenth chapter of the Saint Matthew's Gospel.⁷ This interpretation was supported by the later discovery of a poem by H. F. Waterloos (a contemporary of Rembrandt), inscribed on an impression in Paris:

'Aldus maalt Rembrants naaldt den zoone Godts na 't leeven;

en stelt hem midden in een drom van zieke liên:

Op dat de Werelt zouw na zestien Eeuwen zien,

De wond'ren die hij an haar allen heeft bedreeven.

Hier hellept Jezus handt den zieken. En de kind'ren

(Dat's Godtheyt!) zaalicht hij: En strafftze die'r verhind'ren

Maar (ach!) den Jong'ling treurt. De schriftgeleerden smaalen

't Gelooff der heiligen, en Christi godtheits straalen.'

(And so Rembrandt drew from life, with his etching tool,

The Son of God in a world of sorrow,
Showing how, sixteen centuries ago,
He gave the sign of His miracles.
Here Jesus' hand helps the sick. And to the
children

(Mark of Divinity!) He gives His blessing, and punishes those that hinder them.

Yet (oh!) the young man wails. And the scribes sneer

At the faith in Holiness that crowns Christ's Divinity).

Rembrandt stresses the varied nature of the miracles performed by Christ, in amalgamating different episodes from the account in the Bible. The viewer is introduced to the crowded scene through the diagonal arrangement of the composition and, above all, through the use of lighting. The darkness that appears to deepen behind the figure of Christ evokes the suggestion of a monumental, arched structure. Christ's nobility, however, is enacted as the Redeemer shines forth against the depths of this darkness.

The Hundred Guilder Print is striking for the variety of printing techniques Rembrandt uses. Its large scale is apparently matched by its ambition to compete with painting; and the graphic range of etching is united with its painterly scope in an unusually broad spectrum. In this respect, the work cannot be compared directly with any single work from Rembrandt's printed œuvre. Related examples among the etchings of the period around 1640 may be found for the figures on the left treated in cursory outlines.9 The participants on the right, however, are characteristic of work from no earlier than the second half of the 1640s in their shading, which is elaborately modelled with short, delicate lines. 10 For this reason, there is unanimity regarding a date of 1647/49 for the completion of the print. There has, however, been disagreement as to when Rembrandt started work on the plate. Was the Hundred Guilder Print produced in its totality in about 1647/49, incorporating earlier stylistic means, or should one, rather, posit an interruption in the work, and date Rembrandt's first version to the late 1630s?11

Those arguing for an early dating have eagerly pointed to Rembrandt's dated oil sketch of 1634 for *John the Baptist preaching*. ¹² At first glance, the similarity of the compositional arrangement seems convincing—the view is led diagonally into the picture and the protagonists are arranged diagonally to the picture plane. However, the compositional principle of the London painting of 1644, *Christ and the Woman taken in Adultery*, ¹³ is on the whole nearer to that of the *Hundred Guilder*

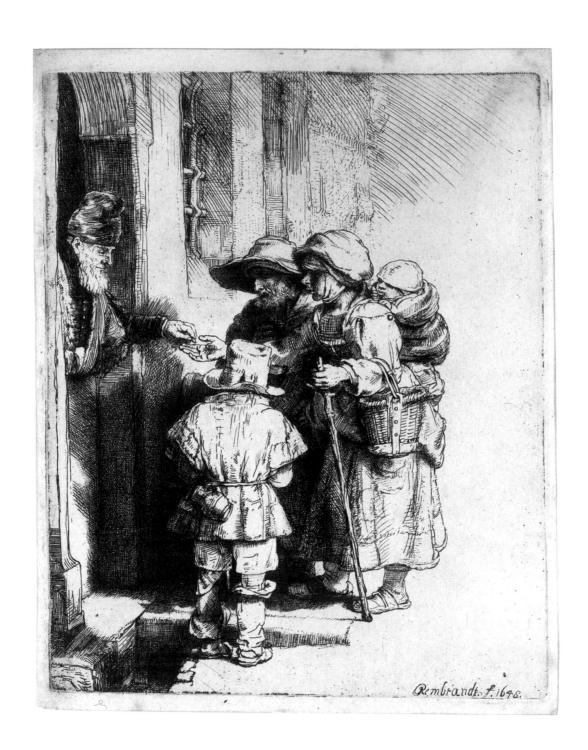

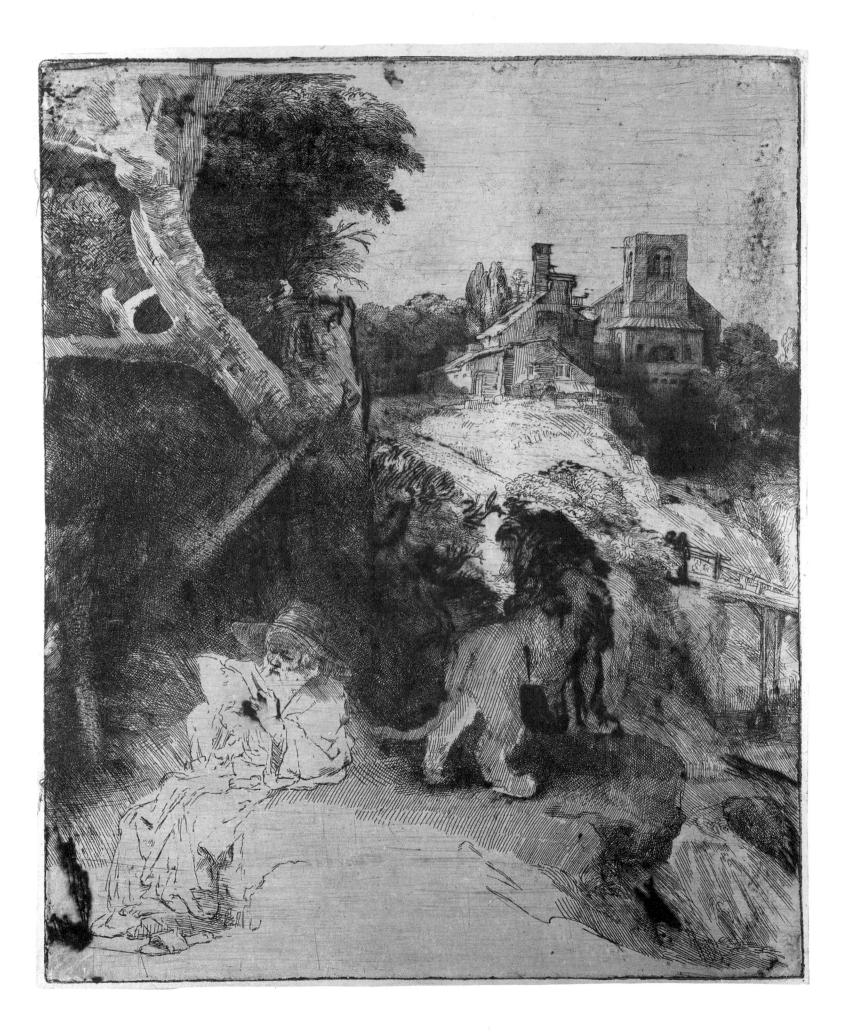

Landscape with three gabled cottages

Etching and drypoint, 161 × 202 mm; 3 states Signed and dated: *Rembrandt f. 1650* B./Holl. 217; H. 246

Berlin: I (317–1893)* Amsterdam: III (O.B. 275) London: I (1847–11–20–6)

Even the shape of this scene, with its rounded corners such as were used for ambitious history paintings, emphasises the monumental character of the composition. The structure is based on two powerful diagonals: a steep plunge into the depth of the depicted space in the form of a road leading from the immediate foreground to the horizon, and the imaginary line that divides the trees and houses from the sky. The sky itself is very effectively integrated into the scene as a surface left white. On the right, an enormous tree occupies the full height of the sheet, dominating the three handsome cottages along the road. A few people have gathered in front of the middle one. The depiction of the scene becomes less precise at a greater distance towards the low horizon, although further trees and houses can be made out. The strong sense of spatial recession is emphasised by the marked difference of scale between the tree and the cottages with the people standing in front. The tree is given heroic prominence, as if it were the protagonist of the composition.

Excellent impressions of this landscape etching show traces of Rembrandt's process of working. Rembrandt obviously fundamentally re-worked the appearance of the tree. Its left half, at first recorded in etching with feathery foliage, was altogether smoothed away at a later stage of work. Traces of a whole mass of foliage can be made out on the left, below the dead branch that is now visible. The thick branches and the summarily noted foliage are drawn in with powerful drypoint strokes that give the scene its imposing quality. Further details are altered accordingly: in the first version the roof of the nearest house was delineated in a very meticulous fashion. Similarly, the bushes behind this house first sketched have been summarised with drypoint hatching.

The small alterations between the three extant states consist merely in varied distribution of light and shade; thus patches in front of the nearest house, left white in the first state, are filled in with hatching in state II, giving this region more visual unity. On the contrary, the compositional changes in the treatment of the tree took place before any of the recorded phases of the work. The sheet thus appears to have been already completed in the exclusively etched version, before Rembrandt subjected it to a fundamental alteration. We do not know, however, how much time passed between the work on these two versions.

The visible alterations have, on occasion, led scholars to the assumption that Rembrandt started work on the etching *en plein air*, and then completed it in the studio.¹ The first sketch of the tree was then judged to be a freely formulated image made from nature. There seems, however, to be no evidence that seventeenth-century artists carried etching plates around with them to be used like a sketch book.² We must, on the contrary, regard both versions of the etching as made in the studio and assume that, during the second stage of the working process, Rembrandt abandoned the original composition in favour of one of greater formal value.

At least two drawings record the same property on the Sloterweg near Amsterdam.³ Only one drawing (Benesch 835), however, is generally dated to the year of the etching; the second drawing was apparently not made before 1652/53.⁴ Rembrandt seems to have made the earlier drawing (Fig. 32a) *en plein air*; and this drawing may have served as general inspiration for the composition of the etching.⁵ However, Rembrandt altered the architectural setting by adding a third building. The heroic picture structure contradicts the concern for an exact topographical record.⁶ There are several sources for Rembrandt's compositional

arrangement in Netherlandish art of the seventeenth century, for example an engraving by Hieronymus Cock also shows a road with houses along it, leading diagonally into the picture space.⁷

Rembrandt, however, increased the dramatic treatment of the landscape through the structure of the composition. The altered treatment of the motif is also the decisive difference between the etching and the Berlin drawing. The drawing is centred on one of the houses, in front of which a tree sways in the wind. Further trees bend in the same direction, allowing one to sense the atmosphere of the landscape. In the etching, interest in mood gives way to concern for a tightly organised picture structure, as if the artist had wanted to avoid the impression of a scene glimpsed by chance. Instead, the tree, with the emphatic incorporation of branches that are already dead as well as leafy tree tops, becomes a symbol of growth and decay, of the transience of all life.

- 1. For example C. P. Schneider, (Washington 1990, No. 20), reports a discussion with J. P. Filedt-Kok.
- 2. See Cat. No. 22.
- 3. Benesch 835, Berlin and Benesch 1293, Berlin. See Bakker 1990, who identified the location.
- 4. See, most recently, Bakker 1990.
- 5. Benesch 835; the connection between the drawing and the etching was first recognised by Haverkamp-Begemann 1961, 57.
- 6. See the Landscape with a Tower (Cat. No. 37).
 7. V. Bastelaer 1908, No. 22; see Amsterdam 1983,
 - . V. Bastelaer 1908, No. 22; see Am lo. 17.

32a: Rembrandt, *Landscape with cottages*. Drawing. Berlin, Kupferstichkabinett SMPK.

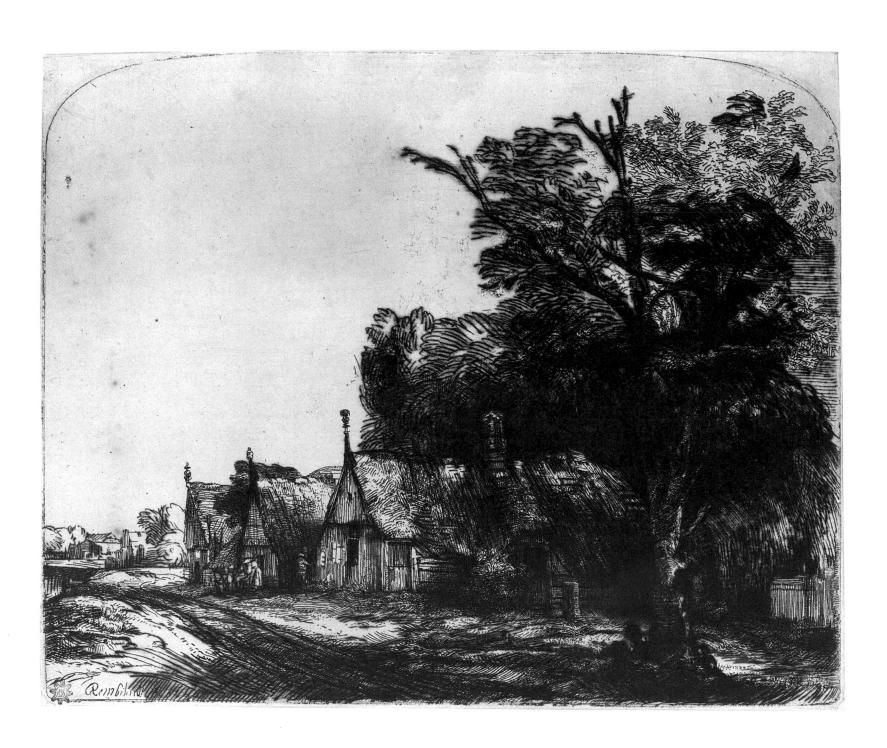

'Faust'

Etching, drypoint and engraving, 210 × 160 mm; 3 states Unsigned and undated; c. 1652 r B./Holl. 270; H. 260

Berlin: II (355–16)* Amsterdam: I on Japanese paper (62:122) London: I (1982 U. 2752)

Anagram inscribed in concentric circles from centre outwards:

INRI

 $+ ADAM + T\epsilon + DAGERAM$

+ AMRTET + ALGAR + ALGASTNA + +

33a: Rembrandt, *Old man in meditation*. Amsterdam, Rijksprentenkabinet.

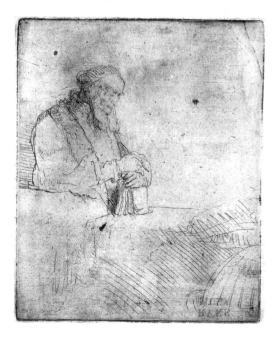

Rembrandt made his so-called *Faust* etching in about 1652. It shows an elderly man who concentrates on an apparition forcing its way through the closed window. The head of this apparition is made up of a circle of light with an anagram inscribed within it; and its hand points to a mirror-like object. The man's surroundings, including an astrolabe, a skull and books, indicate his learning.

The elaborate composition of the etching, almost like that of a painting, is especially notable. This prompts one to wonder if Rembrandt had devised the etching in response to a formal commission—although the existence of such a commission is pure speculation. The etching could just as well have been made for the market. The meticulous elaboration of the scene shows the work to have been an ambitious venture. Both the use of several kinds of paper and the variation in the impressions through the differences in the inking of the plates, further reveal Rembrandt's concern for this work.

It is exceptionally difficult to interpret the subject of this print.² The difficulties appear the more severe in that it has not proved possible to identify precisely the meaning of the anagram. The same sequence of letters has been found on amulets.³ It is perhaps intended merely to suggest a magic formula, rather than a precise message that requires decoding.⁴

There are no surviving drawings in which Rembrandt resolved the composition of the etching. Therefore the etching seems to have been executed without any significant interruptions.⁵ The three states differ only in details. For example, in state II, Rembrandt more strongly shaded the book placed on the right with further hatching, probably to soften the brightness that, in state I, had competed with that of the apparition. The development of the etching would seem to give no explanation as to the meaning of the work.

In the earlier eighteenth century (1731), Valerius Röver listed in the inventory of his art collection, an etching by Rembrandt with the title Dr. Faustus.6 Research has, probably correctly, taken this entry to refer to our sheet. Since Gersaint, the work has been universally listed with the title Faust in catalogues raisonnés. A decisive factor in the subsequent history of the reception of the work was the fact that in 1790 Goethe commissioned a copy of the sheet to serve as the engraved title page for his early Faust fragment. In the early twentieth century there were efforts to find an older version of the Faust legend that Rembrandt might have been illustrating in his etching. A Dutch version of Christopher Marlowe's play, Doctor Faustus, known to have

been performed in Amsterdam in Rembrandt's lifetime, was cited.7 There was even an attempt to determine precisely which moment in the play Rembrandt was illustrating.8 Such views are no longer accepted for a number of reasons, for example the known illustrations of the Faust legend usually showed the devil.9 Finally, Van de Waal (1964) argued that the man shown in the etching was a disguised portrait of Faustus Socinus, founder of the sect of the Socians, who had died in 1604.10 This interpretation had the advantage of explaining how the title Faust referred to the figure shown. According to this theory, Rembrandt did not so much intend to show Socinus himself, as the entity of his ideas.

This explanation fails, however, to do full justice to Rembrandt's etching.11 In no other of his portraits does Rembrandt show his sitter in lost profile. For this reason, the sitter can hardly have been intended to be identified. The subject of the etching is, rather, the event that Rembrandt illustrates. By precise control of perception of the scene, Rembrandt leads the viewer's attention, like that of the man himself, towards the apparition. A third area of emphasis is established by the astrolabe at the lower right edge, which stands out both through its brightness and for its size. Thus both composition and the pictorial narrative make clear that we are here observing a scholar concerned with astrology and confronted by an apparition.

As early as 1679, Clement de Jonghe mentioned an etching with the 'Practisierende Alchemist' (Alchemist at Work). 12 Without exception, research has found this entry to refer to our etching. De Jonghe's entries and those of Röver have been seen as equally reliable. While De Jonghe must have known Rembrandt personally,13 Röver's designation comes from a period when other works were also given new titles apparently because their original significance was no longer known or possibly because they had lost their former interestone may recall the case of the Hundred Guilder Print¹⁴ or that of the Nightwatch. ¹⁵ The title Alchemist at work might, indeed, have become accepted had it not been recognised that the seventeenth-century iconographic tradition for the presentation of alchemists was quite different from this. Thus, for example, paintings by Teniers always show a fire as the most important attribute of the alchemist. 16

Rembrandt, on the contrary, takes up a motif from earlier scenes with scholars:¹⁷ he shows a man of learning, looking up from his books and, indeed, holding a writing instrument in his right hand. In his own etching of a scholar, made in 1645 (Fig. 33a),¹⁸

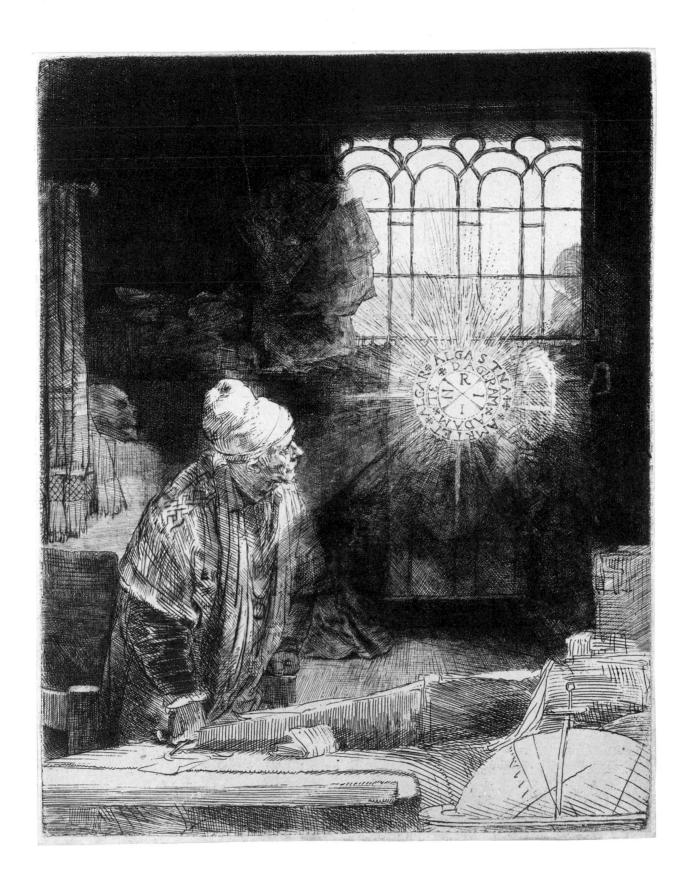

the figure is placed next to a table. In this earlier sheet the figure leans on a book, with a pen in his hand, and looks up thoughtfully. The two etchings show an altogether comparable arrangement of planes: in the earlier work, the figure of the scholar is set off against the brightly lit plane on the right, and in the Faust etching this area is occupied by the window and the apparition. In both sheets, the lower right corner is emphasised through the cropped image of an astrolabe. The 1645 scene with the scholar may have served as inspiration for Rembrandt's Faust etching. Starting from the iconography of the earlier sheet, Rembrandt presents a new interpretation of scholarship. The room, only sketchily indicated in 1645, is as detailed as a painting in the later sheet and becomes a setting that is used to define the protagonist.

Recently, Carstensen and Henningsen have drawn attention to a tradition of scenes of cabbalistic conjuration, apparently well-known in Amsterdam at the start of the seventeenth century. Literary scholarship and magical rites were unified in this form of astrological belief, in which a Magus sought to invoke the ethereal spirits of the stars. Rembrandt might have learned these ideas from Menasseh-ben-Israel, who could have passed on to him various ideas from cabbalistic tradition. 20

It seems that Rembrandt has here established for the first time a visual representation for a form of alchemy that had previously only been recorded in literary tradition. This novel iconographic formula—unlike earlier scenes with alchemists—shows the union of literary scholarship and magic. It introduces a personality that was to receive its classic literary formulation in Goethe's *Faust*. This may be seen to explain the persistent appeal of the essentially ahistorical title. B.W.

- 1. As claimed, for example, by Carstensen/Henningsen 1988, p. 300.
- 2. A survey of the history of research on this matter is provided by Van de Waal 1964, pp. 45–46, *Documents* p. 14, and, most recently, Carstensen and Henningsen 1988.
- 3. See Van de Waal 1964, pp. 9-11; Rotermund 1957.
- 4. Carstensen/Henningsen 1988, p. 302.
- 5. On the question of the relation between drawings and etchings, see, for example the, *Hundred Guilder Print* and the drawings accompanying its own evolution (Cat. No. 27).
- 6. Urkunden 346.
- 7. Leendertz 1921.
- 8. Leendertz 1921, p. 136.
- 9. Van de Waal 1964, Figs. 1-3.
- 10. Van de Waal 1964.
- 11. See, most recently, Carstensen/Henningsen 1988.
- 12. Van Gelder/Van Gelder-Schrijver 1938, p. 1.
- 13. See Cat. No. 30.

- 14. Cat. No. 27.
- 15. Corpus A146.
- 16. For example, Prado, Madrid; Musées Royaux des Beaux-Arts, Brussels.
- 17. See the examples given by Van de Waal, as well as B. 105, B. 147 and B. 148.
- 18. B. 147.
- 19. Carstensen/Hennigsen 1988, who, following Panofsky, elaborate on the context of Rembrandt's *Faust* etching in terms of intellectual history.
 20. See the Menetekel inscription in the London
- Belshazzar's Feast painting Paintings Cat. No. 22.

Etching and drypoint, 213 × 319 mm; 4 states Unsigned, c. 1651 B./Holl, 223; H. 244; White pp. 212–13

Berlin: I (94–1887)*; III on Japanese paper (120–1894)* Amsterdam: I on Japanese paper (O.B. 456);

IV (O.B. 457) London: II (1973 U. 1028); III (1973 U. 1029)

The principal motif in this print of about 1651 with its strip-like format is a compact entity surrounded by trees, between which a path leads. A flock of birds sweeps over the buildings. On the left the view stretches, uninterrupted, to the horizon. Darkness has already crept up on the first group of trees—in one half of the sky the hatching lines close up—and those nearby appear to bend in the wind. The broad, lit foreground emphasises the falling darkness of the evening sky.

The location depicted here has been identified as 'Het Huys met Toorentje' (The House with a Turret) on the Amstelveen road very near to Amsterdam.1 A drawing by Rembrandt formerly in the Hirsch collection (Fig. 34a)² cannot have served as direct preparatory material because of its completely different treatment of the main motif. However, in it Rembrandt has drawn the same group of houses, recognisable through the tower, but from a greater distance and, rather, as the silhouette of a village not dominated by any individual motif. For his etching Rembrandt selects a closer view, in which the main motif, surrounded by trees, becomes the focus of attention. In the drawing the unworked paper surface is already incorprated into the formal structure of the composition. In the printed version even more is made of this device. The dramatic use of light is crucial for the effectiveness of the etching.

In many of his landscape etchings Rembrandt seems to conceive the images in pictorial terms.³ These works stand out for their formal compactness and, above all, their fully elaborated foregrounds. 'First, it seems that our foreground is detailed and emphasised, in order to let the rest [of the composition] retreat behind it, and so that we are persuaded

34a: Rembrandt, *Landscape with a tower*. Drawing. Malibu, J. Paul Getty Museum.

that something important is to be introduced into the foreground [. . .]'⁴ In this etching, however, Rembrandt selects a compositional arrangement that is deliberately not taken from the sphere of traditional landscape painting. Obviously he is seeking to give the impression of a spontaneous study of light effects. The etching owes its particular allure to the contrast between the open foreground and the tightly organised composition in the central area.

The house is sheltered by the trees which sway in the wind. The swelling foliage is captured in short, light strokes. In state I Rembrandt uses line to contrast the solidly constructed wall and the feathery lightness of the thatched roof. In the later states Rembrandt denies the material aspects of the subject through his use of even, unifying crosshatching. At the same time his interest in the topography wanes: in state III the cupola of the tower is burnished out, so that it no longer dominates the scene. The compact quality of the group of house and trees is now emphasised. A realistic record of the village is eschewed in favour of a composition based on formally determined passages, and where the principal concern is the effect of light and shadow.

The further, small corrections, ultimately insignificant for the composition as a whole, add to the intended effect of the image. Spots of etching fluid, visible in state I as black patches in the dark passages of the sky, are burnished out, though the triangular patch on the left near to the house persists through all the states. The lengths to which Rembrandt has gone in establishing the final version of this landscape etching are documented in the four states, each of them surviving also in the form of counterproofs. In some impressions Rembrandt experimented with different sorts of paper as well as with several inks and various degrees of wiping of the plate before printing. The manner in which the Landscape with a Tower evolved—a process during which composition, lighting, and printing technique were all re-worked—reflects Rembrandt's obsessive concern with the possibilities of the landscape etching. B.W.

1. Van Regteren Altena 1954, 12–17; Washington 1990, No. 81.

2. Getty Museum, Malibu; Benesch 1267; see Washington 1990, No. 82.

3. A particularly clear example is Landscape with the three trees (Cat. No. 19).

4. 'Alvooren onsen voor-gront sal betamen Altijts hart te zijn / om d'ander doen vlieden / En oock voor aen yet groots te brenghen ramen'. Karel van Mander (1916), p. 204. 34 State I State III

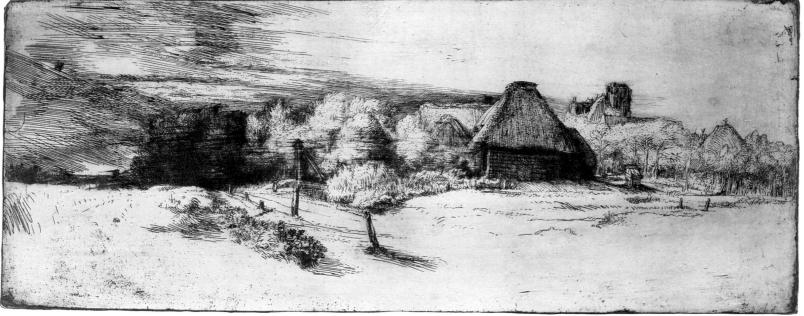

The Three Crosses

Dry point and burin, 385×450 mm; 5 states Signed and dated: (in III, also still detectable in IV) *Rembrandt. f. 1653*. B./Holl. 78; H. 270; White, pp. 75 ff., 99 ff.

First version (I–III) Berlin: III (646–16)* Amsterdam: III (62:39)

London: III (1973 U. 941)

Second version (IV–V) Berlin: IV (643–16)* Amsterdam: IV (62: 40) London: IV (1973 U. 942)

35a: Detail of Cat. No. 35, State III.

35b: Detail of Cat. No. 35, State 1, on parchment.

35c: Master B with the Die, *The Crucifixion with* the Conversion of the Centurion.
Vienna, Graphische Sammlung Albertina.

In 1653, or shortly before, Rembrandt made one of the masterpieces of his printed œuvre: *The Three Crosses*. The scene has the scale of a painting; and it was radically reworked in a later state, and in a way that is unique in the history of printmaking.

The first three states—the first version of the subject—show a crowded Calvary. This type of scene had its roots in fifteenth- and sixteenth-century Netherlandish art, but it was something of an exception in Dutch painting of the seventeenth century. Rembrandt's depiction of the Crucifixion is based, to a large degree, on the text in the Gospel according to Saint Luke: 'And it was about the sixth hour, and there was a darkness over all the earth until the ninth hour. And the sun was darkened, and the veil of the temple was rent in the midst. And when Jesus had cried with a loud voice, he said, Father, into thy hands I commend my spirit: and having said thus, he gave up the ghost. Now when the centurion saw what was done, he glorified God, saying, Certainly this was a righteous man. And all the people that came together to that sight, beholding the things which were done, smote their breasts, and returned. And all his acquaintance, and the women that followed him from Galilee, stood afar off, beholding these things.'1

The cross itself forms the centre of the scene; and, following tradition, Rembrandt included the two thieves who were crucified with Christ. On the left are the Roman soldiers; and the Centurion who was converted at the death of Christ has already dismounted

and kneels at the foot of the cross with outstretched arms. On the opposite side are the mourning Disciples. Mary has fainted in the arms of a companion; John presses his hands to his head as if to tear at his hair (Fig. 35a). Mary Magdalen, consumed with sorrow, embraces the cross. Rembrandt omits some elements in the narrative of the Passion that are frequently found in Calvary scenes, such as the motif of the soldiers casting lots for Christ's clothing. He enhances the scene, however, by including the figures of the onlookers, described in Luke's account as turning away so as not to witness the horror of the event. Two men in the foreground, apparently Jewish scribes, run in panic towards a cave, and further to the left a man, possibly Simon of Cyrene, who is clearly deeply shocked, is led away by his companions. One man covers his face with his hand, another shields his eyes, and fleeing people are thrown to the ground in their haste. It is not always clear whether these are intended as followers or opponents of the crucified Christ; but they all appear to be in a state of great shock. Rembrandt's psychologically penetrating study of terrified humanity has no equal in the iconography of Calvary.

We are shown the climax of the Passion: the moment of Christ's death. The natural phenomena—the quaking earth, the darkness—are illustrated with a powerful use of *chiaroscuro*. Vast beams of bright light pierce the turbulent black sky, falling in a cone to illuminate Christ on the cross and the converted thief on his left who persists in his

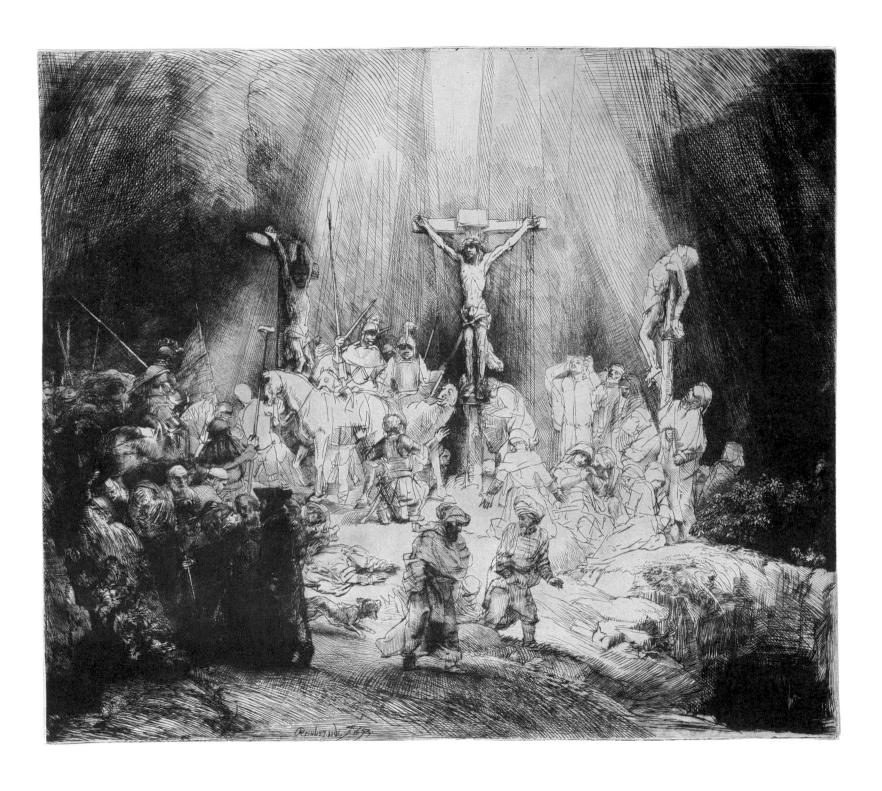

refusal to believe in the Lord.² The violent contrasts in illumination create an impression of chaos. Christ triumphs over this earthly tumult; he shows no trace of sorrow, and exudes a solemn air of peace. Rembrandt must have consciously adopted the form of the crucified Christ found in medieval art, with the feet placed next to each other and each nailed separately to the cross, a presentation that emphasises the idea of Christ's composure and his essential 'distance' from the surrounding confusion.

The angular style of the figures, often only shown in outline, corresponds to the style of Rembrandt's pen drawings of the same period. Apart from a disputed sheet of studies in Weimar, perhaps made in preparation for the group with the man led away by his companions, no preparatory drawings have survived.3 One can, however, assume that there may have been further preparatory studies for the individual figures and for the composition as a whole. Rembrandt apparently transferred the scene directly on to the copper plate in drypoint, and in a few places also with the burin. Only in the case of small landscapes, are there earlier examples of works by Rembrandt executed exclusively in drypoint.4 The transfer of a technique allowing a high degree of control to a large-scale work is witness to the artist's technical virtuosity. In his presentation of darkness, Rembrandt exploited in a unique way the effect peculiar to the drypoint stroke—it appears velvety and 'painterly' when printed because of the burr thrown up at the edges of the lines.

The Calvary scene may have been conceived as a pendant to Rembrandt's *Ecce Homo* of 1655 (see Cat. 38).⁵ Both sheets were, perhaps, planned as parts of a Passion cycle which was, however, left unfinished. This possibility is supported by two observations: the *Ecce Homo*, in its first state before the plate was cut down, has almost the same scale as the *Three Crosses*, and both works are executed in the same technique. In addition, there are other groups of biblical cycles of the 1650s, for example the Passion of 1654 (see Cat. No. 37).⁶

Rembrandt's *Ecce Homo*, in its basic conception, follows Lucas van Leyden's engraving of the same subject from 1510 (see Cat. No. 38).⁷ The *Three Crosses* would also seem to have evolved in conscious relation to the large Calvary scene by Lucas van Leyden of 1517,⁸ yet not in the sense of a direct formal reference to the earlier work, but rather as a reinterpretation of the subject. It appears that Rembrandt wished to demonstrate that he was able to surpass his great Dutch predecessor, whose two most important works Rembrandt

had acquired for large sums. Rembrandt reworked other models directly. The figure of the converted Centurion is derived from an engraving by the Master B with the Die (1532), an Italian engraver from the circle of Raphael (Fig. 35c).9 It is perhaps in this source that the image of the group of Disciples found its inspiration. For the group leading away the old man, a corresponding group from the Conversion of Saint Paul by Lucas van Leyden could have been the source. 10 The Horse Tamers of Antiquity, from the Palazzo del Quirinale in Rome, served as a model for another group in the left half of the scene in the first version (this is even more evident in the second version): the Centurion's horse and the servant holding its reins.11 In spite of these formal borrowings, however, Rembrandt's Golgotha scene is totally original in its composition and iconography.

States I and II differ only minimally; Rembrandt experimented incessantly at these stages, in order to try out various pictorial effects. He used different kinds of paper; many proofs of state I are printed on thick vellum (Fig. 35b), which is very unabsorbent, so that the drypoint lines appear blurred, producing deep black passages in places. In addition, the plate was inked in varying degrees, or wiped with uneven pressure, so that, in one and the same proof, certain areas of the picture may emerge brighter or darker. Each proof is unique. In state III, signed and dated 1653, individual strokes are added to the groups of figures, especially on the left and in the foreground, and also in the areas of sky at the sides, which are now shown as heavier and darker. Only with this state were the proofs printed, without exception, on white paper with slight and even surface tone. The fact that this state is also signed shows that Rembrandt viewed state III as finished and intended it for sale.

The fourth state of The Three Crosses shows a thoroughly altered composition. Opinion has been divided as to whether Rembrandt reworked the plate in 1653, or shortly thereafter (that is to say, in direct connection with the third state), or did so only several years later, in about 1661. Important evidence in support of the second of these possibilities is to be found in the striking similarity of the newly introduced figures, above all that of the soldier right next to the cross, to the figures of Rembrandt's painting in Stockholm, The Conspiracy of Claudius Civilis, finished in 1661.12 Acceptance of the later date has generally prevailed.13 One can only speculate on the reasons for the alteration; the most obvious

explanation would be that the old plate, with its numerous drypoint passages, no longer allowed a satisfactory print to be made, and that Rembrandt took this opportunity to make a new scene.

The plate was substantially and smoothly polished and then reworked with drypoint and burin; in certain passages the lines from the first version are still clearly recognisable under the new strokes. Powerful hatching lines now steep the whole scene in a deep darkness. Only the Crosses with Christ and the thief on his right, and also one of the fleeing men in the foreground, are retained in their original form, though even here there is slight reworking. Even the group of mourners differs from that in the first version, for the characterful figure of John now stands out from those of the other young men, isolated through the beseeching gesture of his raised arms. The figure of the converted Centurion appears almost erased, and it is now superceded by that of a man on horseback. There are, nonetheless, some alterations in the treatment of the figure of the Centurion. Christ has been finely modelled: the facial features are more human, and more sorrowful; the eyes and the mouth are slightly open. It seems as if Rembrandt here shows us the dying Christ, rather than Christ who has just died as in the first version. This could also explain the suppression of the figure of the kneeling Centurion, who was converted to the message of the Gospels only in the very moment of Christ's death.

The role of the main figure on the left, derived from the equestrian figure of Gian Francesco Gonzaga on a medal by Pisanello (of about 1444), remains a mystery (Fig. 35d).14 Possibly he is intended to be the personification of those in power, and thus a symbol of earthly injustice and unbelief; or he might be Longinus with his spear, or Pontius Pilate. The identification of this equestrian figure as Pontius Pilate is subtantiated by iconographic tradition; for even in crucifixions of the fifteenth and sixteenth centuries the equestrian figure of Pilate is, on occasion, depicted in his capacity as a military commander. This is also suggested in the long stick carried by the figure on horseback here; this would seem to be the same stick as Rembrandt gave to the figure of Pilate in the Ecce Homo (Cat. 38), as a sign of his power as a judge. 15 The greater emphasis on the figure of the Apostle John in state IV in relation to the earlier version, also indicates that the figure on horseback is Pilate. John, in his Gospel, speaks throughout of the presence of the Roman Governor at Calvary; it was Pilate that had prevailed in his disputes with the Jews and, for this reason, had insisted that

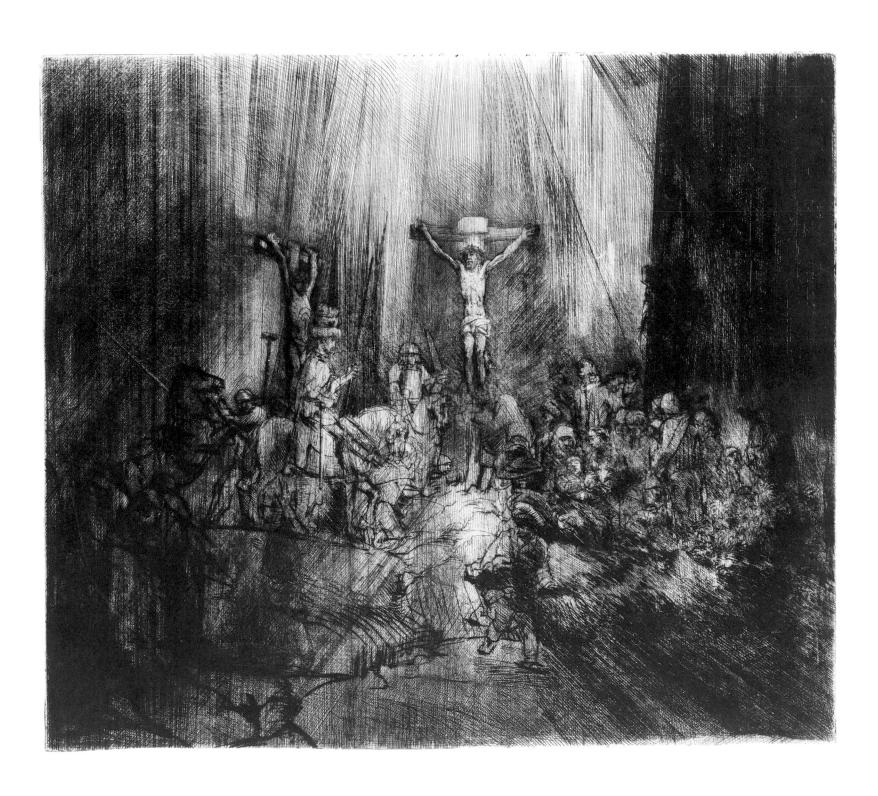

Jesus should be given the title 'King of the Jews' which was to appear on a plaque attached to the cross. It would seem that, in the later version of the *Three Crosses*, Rembrandt had wanted to show the crucifixion as a documented historical event, for John was an eye-witness to the Passion: 'And he that saw it bare record, and his record is true: and he knoweth that he saith true, that ye might believe.' ¹⁶

Both versions of The Three Crosses are informed by one of the themes underlying Rembrandt's treatment of religious subjects: the tragic entanglement of sinful man in his own guilt. Rembrandt often characterised the sinner who had come to see the error of his ways-for example, the Prodigal Son-not as a damned being but as an individual fated to be sinful.¹⁷ This explains his emphasis on the Roman Centurion in the early version of The Three Crosses and on the figure of Pontius Pilate in the later one. Both men were responsible for the death of Christ: the Centurion recognised his own guilt and repented, and the Governor, convinced of Christ's innocence, made himself guilty in a tragic manner, because he was too weak to resist the High Priest, who had demanded Christ's death. But even the sinner who fails to see the error of his ways merits understanding. It is perhaps for this reason that the unconverted thief on Christ's left in the first version appears in a bright light: he will eventually attain understanding and inspiration. The thief on Christ's right, meanwhile, is already converted, and is now repentant.

The proofs of state IV also vary considerably, depending on the burr remaining in the drypoint passages, the kind of paper used, and the manner of inking the plate. There are proofs with so much surface tone that the scene is almost entirely drowned in the blacks. Rembrandt made counterproofs (of which three survive) (Fig. 35e)—that is to say, images printed off freshly made proofs and so recording the composition unreversed as it appears on the plate. In addition there is a maculature, a second proof taken from the plate before re-inking, in which the individual parts of the composition are more clearly legible than in the proof itself. Both images allow one better to study the intended alterations to be made on the plate.

It seems that Rembrandt wanted to alter the scene once more, perhaps in order to achieve a yet more penetrating account of the Crucifixion, this turning point in world history. In the end he settled for the sombre picture of human catastrophe he had achieved in the two versions of *The Three Crosses*.

1. Luke 23: 44-49.

2. As the thief on Christ's left is caught in the bright rays of light, he has usually been seen as the converted thief, even though, in iconographic tradition, he belongs on Christ's right. He does, however, hang painfully bent upon his cross, that is to say in a pose usually characterising the bad thief, who is seen to writhe in agonising death throes. It is also significant that his eyes are bound, suggesting that he refuses to recognise the truth. The body of the man crucified on the right of Christ does not hang in such a contorted fashion on his cross, and may thus be supposed to be in

35d: Antonio Pisano, called Pisanello, Medal of Gian Francesco Gonzaga. Berlin, Staatliche Museen, Münzkabinett.

35e: Rembrandt, *The Three Crosses*. Counterproof. Berlin, Kupferstichkabinett SMPK.

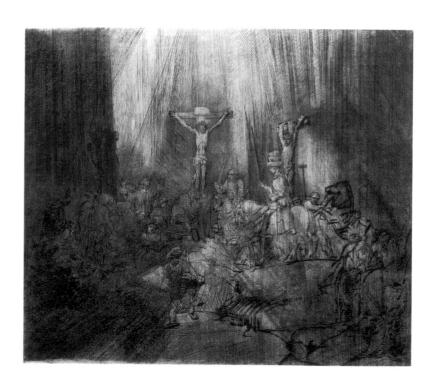

less agony; he must be the thief who believes in the innocence of Jesus. It would also be fair to assume that Rembrandt was familiar with iconographic tradition and that he was well aware that he was reversing the two sides. Wolfgang Stechow, proceeding from the conventional interpretation, suspected that Rembrandt had altered the plate in state IV, in order to make his own iconographic error less evident; but why then would he have fully altered the plate simply on this account?

- 3. Benesch 1000. Haverkamp-Begemann accepted the sheet in Weimar as a study for this group; Haverkamp-Begemann 1961, p. 86, on Benesch 1000. The sketch for a man leaning forwards in the Staatliche Graphische Sammlung in Munich has been connected with the figure of the Magdalen embracing the cross; Benesch 925; Wegner 1973, No. 1124.
- 4. B. 221–22; Washington 1990, p. 126, No. 25, p. 132, No. 27.
- 5. B. 76.
- 6. B. 50, 83, 86, 87.
- 7. B./Holl. 71.
- 8. B./Holl. 74.
- 9. B. 3. Less convincing is the comparison with a Calvary scene by J. B. Fontana (B. 14), which Rembrandt is said to have used as a source; Münz 1952, Vol. II, p. 104, No. 223.
- 10. B./Holl. 107.
- 11. It was known, among other examples, through an Italian engraving dated 1584; Münz 1952, Vol. I, Fig. 70, Vol. II, p. 104, No. 223.
- 12. See Stechow 1950, p. 254. On this matter, see also Paris 1986, p. 230, No. 115.
- 12. Bredius/Gerson 482; White 1969, p. 99.
- 13. It has, in any case, been overlooked that the signature and the date 1653 were not fully polished away and can still be clearly recognised under the new application of hatching. However, Rembrandt may not have regarded this as important.
- 14. This is the reverse of the medal for the Duke of Mantua, that must have been in Rembrandt's possession; see Münz 1952, Vol. I, Fig. 69; Vol. II,
- p. 104, No. 223.
- 15. B. 76. 16. John 19: 35.
- 17. Białostocki 1973.

36 The Virgin and Child with the Snake

Etching, 95 × 145 mm; 2 states Signed and dated: *Rembrandt. f. 1654.* B./Holl. 63; H. 275; White, pp. 80 ff.

Berlin: I (118–16) Amsterdam: I (62:33)* London: I (1910–2–12–380)

There are only a few print cycles in Rembrandt's œuvre. However, in 1954, he made two etched series of biblical scenes: a Passion (see Cat. No. 37), and a series of five or six sheets with scenes from the Childhood of Jesus. There is only a loose connection between individual scenes within each of the series, and each print can stand as a work in its own right. The cycle with scenes from the Childhood of Jesus includes *The Virgin and Child with the Snake*.

The Virgin sits in a room, warmly cuddling the child. Joseph looks in from outside, with almost sad eyes. A cat is playing with the hem of the Virgin's dress. She places her foot on a snake: the motif, common in Catholic iconography indicates that she is to be seen as the new Eve, who will overcome original sin. The armchair and the curtain opening above it suggest a throne with a canopy, a traditional symbol of honour used to present the Mother of the Lord as the Queen of Heaven. The Virgin has not, however, taken her place in the armchair; instead she sits on the floor. Rembrandt is here adopting the motif of the Madonna dell'umiltà originating in Italian art of the fourteenth century, and in the North in the fifteenth century.2 The Virgin confronts the viewer not in a distanced manner, in majesty, but as if humanised; and this impression is increased through the familiar, domestic surroundings—the fire in the hearth, the playful kitten and the open laundry basket. The holy scene takes place in a simple room. Joseph is excluded in that he stands outside; but he can take part in this moment indirectly, as Rembrandt shows him, looking in through the window. The visible traces of a reworking of the plate on the right at the chimney could indicate that Joseph was first placed here, inside the room.3 The circular central pane of the leaded glass seems to form a halo around

the heads of the Virgin and child. A comparably intimate atmosphere is to be found in Rembrandt's painting *The Holy Family* of 1646, in Kassel (Fig. 36a).⁴

As in fifteenth century Netherlandish painting, there is a deeper meaning hidden within Rembrandt's apparently secularised scene. The closed, doorless room, into which Joseph has no right to enter, points to Mary's virginity, just as the dividing window-pane is a symbol of her purity. It is not only the snake that alludes to original sin; the cat too must be intended as an embodiment of evil, and of Satan, who dwelt, according to popular superstition, in the chimney.5 As early as 1641 Rembrandt had shown, in the etching The Virgin on the clouds, an explicitly Catholic motif: the worship of the Mother of God.⁶ These works must have been intended principally for members of the Catholic merchant classes, who were also to be found in Protestant Holland.7

Iconographically and compositionally, the scene is based on models in earlier
Netherlandish art. Various pictures of the
Virgin from the circle of the Master of
Flémalle, for example, show the Virgin and
child in an interior, sitting on the floor in front
of a bench near the hearth. The motif of the
Virgin's halo represented symbolically by an
everyday object is also derived from the Master
of Flémalle.8

An engraving by Andrea Mantegna, meanwhile, provided a direct model for the Virgin and Child (Fig. 36b). Rembrandt was especially interested in the motif of the tender, intimate embrace, and he adopted this almost literally. Mantegna shows the group slightly di sotto in su, like a stone sculpture in a niche; however, Rembrandt softened monumentality by placing it at eye level and rejecting the sharply folded and creased drapery in favour

of more supple cloth. The preoccupation with Mantegna is evident not only in the adoption of motifs and in the clear organisation of the picture planes, but also in the use of relatively restrained line and regular parallel hatching strokes.

In state I white spots are visible on the upper right edge; in state II these have been filled in with hatching. There is further reworking in the upper left corner.

- 1. The Passion: B. 50, 83, 86, 87; The Childhood of Jesus: B. 47, 55, 60, 63, 64 and probably also B. 45, The Adoration of the Shepherds, although the sheet differs a little in size from the other scenes.
- 2. See Meiss 1936, pp. 434–64. Haverkamp-Begemann 1980, p. 168.
- 3. Filedt Kok 1972, p. 60.
- 4. Bredius/Gerson 572.
- 5. Slatkes 1973, pp. 257-58.
- 6. B. 61.
- 7. Tümpel 1977, pp. 29–30.
- 8. See, for example, the *Virgin at the hearth* in London, and the middle panel of the *Mérode Altar*; Panofsky 1953, Vol. I, pp. 163 ff., Vol. II, plates 90–91.
- 9. B. 8, Hind 1. Haverkamp-Begemann 1980, p. 168.

36a: Rembrandt, *The Holy Family with the curtain*. Kassel, Staatliche Kunstsammlungen, Gemäldegalerie Alte Meister.

36b: Andrea Mantegna, *The Virgin and Child*. Berlin, Kupferstichkabinett SMPK.

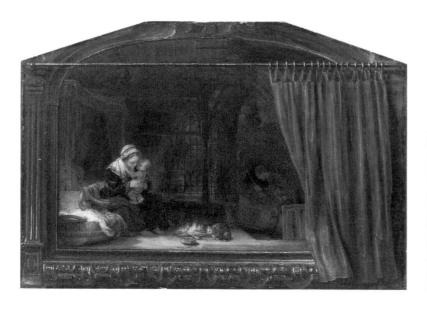

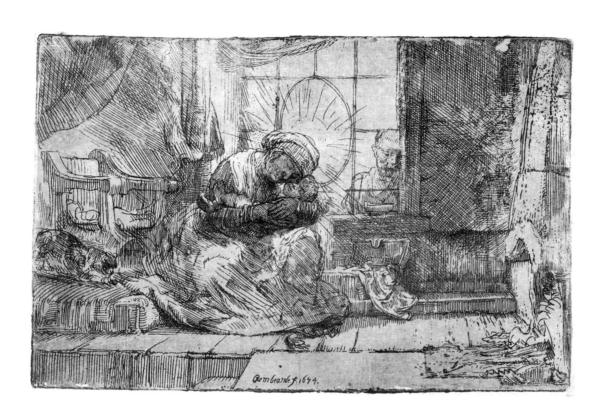

37 The Descent from the Cross by torchlight

Etching, worked over with drypoint, 210 × 161 mm; 1 state Signed and dated: *Rembrandt.f. 1654*. B./Holl. 83; H. 280; White, p. 81

Berlin: (143-16)

Amsterdam: (O. B. 147) London: (1973 U. 1084)*

In the early 1650s Rembrandt focused his attention on a subject that had concerned him throughout his career: the Life and Passion of Christ. In his capacity as a printmaker, he produced various biblical scenes that were probably intended as groups or cycles, even if the relationship of the sheets seems relatively loose and the series incomplete. Rembrandt's interest in the iconographic tradition in sixteenth-century printmaking of treating subjects in a series would have given a decisive impetus to his own cyclical arrangement of biblical material.¹

As well as a small-scale series of scenes from the Childhood of Jesus of 1654 (see Cat. No. 36), Rembrandt produced a large-scale Passion of Christ.² The Presentation in the Temple, The Descent from the Cross, The Entombment (Fig. 37a) and Christ at Emmaus belong to this series.³ The sheets are alike in size, technique and use of line; two of them are dated 1654, including The Descent from the Cross.⁴ Characteristic of this group is the block-like construction of compositions dependent on strong horizontal and vertical lines.

The deposition takes place in darkness; a torch at the left is the only source of light. The dead body of Christ has just been taken down with the help of a large white cloth, and lies in the arms of a helper. Another helper, standing below the earthen bank, stretches out his arms, in order to take hold of the corpse. In the foreground, Joseph of Arimathea spreads a shroud out on the bier that is to serve as Christ's last resting place.

In the Gospels the event is only briefly described: a rich councillor, Joseph of Arimathea, asked Pilate for the dead body of Christ; he took it down from the cross, wrapped it in a cloth, and laid it in a rock tomb. From the Middle Ages the scene was

shown with increasingly more attendants, above all Mary and a group of mourners. The group around Mary, in particular, often took on an important place in the depiction; in Rembrandt's etching, however, this group is pressed into the background and can hardly be detected in the darkness.

Rembrandt's scene differs decisively from iconographic tradition in another way: the cross is not at the centre of the scene, but is visible only as a fragment at the left edge. The group of helpers around the cross with the body of Christ is isolated by the horizontal line of the earthen bank and the vertical lines of both the cross on the left and the building in the right background, and thus constitutes an independent subject within the scene as a whole. The bright lighting of the group also adds to this effect. One almost has the impression that the figures are carrying out their tasks in the narrow space of a reliquary, and this prompts a contemplative viewing of the scene.

Another skilfully devised motif, on the other hand, takes up the whole of the foreground: the preparation for the Entombment. Here we see the bier with the shroud laid across it; it is as brightly lit as the cloth and the body of Christ being taken down from the cross, and in terms of the composition it constitutes a clear parallel to the corpse. Rembrandt does not show the moment at which Christ is wrapped in the cloth, but rather the individual phases of action that lead up to this moment. The gestures of the friends seem to be made in calm understanding: while one helper, notable for the heavy load he bears, supports the body in his arms—for the remaining nail has yet to be removed from Christ's foot—another companion already stretches out his hands in order to take the body, and Joseph of Arimathea, meanwhile, is seen spreading out the shroud. The composition culminates in the motif of the hand, picked out by the light from the torch and so set off against the darkness, towards which Christ's head sinks.

In combining the Deposition with the preparation for the Entombment, Rembrandt's etching constitutes an iconographic exception. Rembrandt had often treated the subject of the Deposition.⁵ The painting of 1633 from the Passion cycle for Frederik Hendrik emerged from a close concern with Rubens's Antwerp *Deposition*.⁶ The 1633 etching closely follows the pictorial arrangement of the painted version albeit in reverse, (see Introduction, Fig. 6) but it adds the motif of the shroud that was to retain its central place and importance in the later, 1654, version.⁷

Like the other three sheets of the Passion,

the *Deposition* is almost entirely etched; additions with drypoint are only to be found in isolated places. The application of line with long, diagonally drawn parallel hatching strokes was a result of Rembrandt's interest in the copper engravings of Andrea Mantegna (see Cat. 36).

H.B.

- 1. Tümpel 1977, p. 103.
- 2. The following belong to the first series: B. 45, 47, 55, 60, 63 and 64.
- 3. B. 50, 83, 86, 87.
- 4. The view that the four sheets were intended as a cycle is not undisputed; Münz Vol. II, p. 110, Nos. 240–241 denies the connection between them and give the two undated sheets B. 50 and B. 86 as later, to the late fifties.
- 5. On this, see Stechow 1929.
- 6. Corpus A65.
- 7. B. 81. The *Deposition* in Leningrad, dated 1634 and signed by Rembrandt, where the motif of the shroud in the foreground is even more strongly stressed, is no longer accepted by the Rembrandt Research Project as authentic; *Corpus* C49.

37a: Rembrandt, *The Entombment*. Amsterdam, Rijksprentenkabinet.

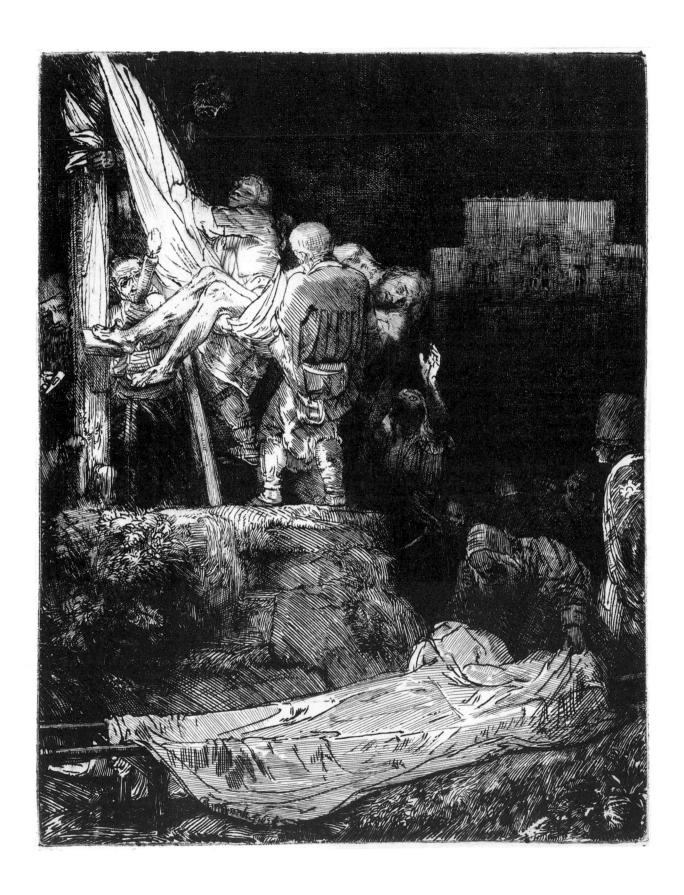

Ecce Homo

Drypoint, 383×455 mm; from IV 358×455 mm; 8 states Signed and dated: (from VII) *Rembrandt f.* 1655 B./Holl. 76; H. 271; White pp. 87–92

First version (I–V)

Berlin: I on Japanese paper (93–1892)*
Amsterdam: III on Japanese paper (75:1; cited in Holl. as English private collection)
London: IV (1868–8–22–665)

Second version (VI–VIII)

Berlin: VIII (635:16; with later additions at the upper edge)

Amsterdam: VIII (62:121)

London: VIII on Japanese paper (1973 U. 931)*

38 State I State VIII

38a: Lucas van Leyden, *Ecce Homo*. Berlin, Kupferstichkabinett SMPK.

competition with the inventions of masters of previous generations was a part of artistic practice. Theorists celebrated competition between artists, and art collectors valued this programmatic demonstration of virtuosity. The work of Lucas van Levden, above all his engravings, constituted a special model for emulation in seventeenth-century Holland. In 1614 the Humanist Scriverius (Fig. 22d) said of Rembrandt's home town, Leiden: 'This city has been praised as much through Lucas's fame As for the wools and linens that also bear its name'.1 The deceased Leiden artist Willem van Swanenburg, the brother of Rembrandt's teacher Jacob Isaacsz. van Swanenburg, was praised by Scriverius as a 'new Lucas van Leyden'.2 The appreciation for Lucas van Leyden as a virtually unsurpassable engraver was a provocation to artists to enter into competition with him. Thus Goltzius engraved a Passion series in the manner of Lucas van Leyden, yet with his own distinct style in the movement of figures and other aspects of the work, which should not be underrated.3 Thus for seventeenth-century connoisseurs it was obvious that Rembrandt's late Ecce Homo was based on a critical examination of Lucas van Leyden's version of the scene (Fig. 38a). Rembrandt had acquired works by this predecessor for a vast sum, as early as 1637, among them the Ecce Homo.4 It was only in the period around 1655, however, that Rembrandt made his own Ecce Homo, to compete with Lucas van Leyden. Possibly conceived as a pendant to the Three Crosses (Cat. No. 35), the Ecce Homo is similarly executed throughout in drypoint, and it marks a further highpoint in Rembrandt's late work as an etcher. As in the Three Crosses, Rembrandt embarked on a full reworking of the plate after the first version had gone through several states.

It was not only in the seventeenth century that

Rembrandt had turned to the subject of the Ecce Homo as early as the 1630s. A grisaille sketch⁵ was made in preparation for the earlier etching, which was then largely executed by Van Vliet (Fig. 38b).6 In this work from Rembrandt's first Amsterdam period, the dialogue between Pilate and the High Priest, who have taken upon themselves the power of judgment, is recorded with theatrical gestures.⁷ The thrusting mob must be appeased. The confusion of figures and contrary movements in the narrow space establish a mood of dramatic disturbance. Christ is removed from this aggressive bustle, through the patience conveyed in the expressive power of both his pose and his face.

Our etching, on the other hand, clearly shows the altered narrative style of Rembrandt's work of the 1650s. A strongly centred figural narrative has taken the place of the earlier lively, diagonally arranged composition. We are presented with figures who act with rather restrained gestures, placed as if in a relief, in front of the architectural façade. The spacious setting evoked on the sheet is taken up with imposing buildings. Stone figures of Justice and Fortitude identify this as the place of judgment and constitute a frame for the main scene. The principal figures rise up in front of the black hollows of the entrance to the palace. Christ, with his hands bound and his head bare, is shown to the people. Pilate, wearing a turban and carrying the justicial rod, points to him. Behind them stands Barabbas, the real criminal. It is unusual for Barabbas to be included in scenes of the Ecce Homo; and only a few examples are to be found in iconographic tradition.8

Rembrandt here defines his own pictorial narrative through deliberate reference to the biblical text. The variety of his motifs accurately reflects the complexity of the biblical account. Thus he illustrates the full breadth of the narrative. For example, a figure standing next to the left stone pedestal, already holds a water jug and a bowl, in which Pilate will innocently wash his hands. The Governor's wife leans at a window on the left; and, in the shadowy interior of the palace, only detectable as a silhouette, is the messenger who has just taken his leave of her in order to report her warning dream to her husband.

In the *Ecce Homo* etching Rembrandt does not use a uniform scale for his figures. With a form of hierarchical perspective, the figures on the platform are shown larger than those among the crowd in the foreground, thus negating their greater distance from the viewer. Particularly striking is the figure seated by the left parapet who seems to be recording the

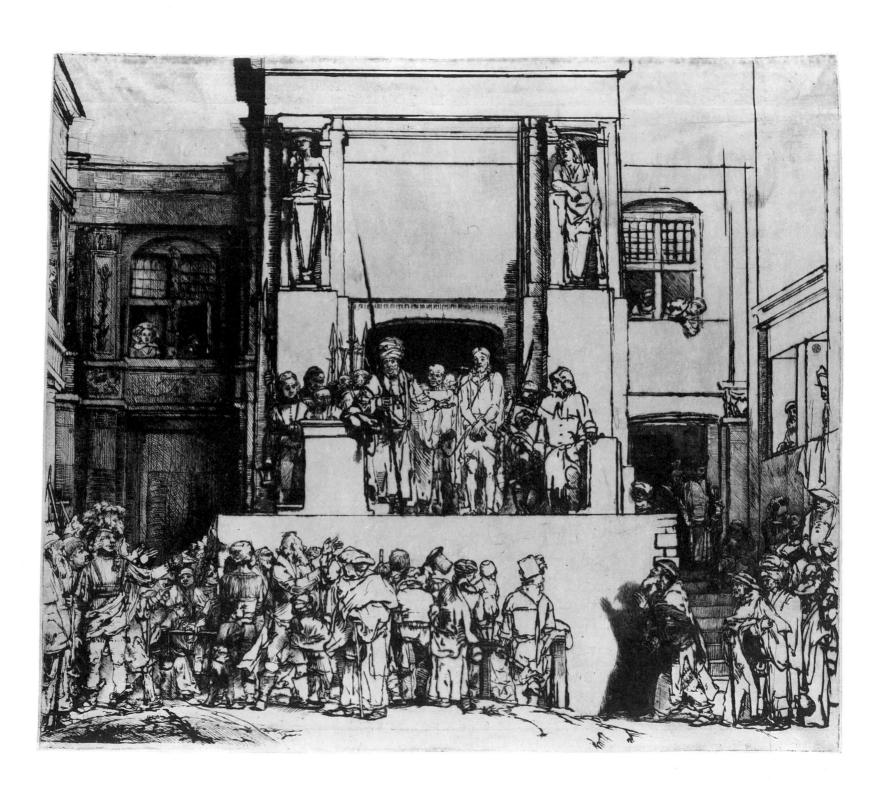

event in writing or, more probably, in a drawing. Rembrandt integrates an 'artist-chronicler' of this sort into other scenes, for example the oil sketch for *John the Baptist preaching*, ¹⁰ and some of the landscape etchings. ¹¹ However, it remains uncertain whether Rembrandt intended this figure as a commentary on the role of the artist.

Rembrandt obviously selected the Renaissance model (Fig. 38a) as the starting point for the composition of his own Ecce Homo etching.12 The marked spaciousness of Lucas van Leyden's print, where the view is drawn to the far distance in an almost calculated manner, is replaced in Rembrandt's scene with an imposing building that runs across the whole picture plane with hardly any recession in depth. One has the impression, nonetheless, that Rembrandt had been looking at Lucas van Leyden's engraving while he was at work on the first version of his own drypoint etching. If one considers the way an etched image comes about, with the drawing as marked on the plate reversed in the printed form of the image, a large number of borrowed motifs are apparent. Thus, for example, the architectural façade on the left, with figures leaning out of the windows, and the staircase placed nearby, are conceived in analogy with Lucas van Leyden's sheet. The group of figures in the earlier work standing in front of this staircase, and so linking the figures at the side with the main event, has been concentrated, in Rembrandt's scene, into a single male figure, dramatised both through its pose and through the lighting which repeats its gesture in the form of a sharp cast shadow. The figure with a stick and a purse standing out from the crowd in the foreground is also derived from a model in the earlier work, although without in the least being a copy. While the bare-headed man between Christ and Pilate is only one of Pilate's henchmen in the Lucas van Leyden scene, Rembrandt makes him Barabbas.

Around 1600, appreciation for Lucas van Leyden had focused, above all, on his engraving manner. Thus, Karel van Mander writes of Goltzius: 'In as far as he could realise that which constituted the particular character of the style of any master whose works he had previously come to know, he could, with his own hand alone, bring to expression the peculiarities of several hands in compositions that were of his own invention.' It was above all in the imitation of earlier manners of engraving that Goltzius and other artists of his generation saw a challenge.

Competition with Lucas van Leyden's manner did not correspond to Rembrandt's artistic ideal. The *Ecce Homo* etching is, indeed,

executed in Rembrandt's own, unmistakeable 'handwriting'. The figures are established with a few, broken lines. Continuous contours are avoided. This use of line clearly stems from his experience as a draughtsman. In contrast to this, the shaded regions are darkened through the use of concentrated hatching. By these means, Rembrandt clearly establishes a different form of competition with his source than that undertaken by artists of the previous generation.

It is striking that in the *Ecce Homo* and *The Three Crosses*, possibly conceived as pendants and with linked subjects and a similar size, the difference of narrative style is crucial: in *The Three Crosses* the powerful drama of the event dominates the composition. One could ask, however, if in these two etchings Rembrandt has substituted variations of narrative style for the variations in engraving style so praised by Karel van Mander in the work of Goltzius.

The first version (states I to V) of the *Ecce Homo* is not signed. However, a large number of impressions have survived; some of them—for example, the sheet in London—on Japanese paper. For this reason, one is tempted to describe this as a final composition intended for sale and not as a rejected working stage.

For the fourth state of the etching, Rembrandt reduced the size of the plate, presumably to make it compatible with standard paper sizes. The impressions of the earlier states are printed on paper with a narrow strip attached to the upper edge. After five states the artist introduced a fundamental change into the composition, comparable to the full re-working of The Three Crosses. After making the trial proof state VI, Rembrandt signed and dated (1655) this second variant of the Ecce Homo in state VII, thus acknowledging it as finished. The eighth and last state simply corrects a few shadings. Rembrandt had repolished the plate in the foreground and removed the crowd grouped below the tribune. The most striking of a large number of changes is the introduction of the two dark cellar arches and, between them, the sculpted, half-length figure of a bearded old man, who supports his head with his right hand. Through an emphatic distribution of light and shade, the figure of Fortitude acquires a greater liveliness and, above all, a fierce facial expression. Lastly, Rembrandt re-works the physiognomies of the main group.

Lucas van Leyden's exemplary status plays no part in Rembrandt's second version of the *Ecce Homo*, as is immediately apparent. Rembrandt now finds his starting point exclusively in his own composition. There has been much controversy over Rembrandt's

motivation in subjecting the already finished plate to this fundamental re-working. Was it principally aesthetic considerations that caused dissatisfaction with the first version? Or was Rembrandt striving to articulate distinct aspects of content? Probably, it would not be constructive to pursue these possibilities in strict opposition to each other. The meaning of the second version must, in any case, count as yet unexplained in many respects. Above all, the stone figure remains a mystery. It has been identified as Neptune,14 but also as Adam. The Father of Mankind had committed the original sin, but he is redeemed by Christ in his role as the 'new Adam'. 15 It is, however, to be observed that Rembrandt challenges the viewer to a new form of dialogue with the event. The removal of the foreground arena with the gesticulating crowd reduces the sense of depth. By means of this device, the side figures draw closer towards the main group, while still retaining their framing role. The imposing block of the tribune is strongly balanced through axial symmetry, and this increases the impression of restrained action. The scene is concentrated on the two protagonists. The pictorial narrative reaches its climax in Pilate's decision of conscience, a decision in which the viewer participates.

The *Ecce Homo*, with its elaborate process of development and radical alteration into a second independent version, is yet another witness to Rembrandt's constant concern with his own narrative style.

- 1. English translation cited from English edition of Schwartz (1985), p. 24.
- 2. See Schwartz (1985), p. 24.
- 3. Karel van Mander (1906), p. 247.
- 4. B. 71; Urkunden 51.
- 5. National Gallery, London; Paintings Cat. No. 15.
- 6. B. 77; Royalton-Kisch 1984.
- 7. Berlin 1970, No. 96.
- 8. See Winternitz 1969.
- 9. Matthew 27: 15-26.
- 10. Gemäldegalerie, Berlin; Paintings Cat. No. 20.
- 11. See The Three Trees, Cat. No. 19.
- 12. Münz 235 has referred to further possible sources of inspiration for individual elements of the composition.
- 13. 'Want bedenckende wat hij [Goltzius] over al voor handelinghen hadde ghesien, heeft hy met een eenighe hant verscheyden handelinghen van zijn inventie getoondt'. Karel van Mander 1906, p. 243.
- 14. White 1969, p. 90.
- 15. Winternitz 1969.

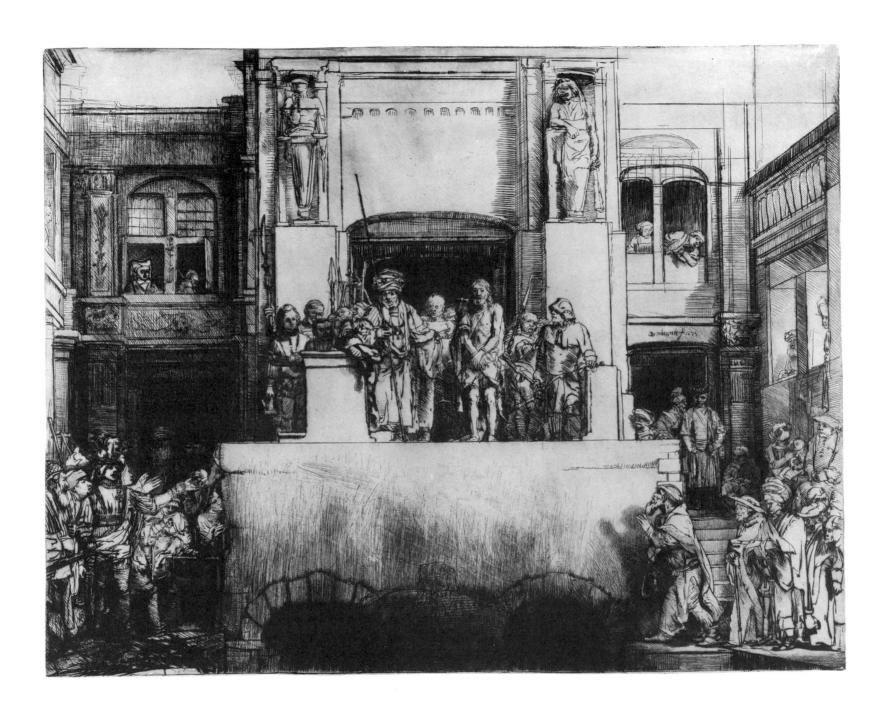

39

Abraham's Sacrifice

Etching and drypoint, 156×131 mm; I state Signed and dated: *Rembrandt f* 1655 ('d' and '6' reversed)

B./Holl. 35; H. 283; White pp. 92-93

Berlin: I on Japanese paper (53-16);

I (54-16)

Amsterdam: I (62-14)*

London: I on Japanese paper (1973 U. 1091)

39a: Rembrandt, *Abraham and Isaac*. Leningrad, Hermitage.

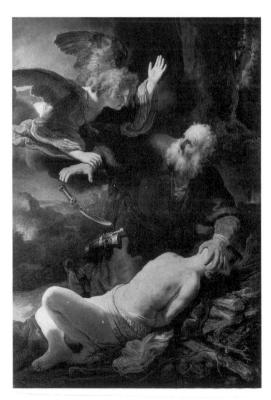

In 1655, the year of the dated state of the Ecce Homo (Cat. No. 38), Rembrandt etched Abraham and Isaac. Abraham is about to sacrifice Isaac at God's bidding. At the last moment, however, he is restrained by an angel. Rembrandt had already treated this subject in 1635, at the high-point his first Amsterdam period. The large-scale painting (Fig. 39a) depicts the event in terms of powerful physical action.1 Abraham roughly pushes down the head of the bound Isaac while the angel suddenly grasps Abraham's arm, so that the knife falls from his hand. In 1645 Rembrandt etched another scene from this biblical storythe dialogue between Abraham and Isaac before the sacrifice.² In 1655 Rembrandt turned once again to the sacrifice itself. Here the mood of the event is thoroughly altered. Rembrandt 'interprets the Biblical text with greater independence of descriptive details and with deeper human insight. Isaac is no longer stretched out like any sacrificial victim. He kneels with an innocent submissiveness beside his father, who presses the son's head to his own body. It is a gesture infinitely more human than the one in the earlier version. The angel appears from behind Abraham, grasping both his arms with an embrace that is powerful and highly symbolic.'3 Rembrandt has succeeded in making abundantly clear both Abraham's obedience and his inner torment.

The change of narrative style, in which dramatic, theatrical action and exaggerated gesture give way to an increasingly psychological record of the event, is a typical measure of Rembrandt's artistic development. The change in approach to this subject may also have been prompted by the treatment of the event in the Antiquitates Judaicae of Flavius Josephus. Occasionally, Rembrandt drew on this work, treating it as a supplement to iconographic tradition and the biblical text.4 After describing the walk to the place of sacrifice, the dialogue between father and son, and Abraham's declaration of his intention to sacrifice Isaac, Josephus goes on: 'Isaac, however, noble-minded as the son of such a father, responded obediently to what had been said and, in turn, declared that it would not have been worth his being born if he did not obey what God and his father had decided for him, as it would be wrong enough to be disobedient even if it had been his father alone who had issued the order. And thereupon he approached the altar in order to be slaughtered. And certainly he would have been, had God had not prevented it. For he called Abraham by his name and told him to refrain from the killing of his son. He, the Lord, was not thirsty for human blood, nor had he demanded the

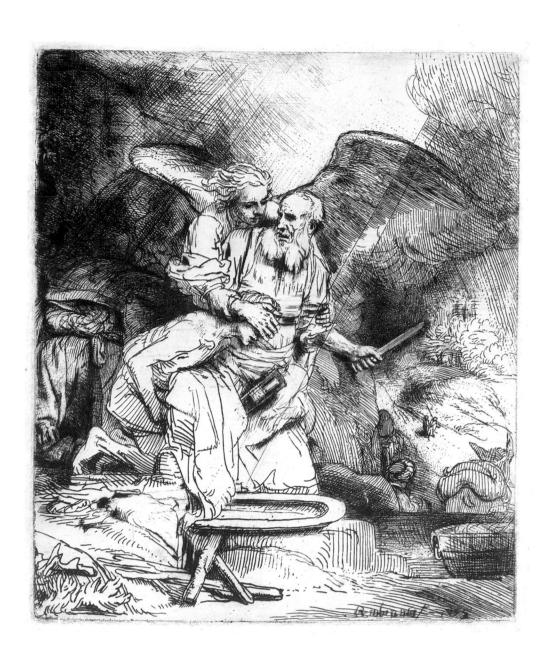

death of Isaac in order so grimly to take back from the father that which he had himself given him. He had done this, rather, because he wished to test Abraham *5

Rembrandt refers to this interpretation of the event with its stress on Isaac's obedience, by depicting him unbound. The readiness to be sacrificed is especially clear in the fact that Isaac has lain aside his clothing. The scene takes place on a cliff ledge, and below one can see the servants left behind and with an ass. This arrangement of motifs is found in the iconographic tradition for this subject, the servant boys embodying, beyond the context of the narrative, 'the blind of spirit, who do not perceive the divine hand of God in human affairs'.6

The figures are set off against the finely detailed background as simply and boldly outlined forms with only summary shading. Divine light floods the darkness falling on the group from behind. In this region the etching shows traces of re-working: the outline of the angel's left wing has been burnished out and replaced. As also in the etching of Jupiter and Antiope (Cat. No. 40) the whole scene has been bitten, deepening the shadows with the burin and with drypoint. Thus, one can detect several distinct working processes taking place before the production of the first surviving state. In contrast to what we find in The Three Crosses (Cat. No. 35) or in the Ecce Homo (Cat. No. 38), the corrections concern details, but not the interpretation of the event.

Rembrandt used the same composition, albeit reversed, in the background of his painting Old Man as Saint Paul, dated 165(9?).7 Rembrandt's pupils also used his motif, reversed, as a model; for example Ferdinand Bol, in a drawing ascribed to him,8 and a pupil of the 1660s (Titus van Rijn?) in a painting9 and the preparatory drawing for it.¹⁰ No detailed drawings survive in Rembrandt's hand, which prepare the etching in reverse. What we now know of Rembrandt's working methods suggests that it is unlikely that there were any such drawings.11 On the contrary, he must have sketched the composition directly on the plate. Rembrandt did, however, make counterproofs (prints taken from the wet proof) of the etching, of which one is in Berlin (Fig. 39b) and one in London. These counterproofs of the 1655 etching were apparently used by Rembrandt and his workshop as models for further images of the Sacrifice of Isaac. 12 B.W.

- 1. Leningrad; paintings Cat. No. 21.
- 2. B. 34.
- 3. Rosenberg 1968, p. 176.
- 4. See Tümpel 1984.
- 5. Flavius Josephus (1979), p. 51.
- 6. Berlin 1970, No. 9.
- 7. London 1988/89, No. 15.
- 8. Stichting P. and N. de Boer, Amsterdam; Sumowski Vol. I, No. 173; see also Amsterdam 1985 ('Bij Rembrandt in de leer'), No. 50.
- 9. Private collection. Sumowski, Vol. IV, 1990, No. 1976; Bruyn 1990.
- 10. Musée Vivenel, Compiègne. In contrast to Sumowski (1971 and 1990, No. 1976) Bruyn 1990 ascribes this drawing to the same pupil as had produced the painting.
- II. On this print, see the general essay by Van de Wetering; 'Painting materials and working methods', in *Corpus* I, pp. II-33; Giltaij 1989 and Royalton-Kisch 1989.
- 12. Surprisingly, Bruyn 1990 does not consider the counterproofs of the etching of *Abraham and Isaac*, though in 1983, pp. 55 ff. he had pointed in general form to the use of counterproofs as composition models in the Rembrandt workshop.

39b: Rembrandt, *Abraham and Isaac*. Counterproof. Berlin, Kupferstichkabinett SMPK.

40

Jupiter and Antiope (the large plate)

Etching, burin and drypoint, 138 × 205 mm; I state (a second state is not by Rembrandt) Signed and dated: Rembrandt f. 1659 B./Holl. 203; H. 302; White pp. 185-86

Berlin: I on Japanese paper (297–16) Amsterdam: I on Japanese paper (O.B. 435) London: I (1855-4-14-266)*

Berlin, Kupferstichkabinett SMPK.

40b: Annibale Carracci, Jupiter and Antiope. London, British Museum.

40a: Rembrandt, Jupiter and Antiope, (small plate).

Jupiter approached the sleeping Antiope, daughter of the king of Thebes, in the guise of a satyr. Made pregnant by him, the young woman fled, but was captured and then enslaved. Her twin sons, Amphion and Zethos, once grown to manhood, avenged their mother's suffering. In painting, and above all in sixteenth- and seventeenth-century prints, the subject was very popular. Rembrandt himself treated it in an early etching in about 1631, at the end of his Leiden period (Fig. 40a).⁵ The character of this early print is, however, entirely different. Behind the brightly lit female nude, the shadowy male figure intrudes into the woman's chamber. The later print, on the other hand, shows Antiope and Jupiter as a couple. The composition is based on an engraving by Annibale Carracci (Fig. 40b).6 Rembrandt adopted the general arrangement of the figures and the composition, but he made significant changes. The scene is reduced to, and attention concentrated on, the actions of the two protagonists. Amor with his bow is excluded and Annibale's landscape view is not adopted. Instead, Rembrandt integrates the unworked paper surface into the composition. Finally, Rembrandt's scene lacks the curtain that Carracci uses to separate the action from the viewer's space. The narrative thus gains in

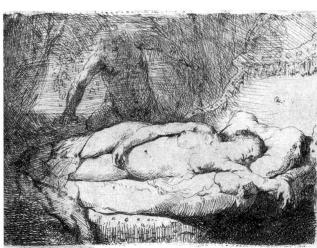

directness: the viewer becomes a witness to the satyr's cautious and intimate approach.

It seems also that the pose of the female figure has been deliberately altered. She bends one arm over her head. This reclining pose is part of a long tradition: it is found in the work, among many others, of Correggio⁷ or Titian⁸ and it is ultimately derived from the Antique model of the *Sleeping Ariadne* in the Vatican.⁹ In this etching Rembrandt thus again displays his knowledge of Italian art. Röver, in his sale catalogue of 1731 speaks of 'de Nimph, (en de) satyr op zijn Italiaansch geetst' (a nymph and satyr etched in the Italian manner).¹⁰

The etching Jupiter and Antiope belongs to the group of Rembrandt's late prints.11 Between 1658 and 1661 the artist was once again more strongly preoccipied with the female nude. As well as etchings, 12 a series of drawings has also survived, for example the sheet in Amsterdam (Fig. 40c).¹³ In contrast to his earlier presentation of the nude,14 Rembrandt here achieves a new monumentality. The exploration of the figure's undulating surface is no longer the main interest in the scene, but rather the study and record of chiaroscuro. The etching Jupiter and Antiope is striking for its refined distribution of light and shade to provide subtle modelling of the woman's body. On close examination, at least of the best proofs,15 three printing techniques can be clearly detected: etching, engraving and drypoint, used by Rembrandt to develop the chiaroscuro effects. The figure as a whole is first established with etching. After the etching process, further refinements are added. Thus, for example, the face is first established through the dark, clear lines of the etching. In the second step, drypoint lines are added, recognisable in that, when printed, they are accompanied by burr-shadows running alongside them—where the printing ink has been caught on the upraised ridges of the plate. Finally, Rembrandt adds lines engraved with the burin. These have a so-called taille and taper off at the ends. The hatching strokes on the woman's cheek, for example, are made with the burin. Such refinements can also be found within the lines used on the stomach of the sleeping woman. The etched lines were overlaid with drypoint. On the lighter parts, the less incisive engraved lines are set off from the darkly etched ones. The scene of Jupiter and Antiope is thus evidence of Rembrandt's use of a variety of techniques.

The various working processes that have been described were all brought into play before the production of the first surviving state, even if one may assume that Rembrandt made trial proofs for himself during the working process. Thus the signature itself is etched. The completion with drypoint and burin is not a record of distinct stages of composition; this approach is intended, rather, to give the work its 'finish'.

B.W.

- 1. No. 30; Urkunden 346.
- 2. See White 1969, 185; Van Gelder/Van Gelder-Schrijver 1938, p. 12.
- 3. Van Gelder/Van Gelder-Schrijver 1938, p. 12.
- 4. G. 195.
- 5. B. 204. This sheet has been variously identified in the literature. It has also been cited as *Venus and a Satyr* or—because of the shower of golden rain—listed as *Jupiter and Danaë*, as in Röver's inventory.
- 6. B. 17; dated 1592.
- 7. Painting of Jupiter and Antiope; Louvre, Paris.
- 8. Painting of *Bacchanal* or *The Andrians*; Prado, Madrid. 9. A copy after a Hellenistic original in the Vatican; see
- 9. A copy after a Hellenistic original in the Vatican; see Bober/Rubinstein 1986, No. 79. This sculpted figure was drawn, for example, by Goltzius during his travels in Italy (Teylers Museum, Haarlem).
- 10. Cat. No. 63; Van Gelder/Van Gelder-Schrijver 1938, p. 12.
- 11. In the last years of his life the artist seems to have made no more etchings (the single exception being the portrait of Jan Antonides van der Linden, dated 1665, B. 264). The reasons for this are not known.
- 12. B. 197; B. 199; B. 200; B. 202; B. 205.
- 13. Benesch 1137; Schatborn 1985, no. 52; see also Drawings Cat. No. 32 (Benesch 1122).
- 14. See Cat. No. 6.
- 15. The impression in London is one of the earliest made from the plate: it reveals rough plate edges, and the parts worked in drypoint are especially brilliant. The impression also shows traces of surface tone.

40c: Rembrandt, *Sleeping female nude*. Drawing. Amsterdam, Rijksprentenkabinet.

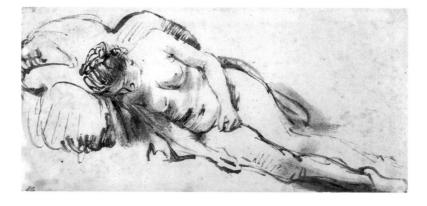

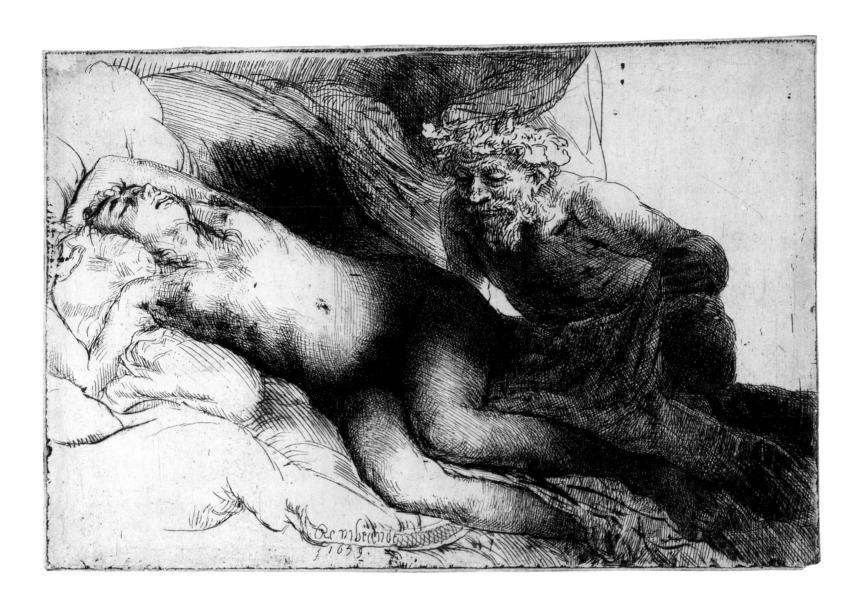

Bibliography

Albach 1979

Ben Albach, 'Rembrandt en het toneel', De Kromek van het Rembrandthuis, 31 (1979), p.2–32.

Alpers 1989

Svetlana Alpers, Rembrandt's Enterprise. The Studio and the Market, Chicago 1988.

Anzelewsky/Mielke 1984

Fedja Anzelewsky and Hans Mielke, Albrecht Dürer. Kritischer Katalog der Zeichnungen. Die Zeichnungen alter Meister im Berliner Kupferstichkabinett, Berlin 1984.

Adam Bartsch, Toutes les Estampes qui forment l'œuvre de Rembrandt et ceux de ses principeaux imitateurs, composé par les Sieurs Gersaint, Helle, Glomy et P. Tver, Vienna 1797.

Adam Bartsch, *Le Peintre-graveur*, I–XII, Vienna 1802–1821.

Bakker 1990

B. Bakker, 'Het onderwerp van Rembrandts ets De Drie Boerenheuzen', *Kroniek van het Rembrandthuis* (1990), pp. 21–29.

Baldwin 1985

Robert W. Baldwin, "On earth we are beggars, as Christ himself was". The Protestant Background of Rembrandt's Imagery of Poverty, Disability and Begging', *Konstbistorisk tidskrift* 54 (1985), pp. 122–35. v. Bastelaer 1908

R. van Bastelaer, Les estampes de Peter Bruegel l'Ancien, Brussels 1908.

Bauch 1960

Kurt Bauch, Der frühe Rembrandt und seine Zeit. Studien zur geschichtlichen Bedeutung seines Frühstils, Berlin 1960. Benesch 1928

Otto Benesch, Die Zeichnungen der niederländischen Schulen des XV. und XVI. Jahrhunderts (Beschreibender Katalog der Handzeichnungen in der Graphischen Sammlung Albertina, Vol. 2), Vienna 1928.

Ben.

Benesch 1954-1957

Otto Benesch, *The Drawings of Rembrandt*, I–VI, London 1954–1957.

Benesch 1973

Otto Benesch, *The Drawings of Rembrandt*, I–VI, enlarged and edited by Eva Benesch, London/New York 1973. Bergström 1956

Ingvar Bergström, Dutch Still-Life Painting in the seventeenth Century, London 1956.

Białostocki 1973

Jan Białostocki, 'Der Sünder als tragischer Held bei Rembrandt', *Neue Beiträge zur Rembrandt-Forschung* ed. O. von Simson and J. Kelch, Berlin 1973, pp. 137–50. Bierens de Haan 1948

J.C.J. Bierens de Haan, L'œuvre gravé de Cornelis Cort, graveur bollandais 1533–1578, The Hague 1948.

Blankert 1982

Albert Blankert, Ferdinand Bol (1616–1680), Rembrandt's pupil, Doornspijk 1982.

Bober/Rubinstein 1986

P.P. Bober and R. Rubinstein, Renaissance Artists and Antique Sculpture. A Handbook of Sources, London 1986. Bock-Rosenberg 1930

E. Bock and J. Rosenberg, Staatliche Museen zu Berlin. Die Zeichnungen alter Meister im Kupferstichkabinett. Die Niederländischen Meister, Berlin 1930.

Bredius/Gerson 1935/1969

A. Bredius, *The Complete Edition of the Paintings*, revised by H. Gerson, London 1969; first edition 1935.

Broos 1977

B.P.J. Broos, Index to the formal sources of Rembrandt's art, Maarsen 1977.

Broos 1081

B.P.J. Broos, review of Walter L. Strauss and Marjon van der Meulen, *The Rembrandt Documents*, New York 1979, *Simiolus* 12 (1981–82), pp.245–62.

Broos 1981-A

Ben Broos, Rembrandt en tekenaars uit zijn omgeving. Oude tekeningen in het bezit van de Gemeentemusea van Amsterdam, waaronder de collectie Fodor, III, Amsterdam 1981.

Broos 1983

Ben Broos, 'Fame shared is fame doubled', *The Impact of a Genius, Rembrandt, his Pupils and Followers in the seventeenth Century, Paintings from Museums and Private Collections*, Amsterdam 1983; with contributions by Albert Blankert, Ben Broos, Ernst van de Wetering, Guido Jansen and Willem van de Watering.

Bruyn 1982

J. Bruyn, 'The documentary value of early graphic reproductions', *Corpus* I, 1982, pp. 35–51.
Bruyn 1983

J. Bruyn, 'On Rembrandt's Use of Studio-Props and Model Drawings during the 1630s', Essays in Northern European Art presented to Eghert Haverkamp-Begemann on his sixtieth birthday, Doornspijk 1983, pp. 52–60. Bruyn 1990

J. Bruyn, 'An assistant in Rembrandt's Workshop in the 1660s', *The Burlington Magazine* 132 (1990), pp. 714–18.

Campbell 1980

Colin Campbell, 'Rembrandts etsen "Het sterfbed van Maria" en "De drie bomen", *De Kroniek van bet Rembrandthuis* 32 (1980), pp. 2–33.

Carstensen/Henningsen 1988

H. Th. Carstensen and W. Henningsen, 'Rembrandts sog. Dr. Faustus; zur Archäologie eines Bildsinnes', *Oud Holland* 102 (1988), pp. 290–312.

Chapman 1990

H. Perry Chapman, Rembrandt's Self-portraits, A Study in Seventeenth-Century Identity, Princeton 1990.

Kenneth Clark, Rembrandt and the Italian Renaissance, London 1966.

Corpus I/III

J. Bruyn, B. Haak, S.H. Levie, P.J.J. van Thiel, E.v.d. Wetering, *A Corpus of Rembrandt Paintings*, I, 1625—1631, The Hague, Boston, London 1982; II, 1631–1634, Dordrecht, Boston, Lancaster 1986; III, 1635–1642, Dordrecht, Boston, London 1989.

Dickel 1987

Hans Dickel, Deutsche Zeichenbücher des Barock. Eine Studie zur Geschichte der Künstlerausbildung, Hildesheim, Zürich, New York 1987.

Documents

Walter L. Strauss and Marjon van der Meulen, with contributions from S.A.C. Dudok van Heel and P.J.M. de Baar, *The Rembrandt Documents*, New York 1979. Dudok van Heel 1977

S.A.C. Dudok van Heel, 'Jan Pietersz. Zomer (1641–1724)—Makelaar in Schilderijen (1690–1724)', Jaarboek Amstelodamum 69 (1977), pp. 89–106.

Dudok van Heel 1979

S.A.C Dudok van Heel, 'Willem Bartel(omeu)sz Ruyters (1587–1639) Rembrandt's bisschop Gosewijn', Maandblad Amstelodamum 66 (1979), pp. 83-87.

Van Eeghen 1956

I.H. van Eeghen, 'De Kinderen van Rembrandt en Saskia', *Maandblad Amstelodamum* 43 (1956), pp. 144–46. Van Eeghen 1985

I.H. van Eeghen, 'Rembrandt en de veilingen', Jaarboek Amstelodamum 77, 1985, pp. 62–63.

Emmens 1956

J.A. Emmens, 'Ay Rembrandt, maal Cornelis stem', Nederlands Kunsthistorisch Jaarboek 7 (1956), pp. 133–65. Emmens 1968

J.A. Emmens, Rembrandt en de regels van de kunst, Utrecht 1968.

FM

Frederik Muller, Beredeneerde Beschrijving van Nederlandse Historieplaten, Zinneprenten en Historische Kaarten I/IV, Amsterdam 1862–1882.

Filedt Kok 1972

Jan Piet Filedt Kok, Rembrandt etchings and drawings in the Rembrandt House, Amsterdam 1972.

Freise 1911

Kurt Freise, Pieter Lastman, sein Leben und seine Kunst, Leipzig 1911.

G.

see Gersaint

Van Gelder/Van Gelder-Schrijver 1938 J.G. van Gelder and N.F. van Gelder-Schrijver, 'De "Memorie" van Rembrandt's prenten in he bezit van Valerius Röver', *Oud Holland* 55 (1938), pp. 1–16 Gersaint 1751

Edmé-François Gersaint, Catalogue raisonné de toutes les pièces qui forment l'œuvre de Rembrandt, Paris 1751. Gerson 1961

H. Gerson, Seven letters by Rembrandt, The Hague 1961. Giltaij 1988

Jeroen Giltaij, De tekeningen van Rembrandt en zijn school in bet Museum Boymans-van Beuningen, Rotterdam 1988. Giltaij 1989

Jeroen Giltaij, 'The Function of Rembrandt Drawings', Master Drawings 27, 1989, pp. 111-17.

Goldner/Hendrix/Williams 1988

George R. Goldner, Lee Hendrix, Gloria Williams, *The J. Paul Getty Museum, Malibu, California. Catalogue of the Collections. European Drawings*, I, Malibu 1988. Grossmann 1955

F. Grossmann, Bruegel. The Paintings, London 1955. Guratzsch 1980

F. Guratzsch, Die Auferweckung des Lazarus in der niederländischen Kunst von 1400 bis 1700. Ikonographie und Ikonoligie, 2 Vols, Kortrijk 1980

н.

A.M. Hind, Rembrandt's etchings, London 1912; 2nd edition: A Catalogue of Rembrandt's etchings, London 1923.

Haak 1969

B. Haak, Rembrandt. His Life, his Work, his Time, New York 1969.

Haden 1877

Francis Seymour Haden, *The etched work of Rembrandt*, critically reconsidered, London 1877.

Hamann 1936

Richard Hamann, 'Hagars Abschied bei Rembrandt und im Rembrandt-Kreis', *Marburger Jahrbuch für Kunstwissenschaft* 8/9 (1936) pp. 471–578.

Haverkamp-Begemann 1959

E. Haverkamp-Begemann, Willem Buytewech, Amsterdam 1959.

Haverkamp-Begemann 1961

E. Haverkamp-Begemann, review of Otto Benesch, *The Drawings of Rembrandt*, London 1954–1957, *Kunstchronik* 14 (1961) pp. 10–14, 19–28, 50–57, 85–91.

Haverkamp-Begemann 1971

E. Haverkamp-Begemann, 'The Present State of Rembrandt Studies', *The Art Bulletin* 53 (1971), pp. 88–104.

Haverkamp-Begemann 1973

E. Haverkamp-Begemann, Hercules Seghers. The complete etchings (with a contribution by K.G. Boon)

Amsterdam, The Hague 1973.

Haverkamp-Begemann 1976

E. Haverkamp-Begemann, 'The Appearance of Reality, Dutch Draughtsmen of the Golden Age', *Apollo* 54 (1976) nr. 177, p.103.

Haverkamp-Begemann 1980

E. Haverkamp-Begemann, 'Creative Copies', *The Print Collector's Newsletter* 11 (1980), pp. 168–70.

Henkel 1942

M.D. Henkel, Tekeningen van Rembrandt en zijn school, Catalogus van de Nederlandse tekeningen in het Rijksmuseum te Amsterdam, I, The Hague 1942.

HdG 1906

C. Hofstede de Groot, Die Handzeichnungen Rembrandts, Haarlem 1906.

HdG Urkunden

C. Hofstede de Groot, Die Urkunden über Rembrandt (1575–1721). Quellenstudien zur holländischen Kunstgeschichte III, The Hague 1906.

Held 1963

Julius S. Held, 'The early appreciation of drawings', Latin American Art, and the Baroque Period in Europe. (Studies in Western Art. Acts of the Twentieth International Congress of the History of Art, III), Princeton, New Jersey 1963, pp. 72–95.

Held 1984

Julius S. Held, 'A Rembrandt "Theme", Artibus et bistoriae 10, 1984, pp. 21–34.

Hellerstedt 1981

Kahren Jones Hellerstedt, 'A Traditional Motif in Rembrandt's Etchings: The Hurdy-Gurdy Player', *Oud Holland* 95 (1981), pp. 16–30.

Hind

A.M. Hind, Early Italian Engraving, 7 Vols, London 1938–48.

Hind 1912 and 1923, see H.

Hoekstra 1980-84

Hidde Hoekstra, Rembrandt en de bijbel, Het Oude Testament, 1–3, Het Nieuwe Testament, 1–3, Utrecht/ Antwerp 1981–84.

F.W.H. Hollstein, *Dutch and Flemish Etchings, Engravings and Woodcuts*, ca. 1450–1700, I ff., Amsterdam 1949 ff.

C. White, K.G. Boon, Rembrandt's etchings, 2 Vols in: Hollstein's Dutch and Flemish Etchings, Engravings and Woodcuts Vol. 17–19, Amsterdam 1969.

Hoogstraten 1678

Samuel van Hoogstraten, *Inleyding tot de Hooge Schoole der Schilder-konst.* . . , Rotterdam 1678.

De Hoop Scheffer/Boon 1971

D. de Hoop Scheffer en K.G. Boon, 'De inventaris-lijst van Clement de Jonghe en Rembrandts etsplaten', *De Kroniek van bet Rembrandthuis* 25 (1971), pp. 1–17. Houbraken 1718–21

A. Houbraken, De Groote Schouburgh der Nederlantsche Konstschilders en Schilderessen 3 Vols, Amsterdam 1718–21.

Constantijn Huygens, 'Zede-printen', Profijtelijk Vermaak. Moraliteit en satire uit de 16e en 17e eeuw (Spectrum van de Nederlandse Letterkunde Vol. 10), Utrecht/ Antwerp 1968, pp 209–56.

de Jongh 1969

E. de Jongh, 'The spur of wit: Rembrandt's response to

an Italian challenge', *Delta* 12 (1969), pp. 46–66. Jordan 1893

A. Jordan, 'Bemerkungen zu Rembrandt's

Radierungen', Repertorium für Kunstwissenschaft 16, 1893. Josephus 1979

Flavius Josephus, Jüdische Altertümer, 2 Vols., trans. H. Clement (1899–1900), Wiesbaden 1979.

see: Bock-Rosenberg 1930.

Kauffmann 1920

Hans Kauffmann, 'Rembrandt und die Humanisten vom Muiderkring', *Jahrbuch der Preussischen Kunstsammlungen* 41 (1920), pp. 46–81.

Kettering 1977

A. McNeil Kettering, 'Rembrandt's Flute Player: a unique treatment of Pastoral', *Simiolus 9* (1977), pp. 19-44.

Konstam 1978

Nigel Konstam, 'Over het gebruik van modellen en spiegels bij Rembrandt', *De Kroniek van het Rembrandthuis* 30 (1978) 1, pp. 24–32.

Kris/Kurz 1980

Ernst Kris, Otto Kurz, *Die Legende vom Küunstler. Ein geschichtlicher Versuch*, Frankfurt a.M. 1980 (Vienna 1934).

Kruse 1920

John Kruse, Die Zeichnungen Rembrandts und seiner Schule im National Museum zu Stockholm, The Hague 1920, ed. Carl Neumann.

Kuretsky 1974

Susan Donahue Kuretsky, 'Rembrandt's Tree Stump: an iconographic attribute of St Jerome', *The Art Bulletin* 56 (1794), pp. 571–80.

Lendertz 1921

P. Leendertz jr., 'Nederlandsche Faust-Illustratie', *Oud Holland* 39 (1921), pp. 130–48.

Lieure

Jules Lierue, *Jacques Callot*, 5 Vols., Paris 1924–27. Lilienfeld 1914

Kurt Freise, Karl Lilienfeld, Heinrich Wichmann, Rembrandts Handzeichnungen, II, Königl. Kupferstichkabinett zu Berlin, Parchim i.M. 1914.

L

F. Lugt, Les Marques de Collection de dessins et estampes, Amsterdam 1921; Supplément, The Hague 1956. Lugt 1920

F. Lugt, Mit Rembrandt in Amsterdam, Berlin 1920. Lugt 1931

F. Lugt, 'Katalog der Niederländischen Handzeichnungen in Berlin', *Jahrbuch der Preussischen Kunstsammlungen* 52 (1931), pp. 36–80.

F. Lugt, Inventaire général des dessins des écoles du Nord, Musée du Louvre, Ecole Hollandaise, III, Rembrandt, ses élèves, ses imitateurs, ses copistes, Paris 1933.

Luijten en Meij 1990

Ger Luijten en A.W.F.M. Meij, Van Pisanello to Cézanne, Keuze uit de verzameling tekeningen in bet Museum Boymansvan Beuningen, Rotterdam 1990.

Van Mander

K. van Mander, *Het schilder-boeck*, Haarlem, 1604. Van Mander 1916

K. van Mander, *Das Lebrgedicht*, trans. R. Hoecker, The Hague 1916.

Mannocci 1988

Lino Mannocci, *The Etchings of Claude Lorrain*, New Haven and London, 1988.

Meder 1923

J. Meder, Die Handzeichnung. Ihre Technik und Entwicklung, Vienna 1923.

Meijer 1971

R.P. Meijer, Literature of the Low Countries, Assen 1971. Meiss 1936

M. Meiss, 'The Madonna of Humility', The Art Bulletin 18 (1936), pp. 434-64.

Münz 1952

Ludwig Münz, Rembrandt's Etchings, 2 Vols, London 1952.

Panofsky 1953

E. Panofsky Early Netherlandish Painting. Its Origins and Character, 2 Vols, Cambridge Mass., 1953.

G. Parthey, Wenzel Hollar. Beschreibendes Verzeichnis seiner Kupferstiche, Berlin 1853; 2nd ed. Berlin 1858. Pennington 1982

R. Pennington, A descriptive catalogue of the etched work of Wenceslaus Hollar 1607–1677, Cambridge 1982.

Walter L. Strauss, Marion van der Meulen e.a., *The Rembrandt Documents*, New York 1979.

Raupp 1984

H.-J. Raupp, Untersuchungen zu Künstlerbildnis un Künstlerdarstellung in den Niederlanden im 17. Jahrhandert, Hildesheim 1984.

Van Regteren Altena 1935

I.Q. van Regteren Altena, Jacques de Gheyn. An Introduction to the study of his drawings, Amsterdam 1935. Van Regteren Altena 1954

I.Q. van Regteren Altena, 'Retouches aan ons Rembrandt-beeld II: Het Landschap van den Goudweger', *Oud Holland 69*, 1954, pp. 1–17. Van Regteren Altena 1959

I.Q. van Regteren Altena, 'Rembrandt en Wenzel Hollar', *Kroniek van de vriendenkring van bet Rembrandtbuis* 13, 1959, pp. 81–86.

Van Regteren Altena 1983

I.Q. van Regteren Altena, Jacques de Gheyn. Three Generations 3 Vols., The Hague, Boston, London 1983. Reznicek 1961

E.K.J. Reznicek, Die Zeichnungen von Hendrick Goltzius, 2 Vols, Utrecht 1961.

Robinson 1980

F.W. Robinson, 'Puns & Plays in Rembrandt's Etchings', *The Print Collector's Newsletter* 11 (1980), pp. 165–68.

Robinson 1980/81

W.W. Robinson, "'This Passion for Prints": Collecting and Connoisseurship in Northern Europe during the Seventeenth Century', exh. cat. Boston 1980/81, pp. XXVII–XLVIII.

Robinson 1988

William W. Robinson, review of Schatborn 1985 in: *Kunstchronik* 41 (1988) pp. 579–86.

Rosenberg 1968

J. Rosenberg, Rembrandt. Life and Work, London, New York 1968.

Royalton-Kisch 1984

Martin Royalton-Kisch, 'Over Rembrandt en van Vliet', *De Kroniek van bet Rembrandthuis* 36 (1984), pp. 3–23.

Royalton-Kisch 1989

Martin Royalton-Kisch, 'Rembrandt's Sketches for his Paintings', *Master Drawings* 27 (1989), pp. 128–45. Royalton-Kisch

Martin Royalton-Kisch, 'Tradition and Innovation: the Study of Rembrandt's Drawing of the Entombment over the Raising of Lazarus' (manuscript).

0 1111

see Seidlitz. Saxl 1910

Fritz Saxl, 'Zur Herleitung der Kunst Rembrandts', Mitteilungen der Gesellschaft für vervielfältigende Kunst,

1910, pp. 41-48.

Schama 1987

Simon Schama, The Embarassment of Riches. An Interpretation of Dutch Culture in the Golden Age, New York 1987.

Schatborn 1975

P. Schatborn, 'Over Rembrandt en kinderen', De Kroniek van het Rembrandthuis (1975), pp. 9-19. Schatborn 1977

P. Schatborn, 'Beesten nae 't leven', De Kroniek van het Rembrandthuis (1977) 2, pp. 3-31.

Schatborn 1981

Peter Schatborn, Figuurstudies, Nederlandse tekeningen uit de 17de eeuw, The Hague 1981.

Schatborn 1981-I

P. Schatborn, 'Van Rembrandt tot Crozat, Vroege verzamelingen met tekeningen van Rembrandt'. Nederlands Kunsthistorisch Jaarboek 32 (1981), pp. 1-54. Schatborn 1985

Peter Schatborn, Tekeningen van Rembrandt, zijn onbekende leerlingen en navolgers, Catalogus van de nederlandse tekeningen in het Rijksprentenkabinet, Rijksmuseum, Amsterdam, IV, The Hague 1985.

Schatborn 1985-I

Peter Schatborn, 'Tekeningen van Rembrandts leerlingen', Bulletin van het Rijksmuseum 33 (1985) 2, pp. 93-109.

Schatborn 1986

Peter Schatborn, 'Tekeningen van Rembrandt in verband met zijn etsen', De Kroniek van het Rembrandthuis 38 (1986), pp. 1-38.

Schatborn 1987

Peter Schatborn, 'Rembrandt's late drawings of female nudes', Drawings Defined, edited by Walter Strauss and Tracy Felker, New York 1987, pp. 307-20. Schatborn 1989

Peter Schatborn, 'Notes on early Rembrandt Drawings', Master Drawings 27/2 (1989), pp. 125-26. Schatborn 1990

Peter Schatborn, 'Met Rembrandt naar buiten', De Kroniek van het Rembrandthuis 1-2 (1990), pp. 31-39. Scheller 1969

R.W. Scheller, 'Rembrandt en de encyclopedische verzameling', in Oud Holland 84 (1969), pp. 81-147. Schneider 1990

Cynthia P. Schneider, Rembrandt's Landscapes, New Haven and London, 1990.

Schwartz 1987

G. Schwartz, Rembrandt. Sämtliche Gemälde in Farbe, Zürich and Stuttgart, 1984/87.

Seidlitz 1922

W. v. Seidlitz, Die Radierungen Rembrandts, Leipzig 1922. Six 1969

J. Six, 'Jan Six aan het venster', De Kroniek van het Rembrandthuis 23 (1969), pp. 34-52.

Slatkes 1973

Leonard J. Slatkes, review of C. White and K.G. Boon, Rembrandt's Etchings and C. White, Rembrandt as an etcher, in Art Quarterly 36 (1973), pp. 250-63.

Slive 1953

S. Slive, Rembrandt and his Critics 1630-1730, The Hague 1953.

Smith 1988

David R. Smith, "I Janus": Privacy and the Gentlemanly Ideal in Rembrandt's Portraits of Jan Six', Art History 11, 1988, pp. 42-63.

Stechow 1929

Wolfgang Stechow, 'Rembrandts Darstellungen der Kreuzabnahme', Jahrbuch der Preussischen Kunstsammlungen 50 (1929), pp. 217-32. Stechow 1950

Wolfgang Stechow, review of J. Rosenberg, Rembrandt, The Art Bulletin 32 (1950), pp. 252-55.

Stratton 1986

Suzanne Stratton, 'Rembrandt's Beggars: Satire and Sympathy', The Print Collector's Newsletter 17 (1986), pp. 77-82.

Strauss 1983

Walter L. Strauss, 'The Puzzle of Rembrandt's Plates', Essays in Northern European Art presented to Egbert Haverkamp-Begemann on his Sixtieth Birthday, Doornspiik 1983, pp. 261-65.

Strauss/van der Meulen

see Documents

Sumowski Drawings

Werner Sumowski, Drawings of the Rembrandt School, I-, New York 1979-.

Sumowski 1961

Werner Sumowski, Bemerkungen zu Otto Beneschs Corpus der Rembrandtzeichnungen, II, Bad Pyrmont 1961. Sumowski 1971

W. Sumowski, 'Rembrandtzeichnungen', Pantheon 29 (1971), pp. 125-38.

Sumowski 1983

Werner Sumowski, Gemälde der Rembrandt-Schüler, I-V, Landau/Pfaltz 1983.

Trautscholdt 1961

Eduard Trautscholdt, "De Oude Koekebakster". Nachtrag zu Adriaen Brouwer', Pantheon 19 (1961), pp. 187-95.

Tümpel 1968/71

Christian Tümpel, 'Ikonographische Beiträge zu Rembrandt. Zur Deutung und Interpretation seiner Historien', Jahrbuch der Hamburger Kunstsammlungen 13 (1968), pp. 95-126, en 16 (1971), pp. 20-38. Tümpel 1969

Christian Tümpel, 'Studien zur Ikonographie der Historien Rembrandts', Nederlands Kunsthistorisch Faarboek 20 (1969), pp. 107–98.

Tümpel 1970

Christian Tümpel, Rembrandt legt die Bibel aus. Zeichnungen und Radierungen aus dem Kupferstichkabinett der Staatlichen Museen Preussischer Kulturbesitz Berlin, Berlin

Tümpel 1977

Christian Tümpel, Rembrandt, Reinbek b. Hamburg 1977.

Tümpel 1984

Christian Tümpel, 'Die Rezeption der Jüdischen Altertümer des Flavius Josephus in den holländischen Historiendarstellungen des 16. 17. Jahrhunderts', in: H. Vekeman, J. Müller-Hofstede, Wort und Bild in der niederländischen Kunst und Literatur, Erftstadt 1984, pp. 173-204.

Tümpel 1986

Christian Tümpel, Rembrandt, Amsterdam 1986. Urkunden

C. Hofstede de Groot, Die Urkunden über Rembrandt (1575-1721). Quellenstudien zur holländischen Kunstgeschichte III, The Hague 1906.

Valentiner I 1925; II 1934

Wilhelm R. Valentiner, Rembrandt, des Meisters Handzeichnungen (Klassiker der Kunst 31), I Stuttgart/ Berlin/Leipzig 1925; II Stuttgart/Berlin 1934. Voûte 1987

J.R. Voûte, 'Clement de Jonghe exit', De Kroniek van het Rembrandthuis 39 (1987), pp. 21-27.

De Vries 1978

A.B. de Vries, Magdi Tóth-Ubbens, W. Froentjes, Rembrandt in the Mauritshuis, Alphen aan de Rijn 1978.

H. van de Waal, 'Rembrandt's Faust Etching, a Socian

document, and the iconography of the inspired scholar', Oud Holland, 79 (1964), pp. 7-48.

Wegner 1973

Wolfgang Wegner, Die Niederländischen Handzeichnungen des 15.-18 Jahrhunderts, Kataloge der Staatlichen Graphischen Sammlung München, I, Berlin 1973.

Welcker 1954

A. Welcker, 'Een onbekende eerste ontwerp voor Rembrandt's ets van Jan Cornelis Sylvius (B. 280)', Oud Holland 69 (1954), pp. 229-34.

Werbke 1989

Axel Werbke, 'Rembrandts "Landschaftsradierungen mit drei Bäumen" als visuell-gedankliche Herausforderung', Jahrbuch der Berliner Museen 31 (1989), pp. 225-50.

Wheelock 1973

A.K. Wheelock, Perspective, Optics, and Delft Artists around 1650, New York 1977.

Wheelock 1983

A.K. Wheelock jn., 'The Influence of Lucas van Leyden on Rembrandt's narrative Etchings', in Essays in Northern European Art presented to Egbert Haverkamp-Begemann on his Sixtieth Birthday, Doorspijk 1983, pp. 201-06.

White 1969

Christopher White, Rembrandt as an Etcher, I-II, London 1969.

Wiebel 1988

Christiane Wiebel, Askese und Endlichkeitsdemut in der italienischen Renaissance. Ikonologische Studien zum Bild des heiligen Hieronymus, Weinheim 1988.

Winternitz 1969

E. Winternitz, 'Rembrandt, Christ presented to the people, 1655', Oud Holland 84 (1969), pp. 177-98. Yver 1756

Pierre Yver, Supplément au Catalogue Raisonné de MM. Gersaint, Helle et Glomy, Amsterdam 1756.

Exhibition Catalogues

Amsterdam 1956

Rembrandt, Etsen, Amsterdam (Rijksmuseum) 1956; catalogue by K.G. Boon.

Amsterdam 1964-1965

Bijbelse inspiratie, Tekeningen en prenten van Lucas van Leyden en Rembrandt, Amsterdam (Rijksprentenkabinet) 1964–1965; introduction by C.W. Mönnich, catalogue by L.C.J. Frerichs and J. Verbeek.

Amsterdam 1969

Rembrandt 1669—1969, Amsterdam (Rijksmuseum) 1969; catalogue of the drawings by L.C.J. Frerichs and P. Schatborn.

Amsterdam 1973

Hollandse Genre-Tekeningen, Amsterdam (Rijksprentenkabinet) 1973; introduction by K.G. Boon, catalogue by P. Schatborn.

Amsterdam 1976

Tot Lering en Vermaak. Betekenissen van Hollandse gemevoorstellingen uit de zeventiende eeuw, Amsterdam (Rijksmuseum) 1976; catalogue by E. de Jongh e.a. Amsterdam 1981

Work in process. Rembrandt etchings in different states, Amsterdam (Museum het Rembrandthuis) 1981; catalogue by E. Ornstein-van Slooten. Amsterdam/Washington 1981–1982

See: Schatborn 1981

Amsterdam 1983

Het beste bewaard, Een Amsterdamse verzameling en bet ontstaan van de Vereniging Rembrandt, Amsterdam (Rijksprentenkabinet) 1983; by Marijn Schapelhouman. Amsterdam 1983–I

Landschappen van Rembrandt en zijn voorlopers, Amsterdam (Museum het Rembrandthuis) 1983; catalogue by Eva Ornstein-van Slooten, introduction by P. Schatborn. Amsterdam 1984/1985

Bij Rembrandt in de leer/Rembrandt as teacher, Amsterdam (Het Rembrandthuis) 1984/1985; catalogue Eva Ornstein-van Slooten, introduction P.Schatborn. Amsterdam 1985/86

Rembrandt en zijn voorbeelden/Rembrandt and bis sources, Amsterdam (Het Rembrandthuis) 1985/86; catalogue by B. Broos.

Amsterdam 1986/87

Oog in Oog met de modellen van Rembrandts protret-etsen/Face to Face with the sitters for Rembrandt's etched portraits, Amsterdam (Museum het Rembrandthuis) 1986/87; catalogue by R.E.O. Ekkart and E. Ornstein-van Slooten.

Amsterdam 1987

Dossier Rembrandt/The Rembrandt Papers, Amsterdam (Museum het Rembrandthuis) 1987–1988; catalogue by S.A.C. Dudok van Heel, with contributions from E. Ornstein-van Slooten and P. Schatborn.

Amsterdam 1988/89

Jan Lievens (1607–1674). Prenten en Tekeningen/Prints and Drawings, Amsterdam (Museum het Rembrandthuis) 1988/89; catalogue by E. Ornstein-van Slooten and P. Schatborn.

Berlin 1970

Rembrandt legt die Bibel aus. Zeichnungen und Radierungen

aus dem Kupferstichkabinett der Staatlichen Museen Preussischer Kulturbesitz, Berlin, Berlin (Kupferstichkabinett SMPK) 1970; catalogue by Christian Tümpel, with a contribution by Astrid Tümpel.

Berlin 1984

Von Frans Hals bis Vermeer. Meisterwerke bolländischer Genremalerie, Berlin (Gemäldegalerie SMPK) 1984; catalogue by P.C. Sutton e.a.

Boston/New York 1969/70

Rembrandt: Experimental Etcher, Boston (Museum of Fine Arts) and New York (Pierpont Morgan Library) 1969/70; catalogue by C. Ackley e.a.

Boston 1980/81

Printmaking in the Age of Rembrandt, Boston (Museum of Fine Arts), 1980/81; catalogue by C.S. Ackley e.a. Brussel/Rotterdam/Paris/Bern 1968–1969
Dessins de paysagistes bollandais du XVIIe siècle, Brussel (Bibliotheek Albert I), Rotterdam (Museum Boymansvan Beuningen), Paris (Institut Néerlandais), Bern (Musée des Beaux-Arts) 1968–1969; catalogue by Carlos van Hasselt.

Braunschweig 1978

Die Sprache der Bilder. Realität und Bedeutung in der niederländischen Malerei des 17. Jahrbunderts, Braunschweig (Herzog Anton Ulrich-Museum), 1978; catalogue by R. Klessmann e.a.

Chicago/Minneapolis/Detroit/ 1969

Rembrandt after three bundred Years, Chicago (The Art Institute), Minneapolis (The Minneapolis Institute of Arts), Detroit (The Detroit Institute of Arts) 1969—1970; catalogue by J.Richard Judson, E. Haverkamp-Begemann and Anne Marie Logan.

Hamburg 1987

Rembrandt. Hundert Radierungen, Hamburg (Kunsthalle) 1987; catalogue by E. Schaar.

Lawrence/Kansas, New Haven and Austin 1983/84 Dutch Prints of Daily Life. Mirrors of Life or Masks of Morals? Lawrence, Kansas (The Spencer Museum of Art), New Haven (Yale University Art Gallery) and Austin (Huntington Gallery, University of Texas) 1983/84; catalogue by L.A. Stone-Ferrier.

Leiden 1956

Rembrandt als leermeester, Leiden (Stedelijk Museum De Lakenhal) 1956; introduction by J.N. van Wessen. London 1835

A Catalogue of One Hundred Original Drawings by Sir Ant. Vandyke and by Rembrandt van Rijn Collected by Sir Thomas Lawrence, London 1835; catalogue by S. and A. Woodburn

London 1929

Dutch Art, 1450–1900, London (Royal Academy of Arts) 1929.

London 1969

Old Master Drawings from Chatsworth, London (Royal Academy of Arts) 1969; catalogue by A.E. Popham. London 1969–I

The late etchings of Rembrandt: a study in the development of a print, London (The British Museum) 1969; catalogue by C. White.

London 1988/89

Rembrandt. Art in the Making, London (The National Gallery) 1988/89; catalogue by D. Bomford, C. Brown and A. Roy.

Milaan 1970

Rembrandt, Trentotto Disegni, Milaan (Pinacoteca di Brera) 1970; catalogue by Peter Schatborn, introductions by Karel G. Boon and Lamberto Vitali. New York/Cambridge 1960

Rembrandt Drawings from American Collections, New York (The Pierpont Morgan Library) and Cambridge (Fogg

Art Museum) 1960; catalogue by Felice Stampfle and E. Haverkamp-Begemann, introduction by J. Rosenberg. New York/Boston/Chicago 1969

Drawings from Stockholm, New York (The Pierpont Morgan Library), Boston (Museum of Fine Arts), Chicago (The Art Institute) 1969; catalogue by Per Biurström.

New York 1972-1973

Dutch Genre Drawings of the Seventeenth Century, New York (The Pierpont Morgan Library), Boston (Museum of Fine Arts), Chicago (The Art Institute of Chicago) 1972–1973; introduction by K.G. Boon, catalogue by P. Schathorn

New York/Paris 1977-1978

Rembrandt and bis Century, Dutch Drawings of the Seventeenth Century from the Collection of Frits Lugt, Institut Néerlandais, Paris, New York (Pierpont Morgan Library), Paris (Institut Néerlandais) 1977–1978; catalogue by Carlos van Hasselt.

New York 1988

Creative Copies, Interpretative Drawings from Michelangelo to Picasso, New York (The Drawing Center) 1988; catalogue by Egbert Haverkamp-Begemann and Carolyn Logan.

Paris 1974

Dessins flamands et bollandais du dix-septième, Paris (Institut Néerlandais) 1974.

Paris, Antwerp, London and New York 1979–1980 Rubens and Rembrandt in Their Century. Flemish and Dutch Drawings of the Seventeenth Century from The Pierpont Morgan Library, Paris (Institut Néerlandais), Antwerp (Koninklijk Museum voor Schone Kunsten), London (The British Museum), New York (The Pierpont Morgan Library) 1979–1980; catalogue by Felice Stampfle.

Paris 1986

De Rembrandt à Vermeer, Les peintres bollandais au Mauritshuis de La Haye, Paris (Grand Palais) 1986; catalogue by Ben Broos.

Paris 1986-I

Rembrandt et son école, dessins du Musée du Louvre, Paris (Musée du Louvre, Cabinet des dessins), 1988/89; catalogue by M. de Bazelaire and E. Starcky. Paris 1988–1989

Rembrandt et son école, dessins du Musée du Lourre, Paris 1988–1989; catalogue by Menehould de Bazelaire and Emmanuel Starcky.

Rotterdam/Amsterdam 1956

Rembrandttentoonstelling tekeningen, Rotterdam (Museum Boymans) and Amsterdam (Rijksprentenkabinet) 1956; introduction by J.C. Ebbinge Wubben and I.Q. van Regteren Altena; catalogue by

E.Haverkamp-Begemann.

Sacramento 1974

The Pre-Rembrandtists, Sacramento (E.B. Crocker Art Gallery) 1974; introduction and catalogue by Astrid Tümpel, essay by Christian Tümpel.

Stockholm 1965

Rembrandt, Stockholm (Nationalmuseum) 1965. Washington 1973

Early Italian Engravings from the National Gallery of Art, Washington (National Gallery of Art) 1973; catalogue by J.A. Levenson, K. Oberhuber, J.L. Sheehan. Washington, Denver and Fort Worth 1977
Seventeenth Century Dutch Drawings from American Collections, Washington (National Gallery of Art), Denver (The Denver Art Museum) and Fort Worth (Kimbell Art Museum) 1977; catalogue by Franklin W.

Robinson. Washington 1989

Frans Hals, Washington (National Gallery of Art),

London (Royal Academy of Arts), Haarlem (Frans Halsmuseum) 1989/90; catalogue by S. Slive. Washington 1990 Rembrandt's Landscapes. Drawings and Prints, Washington (National Gallery of Art) 1990; catalogue by Cynthia P. Schneider.

The exhibition in Amsterdam is supported by The City of Amsterdam Golden Tulip Barbizon Centre Hotel Ministry of Welfare, Health and Cultural Affairs

KLM Royal Dutch Airlines is the official carrier of the Rijksmuseum, Amsterdam